LABOUR PAINS

LABOUR PAINS

Women's Work in Crisis

Pat Armstrong

The Women's Press

CANADIAN CATALOGUING IN PUBLICATION DATA

Armstrong, Pat, 1945-
Labour pains: women's work in crisis

Bibliography: p.
ISBN 0-08896-091-6

1. Women - Employment - Canada. 2. Women - Canada - Economic conditions. 3. Canada - Economic conditions. I. Title.

HD6099.A75 1984 331.4'125'0971 C84-098739-0

Copyright © 1984 by Pat Armstrong

Edited by Jane Springer
Cover and book design by Liz Martin
Assembled by Sharon Nelson
Printed and bound in Canada
Published by the Women's Educational Press
16 Baldwin Street
Toronto, Ontario, Canada

CONTENTS

CHAPTER ONE
INTRODUCTION
13

CHAPTER TWO
THEORETICAL APPROACHES
19

CHAPTER THREE
SETTING THE STAGE
49

CHAPTER FOUR
LABOUR FORCE WORK
67

CHAPTER FIVE
HOUSEHOLD LABOUR
99

CHAPTER SIX
STATE PROGRAMS, VOLUNTEER WORK
AND PART-TIME JOBS
120

CHAPTER SEVEN
MICROELECTRONICS IN THE WORKPLACE
137

CHAPTER EIGHT
CONCLUSION
173

APPENDIX: METHODOLOGY
178

TABLES
195

BIBLIOGRAPHY
251

TABLES

Table 3.1
The Concentration of Labour Force[1] by Occupation,
Canada, 1951, 1961, 1971 and 1981
197

Table 3.2
The Concentration of Female and Male Labour Force[1]
by Occupation, Canada, 1951, 1961, 1971 and 1981
198

Table 3.3
The Concentration of Labour Force[1] by Industry Division,
Canada, 1951, 1961, 1971 and 1981
200

Table 3.4
The Concentration of Females and Males by Industry,
Canada, 1951, 1961, 1971 and 1981
201

Table 3.5
Labour Force Participation, Employment and Unemployment,
Canada, 1966-82
202

Table 3.6
Full-time and Part-time Employment, Canada, 1966-82
203

Table 4.1
Actual and Hypothetical Distribution of Labour Force,
by Occupation and Sex, Canada, 1980 and 1982
204

Table 4.2
Employed by Industry and Sex, Canada, 1975, 1980 and 1982
206

Table 4.3
Industrial Concentration by Sex and Occupation, Canada, 1982
208

Table 4.4
Female Sex-Typing by Industry, by Occupation, Canada, 1982
209

Table 4.5
Employment by Detailed Industry by Sex, Canada, 1982
210

Table 4.6
Part-time Employment by Industry by Sex,
Canada, 1975, 1980 and 1982
214

Table 4.7
Full-time Job Creation by Industry and Sex,
Canada, 1980-82
216

Table 4.8
Full-time Job Loss by Industry and Sex,
Canada, 1980-82
217

Table 4.9
Part-time Job Creation by Industry by Sex,
Canada, 1980-82
218

Table 4.10
Unemployment Rates by Industry and Sex,
Canada, 1975, 1980 and 1982
220

Table 4.11
Unemployment by Industry and Sex,
Canada, 1975, 1980 and 1982
222

Table 4.12
Concentration of Unemployment Within Occupations,
by Sex and Industry, Canada, 1982
224

Table 4.13
Employed Persons by Usual Hours Worked at Main Job,
by Industry and Sex, Canada, 1975 and 1982
225

Table 4.14
Union Membership, Canada, 1981
226

Table 4.15
Employed by Occupation and Sex,
Canada, 1975, 1980 and 1982
227

Table 4.16
Occupational Concentration by Sex and Industry, Canada, 1982
228

Table 4.17
Concentration of Male and Female Unemployment,
by Industry and Occupation, Canada, 1982
229

Table 4.18
Concentration of Unemployment within Industries,
by Sex and Occupation, Canada, 1982
230

Table 4.19
Full-time Job Creation by Occupation and Sex,
Canada, 1980-82
231

Table 4.20
Full-time Job Loss by Occupation and Sex,
Canada, 1980-82
232

Table 4.21
Employment by Detailed Occupation by Sex, Canada, 1982
233

Table 4.22
Part-time Employment by Occupation by Sex,
Canada, 1975, 1980 and 1982
240

Table 4.23
Part-time Job Creation by Occupation by Sex,
Canada, 1980-82
242

Table 4.24
Employed Persons by Usual Hours Worked at Main Job,
by Occupation and Sex, Canada, 1975 and 1982
244

Table 4.25
Unemployment by Occupation and Sex,
Canada, 1975, 1980 and 1982
246

Table 4.26
Unemployment Rates by Occupation and Sex,
Canada, 1975, 1980 and 1982
248

PREFACE

Labour Pains represents another instalment in a series which began, in printed form, with the 1975 publication of Hugh Armstrong's and my article on segregation in the labour force. Since that time, we have continually broadened our examination and definition of women's work. Each new investigation has exposed for us more links between segregation and the economic structure, between domestic and wage labour, between ideas and work, between the personal and the political. In the process, we have become increasingly convinced of the need to integrate theoretical and empirical work and to combine qualitative and quantitative data. We have also become increasingly aware of the complex nature of women's work, of the persistence and pervasiveness of segregation and subordination. We have come to realize that all economic development, all state policies, all social movements, have different consequences for women and men. All issues are women's issues.

We have always been convinced that, in spite of severe structural and social restraints, people are conscious participants in changing, if not in creating, their world. For this reason, we think that sex-conscious analysis can make an important contribution by exposing how segregation and subordination work and are maintained as well as by indicating who benefits from this sexual division of labour. Such research and writing can form an integral part of collective strategies for change.

Labour Pains grew out of this perspective and these concerns. In it, I examine the consequences, for women's household and labour force work, of

changes in the political economy during the current crisis and, on the basis of this analysis, make some predictions about the future. I am, of course, taking a chance in writing about a crisis in progress. Conditions are continually and rapidly changing. As I write this, delegates to the Canadian Labour Congress's national convention are expressing strong support for a shorter work week as a means of coping with the crisis in employment. The growing numbers and power of women in unions are reflected in resolutions on affirmative action. At the same time, the second largest union in Canada — the National Union of Provincial Government Employees — has passed a resolution calling on members to withdraw their financial support from The United Way unless that voluntary organization refuses to accept government contracts to provide social services, such as programs for abused children and battered wives, that were previously done by paid public employees. Candidates for the leadership of the Liberal Party are rushing to appeal to what is now being called the new majority. If such promises are fulfilled, the crisis could indeed begin to take a different direction, particularly for women.

But it is precisely because we need to know the implications and possibilities of these and other policies that such a book is necessary. It is risky to make predictions about the future on the basis of such a volatile situation but predictions are necessary if we are to evaluate and develop the strategies needed to create a future different from the one indicated by the trends examined here.

I was enrolled in the doctoral program at Carleton University when I decided to delay my plans to study Canadian families and instead focus my energies on developing an analysis of the sex-specific impact of the crisis. I was fortunate in finding a committee sympathetic to my project and one that combined warm support with strong criticism. I would like to thank the members of that committee, Professors Wallace Clement, Jared Keil and Bruce McFarlane, and Professor Patricia Connelly, who served on the committee while she was on sabbatical leave in Ottawa. I would also like to thank the external examiners, Professors Rianne Mahon and Peta Tancred-Sherrif. Their comments were very useful in transforming the thesis into a book. The graduate students too provided valuable stimulus and criticism. My theoretical chapters in particular benefited from lively sessions with Bonnie Ferguson, Erica Van Meurs and Professors Jacques Chevalier and Jared Keil.

I have learned over the years that a good relationship with the publisher makes a great deal of difference in the production of a book and I have thoroughly enjoyed working with The Women's Press. Jane Springer's

skills, knowledge of the issues and humour made the copyediting part of the process a pleasure.

As usual, Hugh was my staunchest, and stoutest, critic. Once again, Jill and Sarah did without, although this time they also helped. And once again, Irene Christie did an excellent job of producing a clean, typed copy from my complicated script.

−P.A.

CHAPTER ONE

INTRODUCTION

WHO SUFFERS DURING an economic crisis? What are the consequences of rising unemployment for those whose jobs disappear, for those who have paid employment and for those who do household work? Writing during the Great Depression, Leonard Marsh (1939:55) concluded that unemployment "is primarily at least, a male problem." And so it was, by all official counts. Nevertheless, Marsh went on to argue that "not to bring women into scope at all would be to ignore one of the outstanding economic trends of the last decade – the widening of the range of women's occupations and the greater proportion which women have come to represent in the total working force of the country" (Marsh, 1939:144). He maintained that a separate analysis of women's situation was required because:

> the range of women's occupations is still relatively narrow, even if numbers employed have increased. Further, the problem of employment among women is almost entirely an urban one; it is in the cities that the newer fields of women's employment have developed. And in the third place, the majority of unemployed women are not married, whereas the opposite is true in the case with men. To the woman with no other resources than her job – unemployment is an even more serious problem of dependency than to a man. She is very far from having the freedom of movement that is open to the single man; and unless she is able to return to her family, she is far more likely to be in need of assistance (Marsh, 1939:255).

Canada is once again experiencing an economic and social upheaval of crisis proportions and the growth in women's labour force participation continues to be one of the outstanding trends of the last few decades. The range of women's occupations is still relatively narrow,[1] even if the numbers employed have continued to increase. Unemployment, particularly in urban areas, still creates a serious problem of dependency for women and most women who work for pay need the income. The link between domestic and wage labour that is implied but not made explicit in Marsh's statement also remains and, as was the case in that last Great Depression, women and men do different kinds and amounts of work in the household. Once again, a separate analysis of women's situation is required.

Of course, dramatic changes have taken place in Canada since the last Depression. First, while the actual number of women working for pay outside the home was probably greatly underestimated in the 1930s, only a small proportion of women in general, and married women in particular, were counted as being in the labour force. In 1931, less than one woman in five was so recorded; by 1981, more than one woman in two was counted as having a paid job or wanting one. Now, over 40 percent of the unemployed are women and about 50 percent of the married women are in the labour force.

Although there has been little change in the sex-segregated nature of either labour force or domestic work, the dramatic increase in numbers of women with paid employment means that some conditions in the household and in the formal economy have changed significantly. Drawn into labour force jobs by the increasing demand for female workers, women have been pushed out of the household by their growing need for income. Since the 1930s, money has become more and more essential in order to pay for the mortgage, the taxes, the heating bill, the costs of transportation, in short for all the "conveniences" required by health, the structure of the market and the law. Goods previously produced in the household have become more cheaply and conveniently available in the market for cash. Unlike the women Ruth Milkman (1976) describes in her study of the 1930s, few women now have the skills, the tools, the space or other resources that would enable them to substitute goods produced in the household for those available in the market. Moreover, even if they could, there is little evidence to indicate that they would save money by doing so. There are now more women in the labour force to be influenced by the changes there, fewer of them are available to take on extra domestic chores, and it is much more difficult to increase

INTRODUCTION

household labour as a means of compensating for declining incomes. Marsh argued that unless a single woman could return to her family, her unemployment problem was more severe than that of men. Now, married or not, many women do not have the option of relying on their families for support. During this economic depression many married women too are in need of assistance, and their opportunities are more limited than those of men.

Second, the state has grown enormously in size and influence. Social scientists from a wide range of perspectives[2] have explored the implications of state policy for the structure and labour of households. Others have demonstrated the impact of the state on employment and on the provision of social services.[3] All indicate that the state has fundamentally altered conditions for labour, whether in the household, in the formal economy or both. Social security systems cushion the impact of unemployment, illness and old age; the state provides many services otherwise performed in households; state policies regulate many aspects of employment; and state agencies employ many workers, especially female workers. Because the state is so pervasive and because state policies are being reexamined and altered during this crisis, the situation now is very different from that of the 1930s. This new situation has profound consequences for the work of women and men, in both the household and the formal economy.

Third, unlike the 1930s, we are in the midst of a technological revolution, one that will leave few aspects of daily life untouched. The literature on the new technology is mushrooming.[4] Social scientists from a variety of perspectives are rushing to predict the shape of this future world. While disagreeing on the specific consequences of the new technology, all agree that the effect will be enormous and that it will probably be very different for women and men. Not only will the microchip change the structure and number of jobs in the market but it will change their location as well. Reversing a trend that is more than a century old in this country, microelectronic technology encourages the growth of employment in the household, thus confounding the separation that has grown up between (labour force) "work" and "home." Again, the current situation differs fundamentally from the Great Depression.

Contemporary American and Canadian studies of the 1930s crisis and more recent research[5] as well indicate that the Great Depression had different consequences for women and men, both in the household and in the formal economy, yet there has been little if any attempt to apply these lessons to the current, and in many ways different, Canadian situation. This book sets out

to fill the gap by examining the impact of the economic crisis on women's work, on sex-segregated labour within the context of a political economy understood to encompass the state, the household and the formal economy.

Feminist theory[6] has considered not only the sexual division of labour but also the interpenetration of work in the home and in the labour force. Economic theory[7] has explored the uneven development of capitalism and the inevitability of crisis. In line with feminist theory, this book accepts the central importance of a sexual division of labour and the overlap of domestic and wage labour. And following the economic theorists, it assumes that the conditions are set by a capitalist economy driven into crisis. This book is an attempt to extend the analytical debate by bringing together feminist and economic theory, by beginning an analysis of the interrelationship between uneven economic development in the formal economy and in the household and by integrating the role of the state and of technology in setting the stage for women's work in both spheres. The approach is sex-conscious; it recognizes that people come in two sexes[8] and that all change has different consequences for women and men.

For those who are interested in these theoretical issues, the next chapter describes my theoretical framework in some detail. Chapter Two presents a critical evaluation of both feminist and economic literature and outlines the important contributions of various perspectives. The proposals for a more sex-conscious analysis of crises are built on these lessons from the past.

For those primarily interested in what actually happens to work during crises, Chapter Three is the place to turn. Here women and men's work is located within the context of restructured domestic and wage labour, of resistance and of a changing ideology.

Chapter Four examines the consequences of the current crisis for the labour force work of women and men, arguing that the combination of segregation and uneven development has meant that many women have been protected from the most obvious and visible consequences of a deteriorating economy. However, it should not be assumed that women have entirely escaped during these hard times. Women's unemployment rates are rising and remain higher than those of men in all occupations where there are enough women to make the statistics reliable. Fewer and fewer of the women who do find paid employment find full-time work and full-time pay. In addition, many of the women who have part-time jobs have seen their hours and therefore their wages reduced. Where women directly compete with men for jobs, the women usually lose. And, as Chapter Five explains, women

INTRODUCTION

have suffered many less visible consequences within the household. Declining incomes and services mean increasing tensions and more household work for women.

Finally, Chapters Six and Seven argue that the same segregation and uneven development that have provided some protection for women in the early stages of the crisis will ultimately make them much more vulnerable. Government restraint programs will eliminate women's best jobs in the labour force while increasing their domestic work. Technology will destroy large numbers of women's jobs while creating few that will offer women meaningful work in the future.

This future is not predetermined. Women can and do make their own history, if not under conditions of their own choosing. However, women's ability to resist these changes will be limited by falling union membership, by the pressure from unemployed women and men and by the return of some work, and some women, to the household. The rise of a new right ideology will also inhibit women's struggle for change. The empirical data, as well as the power of employers and the interests of the state, suggest that women will face more work and less pay, more labour but less employment. The following analysis is intended to expose this process so that we can work together towards an alternative future, one that will work for women and for men.

NOTES

[1] For evidence on the continued segregation of the labour market, see Armstrong and Armstrong (1975, 1978 and 1982b), Connelly (1978), Lautard (1976) and Nakamura *et al.* (1979).

[2] For a discussion of the relationship between state policy and family structures, see Eichler (1978 and 1983), Land (1976 and 1978), Mary McIntosh (1978 and 1979), Parsons (1952 and 1956) and Zaretsky (1976 and 1982).

[3] Armstrong (1977) has examined the growth of state employment and Finkel (1977) has investigated the growth in state services. Both articles are part of a collection edited by Panitch (1977), which explores the theoretical and empirical aspects of the expansion in the state.

[4] For examples of different interpretations of technological implications, see Abt Associates (1982a and 1982b), Action Travail des Femmes (1982), Hainsworth (1982), Labour Canada Task Force (1982), Menzies (1981 and 1982) and Stinson (1980).

[5] Social scientists from a variety of disciplines examined the social and political implications of the Depression as it was happening. See, for example, Cavan and Ranck (1938), Komarovsky (1940), LaFollette (1934), Marsh (1935, 1939 and 1940) and Morgan (1939). Milkman (1976) and Humphries (1976) used historical documents to analyze the effects from a contemporary perspective.

[6] A number of Canadians have explored the theoretical issues arising from the relationship between domestic and wage labour as well as the segregation of work in the household and in the formal economy. See Armstrong and Armstrong (1978 and 1983a), Connelly (1978), Benston (1969), Fox (1980), Hamilton (1978), Morton (1972) and Seccombe (1974 and 1983).

[7] Marx (1977) outlined an economic theory of crisis and the implications of this theory have been drawn out by such authors as Gamble and Walton (1976), Lebowitz (1982) and Mandel (1968).

[8] While it seems clear that the overwhelming majority of what are called sex differences are actually gender differences — are socially rather than biologically generated — the term sex is used throughout this book both because the distinction is frequently difficult to make and because sex is a more commonly used term than gender.

CHAPTER TWO
THEORETICAL APPROACHES

UNTIL FEMINISM EMERGED in the 1960s, sexual divisions were not a central factor in social science research and theory,[1] with the possible exception of anthropological studies of "primitive" societies. This was nowhere more evident than in the approach to the sociology of work. Theoretical and empirical investigations of work focused on labour force employment and assumed at best a sexless worker, at worst an all-male cast. These studies of men on the job[2] usually examined work in isolation from domestic responsibilities and structure. If men's life outside the job was treated at all, it was assumed to be dependent on men's labour force work.[3] Men's household responsibilities rarely appeared in the literature as influences on paid work. From this perspective, paid work was primary for men and men were the primary workers.

On those few occasions when women's paid labour was considered, it was looked on as an aberration, as a problem for the state, employers, husbands, children and the women themselves. In his review of industrial sociology, Richard Brown (1976:27) makes this point succinctly:

> The largest category of studies on women as employees is that which regards the employment of women as in some way giving rise to problems – for the women themselves in combining their two roles; for the employer in coping with higher rates of absence and labour turnover, and demands for part-time work; for the social services in providing for the care of children of working mothers, or in coping with the supposed results of maternal neglect; for husbands and other kin in taking over part of the roles of wife and mother; and

even for the sociologist in attempting to discern the 'motivation' of women in paid employment. As this list suggests, the focus of attention has been on the employment of married women, but, as has been pointed out often enough, in a society where the great majority of women marry, and at younger ages, than in the past, women in employment now more often than not means married women.

But, as Roslyn Feldberg and Evelyn Glenn (1982:68) convincingly argue,

> In all these "family consequences" studies, the supposed effects of women's employment are studied without reference to the actual activities of women on the job. Thus, they provide little information on how consequences vary for families of women doing different jobs under different working conditions.

In this literature on work, women's domestic responsibilities were primary, their paid employment secondary, at best. Those few studies of working conditions that included women and men employed in similar jobs frequently used quite different explanations for the responses of female and male workers. Blauner's (1964) *Alienation and Freedom,* for example, as Feldberg and Glenn (1982) point out, links male attitudes and behaviour to working conditions but attributes women's patterns to female biology and family responsibilities.

While married women's paid work received some attention, their domestic labour was seldom discussed as work. If treated at all, it was assumed to fall under family sociology, not the sociology of work. Talcott Parsons' (1956:23-24) dominant theoretical paradigm accorded women "an expressive leadership role" which was in effect viewed as taking "primary responsibility for the children." But such a "role" was not really work, certainly not work that was equivalent to male employment. For Parsons (1964:193), "The normal married woman is disbarred from testing or demonstrating her fundamental equality with her husband in competitive occupational achievement." Women provided tender loving care, men worked.

Elizabeth Fox-Genovese (1982:16) has developed a succinct outline of the structural functional position.

> Their thought invited the inclusion of female experience, but it has passed verdict on the meaning of that experience before the work began. Women naturally fit into familial roles; their activities naturally complement those of men; they naturally provide a nurturing climate for the inculcation of the young into their preordained adult roles. Furthermore, women's natural familial roles governed their access to the public sphere – to those economic, social and political roles that naturally accrue to men.

THEORETICAL APPROACHES

Helena Lopata's (1971) study, *Occupation: Housewife* thus marked a radical new direction in sociology, a trend that took housework seriously, that acknowledged it as work.

The fact of taking women's wage labour and domestic work seriously, a development which itself reflected the dramatic changes in women's labour force participation and the structure of domestic work, engendered both new developments in the social sciences and fundamental critiques of old theories. As Ann Oakley (1981:318) has explained, these new concerns "involved a general reassessment of academic literature as a resource for learning about women's situation." The approach was, in her words, "interdisciplinary, or, rather, anti-disciplinary." It attempted to adapt, to challenge and, in the end, transform the dominant paradigms that failed to examine and explain the different and unequal work of women and men. It drew on the theories and tools of all the social sciences, constructing in the process new feminist approaches to social theory. What has emerged is far from a consensus, except for the unanimous agreement that any theory must take sex differences into account.

While critiques of the social sciences in general were multiplying in the 1960s, it was feminists who challenged the inadequacy of approaches to the division of labour by sex. They began by focusing on women but continued to assume a male standard, to treat women as a special kind of worker. Gradually, the emphasis moved from adding women in to developing an analysis that explained sex divisions in general, one which understood that workers come in two sexes. Since feminists have led the way in the theoretical and empirical work on the sexual division of labour, feminist literature forms the basis for the perspective taken in this book. The approaches considered feminist, however, have expanded enormously in the last two decades and cover a wide range of disciplines and paradigms that are impossible to discuss here. For the purposes of this study then, I have lumped together the predominant perspectives into three broad categories – structural functionalism, labour market segmentation theory and socialist feminism. The brief critical outlines of these three approaches are designed to provide the background for the book's theoretical perspective.

Structural Functionalism

Shared assumptions have brought together those structural functional sociologists and those human capital theorists who have investigated the sexual division of labour. As John Porter (1965:16) explained in *The Vertical*

Mosaic, the original functional theory of Kingsley Davis and W.E. Moore claimed inequality was a functional necessity because "different jobs require different degrees of trained capacity and inherited qualities which are not equally distributed throughout a population." Such an approach, Porter points out, assumes equality of opportunity. It also ignores class or other structural barriers to job allocation. Even in its more recent interpretations, much stratification theory assumes not only free choice by rational people aware of the possibilities and consequences of these choices but shared values concerning the utility and rewards of particular occupations. Hierarchies, rather than classes, result from this distribution based on achieved status positions ranked in a societally determined order.

The basis of the human capital version of orthodox economic theory is very similar. According to Andrew Gamble and Paul Walton (1976:37), these approaches assumed that

> Markets were composed of economic agents acting independently, pursuing the greatest possible 'utility' by maximizing their returns and minimizing their costs. No essential difference existed between buyers and sellers, producers and consumers. All were 'economic men' subject to the external discipline of the market, the invisible hand of competition. Rational behaviour meant maximizing benefits.
>
> The subjective preferences of all individuals together added up to consumer demand.

Individuals are viewed as investing in their own human capital by improving their education, training and skills for which they are accordingly rewarded (or not if they have failed to develop those skills in high demand). Wages and jobs respond to factors of supply and demand and are based on the individual worker's marginal productivity. Consequently, this theory assumes "the economy is indifferent to gender" (Siltanen, 1981:27). If women receive lower pay and face restricted employment opportunities, it is because they have made poor choices. And, as Isabel Sawhill (1980:136) makes clear in her overview of economic perspectives on the family,

> There are essentially three reasons for poor choices: insufficient knowledge of private consequences, failure to consider social consequences, and the obsolescence of social guidelines and mores in a rapidly changing world.

Central to both the structural functional and human capital approaches is the belief in the constant move to equilibrium and in a consensus on values. These agreed-upon values play a crucial part both in explaining people's choices and in allocating rewards.

THEORETICAL APPROACHES

Beginning from such a perspective, theorists interested in explaining the segregation of the labour force examined the personal characteristics of the women who work for pay. Their education, training and length of service were investigated,[4] because causes for their participation were sought in individual women's marginal productivity. It was, however, also assumed that women were influenced in their labour force work by their responsibilities as wives and mothers, and by their husbands' incomes as well as by the human capacity they brought to the market.[5] For human capital theorists, "women's primary orientation to their childbearing role results in their stock of human capital being, in general, lower than men's" (Siltanen, 1981:26). In her critique of what she calls these status attainment approaches, Natalie Sokoloff (1980:4) explains that

> the method by which women's family-related sex role responsibilities are incorporated in this model is to factor out, control for, or otherwise take into account these relevant or confounding influences, which, no doubt, play a role in determining women's occupational statuses and rewards.

These procedures revealed links between the number and ages of children, family income and resources, marital status and fertility patterns and the length and duration of married women's labour force participation.[6] Yet, researchers like Sylvia Ostry (1968:45) found that "even after 'accounting for' such differences in work year, occupational deployment and 'quality' of labour between the sexes, there remained fairly sizeable pay gaps between male and female workers in Canada." And personal characteristics and family responsibilities still left the fundamental differences in male and female labour force jobs largely unexplained. Poor choices were clearly not the only factor.

Responding to this evidence, investigators looked to "non-economic" factors like the values of employers, called discrimination, and the values of female employees, usually considered under the general rubric of socialization. In *A World of Difference: Gender Roles in Perspective,* Esther Greenglass (1982:192) clearly lays out this perspective:

> Of course, even if improved legislation changes hiring practice, it will not automatically eliminate social and economic discrimination. Attitudes according to which women are considered unsuitable for certain types of jobs will continue to bar women from access to the training that will give them the skills necessary to take advantage of more available opportunities. Stereotyped and outmoded ideas of women's ability, held not only by employers, but also by

potential female applicants themselves, will also effectively bar women from many positions.

Ideas interfere with the market, limiting job allocation based on human capital alone, affecting the individual achievement process and limiting rational choices.

Both theories assumed a move towards a largely beneficial functional specialization. For Parsons (1956:20), the family is becoming "a more specialized agency than before." It is losing many of its functions to separate institutions. Particularly important in this regard is the state, the institution that is providing more and more services previously offered in the home. For human capital theorists, the specialization within the formal economy increases the demand for a more highly skilled labour force.

Theoretical and empirical work undertaken from these perspectives has provided some important clues for an understanding of sex-segregated work. The ideological support for segregation that is learned early in life has been identified and challenged. The parts played by husband's income, by women's education and experience, by married women's child-care responsibilities have been acknowledged in the literature. Although the research has often been more descriptive than analytical, seeking statistical relationships rather than explanation, links between women's domestic and wage labour have been partially exposed. So have the inadequacies of this approach.

Such a perspective views women as a special kind of worker – one influenced by factors outside the job – and thus gives little attention to male activites and experiences "off the job."[7] In their examination of models used in the sociology of work, Feldberg and Glenn (1982:67) conclude that:

> While analyses of men's relationship to employment concentrate on job-related features, most analyses of women's relationship to employment (which are rare by comparison) virtually ignore type of jobs and working conditions. When it is studied at all, women's relationship to employment is treated as derivative of personal characteristics and relationships to family situations.

That women and men are analyzed in this fashion reveals the fundamental assumptions behind this theory. First, the approach is teleological. The structure is taken for granted, described rather than explained. What is, is taken to be necessary, to be functional for the maintenance of a society that is itself defined as an active agent which transcends the individuals and classes who constitute it. As Sokoloff (1980:4) puts it, there is no analysis of "the construction, in the first place, of women's responsibility for the devalued

sphere of the home and of men's for the more highly valued world outside the home." Indeed, the segregation is often justified on the basis of the personal characteristics, natural tendencies or freely chosen family responsibilities of women. When individual, personal and human capital factors fail to explain the segregation, these theorists fall back on false ideas whose origins are unknown and whose tenacity remains unaccounted for. Focusing on individual choices and false ideas, they ignore changing structural relationships and barriers.

Second, the approach is thus also basically ahistorical, failing to comprehend the structure and division of labour within the context of a political economy in constant flux. When change is considered, it is conceived in a linear fashion, unexplained except in terms of a move towards a more functional, specialized equilibrium. People are inactive in the making of history, passive recipients in a socialization process and merely actors playing out their socially determined roles in adult life. But, as Danziger (1971) and Bowles and Gintis (1976) make clear in different ways, people of all ages are active participants in their own development. And, as the literature on women in unions[8] and the documentation on women's struggles in other areas[9] forcefully illustrate, women have seldom passively accepted a predetermined part in the social drama.

Third, in relating women's but not men's work in the market to household structure and labour, this approach is assuming Parsons' (1956) allocation of instrumental activities to men and expressive ones to women, as well as his contention that families are functionally distinct from economic institutions. Yet the interpenetration of the two spheres is revealed by the functionalists' own examination of women's child-care responsibilities. The dramatic increase in women's labour force work has made the expressive / instrumental division difficult to maintain, if it ever did have some efficacy. As D.H.S. Morgan (1975:44-45) argues convincingly, the distinction itself should be questioned since the same person may perform both kinds of activities and many activities have both an instrumental and an expressive aspect. With women taking on more of what Parsons called instrumental work, there is little evidence to indicate that the conditions of this work are less significant factors than domestic ones for women's behaviour. For example, research[10] suggests that the nature and conditions of paid jobs are at least as important as domestic responsibilities in determining women's attachment to labour force work. A recent study carried out in Alberta (Lowe and Northcott, 1984) found no differences in stress levels among male and

female coders in the post office. However, differences by sex did appear when all jobs in the post office were included, suggesting, the researchers argue, that job segregation, rather than sex-specific characteristic, explains the differences in behaviour by sex. Nevertheless, the two-role theories of researchers like Myrdal and Klein (1956) assume not only the separation of such activities but also the natural primacy of women's expressive, home-centred work. Current approaches to women's unemployment, for example, continue to reflect the conviction that women have only a secondary commitment to the labour force.[11]

These problems are in turn related to the assumptions of equality of opportunity, consensus and equilibrium. The critiques of structural functional stratification theory[12] are wide ranging, exposing the structural and class barriers, the psychological and ideological restrictions that deny the equal right to become unequal. But even within their own paradigm, these theorists have difficulty fitting women in. As Christine Delphy (1981:118) points out, "A woman's own position, that is to say, having a job, and one job rather than another, or not having a job at all, is not taken into account in determining her class membership." Men are classified by occupation, by education, by income; women by their marriage or their father's socioeconomic status. If employed women's paid occupations are considered, the problem does not disappear.

> The net result is that if, *like her husband,* a woman has an occupation, this distances her from him in terms of social ranking, while if, *unlike her husband,* she is not employed, this brings her closer to him in terms of ranking (Delphy, 1981:123, emphasis in the original).

If, on the other hand, they are classified on the basis of their domestic labour, all married women without paid employment fall into the same place in the stratification system, a conclusion denied by theory and research.[13] In addition to the more well-known problems with such stratification theory, then, there is the inability of this approach to situate women within the status hierarchies. This in turn reflects the functionalists' view that the "normal worker" is male, and that females are merely dependents primarily devoted to their expressive roles even if some make occasional forays into the labour market.

Not only is it assumed that women are first and foremost wives and mothers but also that they are happy there. However, with Betty Friedan's (1963)

THEORETICAL APPROACHES

exposure of the problem with no name, with Jessie Bernard's (1972) revelations about his and her marriages, with the open discussion of wife battering (MacLeod, 1980), with the attention given to rape (Clark and Lewis, 1977) and sexual harassment (Backhouse and Cohen, 1978) and more generally with the rebirth of the women's movement, the assumptions of consensus and equilibrium were difficult to maintain. This research reveals fundamental cleavages, both in the home and in the labour force, that challenge frameworks which assume smoothly functioning and integrating hierarchies based on consensus. Not a new equilibrium but new conflicts and struggles have emerged. Locked into subordination rather than separate but equal positions, most women have only poor "choices." Conflict, contradiction, subordination and struggle appear as necessary concepts in dealing with the division of labour by sex.

Finally, while it is clear that the state does offer many services previously provided in the home, there is plenty of evidence[14] to support the view that the state also actively bolsters families. State policies and programs from Census questions[15] to veterans' allowances, from income tax deductions for child-care expenses to student aid, assume and reinforce a family with shared financial resources. Families have not lost most of their functions to a specialized state and the state does not operate in isolation from families.

Focusing on rational individual choices and false ideas, on consensus and equilibrium, on markets and labour supply, on hierarchies and status groups, on women's expressive and men's instrumental roles, on isolated families and independent economic units, on passive responses and complementary roles, on equality of opportunity and an accepted social structure, structural functional sociology and human capital economics have revealed some of the factors that help maintian the sexual division of labour. But in failing to examine the structure of jobs and employers' interests, to acknowledge classes and conflicts, to look for the contradictions within and between groups and structures, to relate household and economy except through the family responsibilities of women, to investigate why the disclosed relationships among variables exist, or to place the segregation within the historically changing context of a complex interpenetrating political economy, these approaches have proven inadequate for the task of explaining the division of labour by sex.

Labour Market Segmentation Theory

While structural functionalism stressed the significance of individual characteristics in explaining the division of labour by sex, labour market segmentation theory emphasized the importance of group and structural factors. Empirical evidence consistently exposed fundamental divisions among workers that could not be attributed primarily to differences in human capital. As Michael Reich, David Gordon and Richard Edwards (1980:232, emphasis in the original) argue,

> These groups seem to operate in different *labour markets,* with different working conditions, different promotional opportunites, different wages, and different market institutions.

Some theorists, in the face of this evidence, began to focus on divisions rather than on a single occupational hierarchy. What emerged were basically two approaches: the dual labour market theories (Doeringer and Piore, 1971; Doeringer, 1980) and the radical theories (Gordon, 1972; Gordon, Edwards and Reich, 1982).

Dual labour market theory, as the name implies, understands the market as divided into basically two sectors. According to Doeringer and Piore's (1971:165) classic statement, jobs in the primary sectors usually have

> High wages, good working conditions, employment stability, chances of advancement, equity and due process in the administration of work rules. Jobs in the secondary market, in contrast, tend to have low wages and fringe benefits, poor working conditions, high labor turnover, little chance of advancement, and often arbitrary and capricious supervision.

Internal markets in the primary sector have established institutional rules that define where people from outside the occupation or industry may enter specified job ladders as well as the promotion possibilities and other benefits available to them once they pass through these "ports of entry" (Doeringer, 1980:213). This internal market may itself be dichotomized, particularly into permanent and temporary workers, creating a secondary market within the primary sector. Technological developments, the need to retain internally trained skilled workers and "The force of custom, tradition, employee pressure, and in many instances, unionism" (Doeringer, 1980:229) structure the market and benefit workers in the primary group. Flexibility results from the discretion in categorizing jobs and from the division of work into

primary and secondary sectors. When jobs are unstable, they are subcontracted, left to the secondary sector or separated out within the primary sector. Employers in both sectors rely on highly visible characteristics and assumed group traits when hiring employees. Furthermore, there is a constant interaction between the characteristics of the jobs and those of the worker. A woman, for example, may be hired for a short-term job because she is thought to have a secondary commitment to the labour market. The temporary nature of the job ensures that this will be the case.

Such an approach was an improvement over human capital or structural functional theory. As Jane Siltanen (1981:30) explains,

> The implications of drawing the distinction between the characteristics of work and workers and analyzing the relationship between them is that women's decisions to leave paid employment may be less a reflection of a moral choice between family and work and more a reflection of the reality of their position as wage labourers.

Jobs rather than people, structures rather than personal characteristics, were the focus of attention. For this perspective, it was not poor choices but lack of choice that explained the division of labour by sex. Workers played a part, although a minor one, in structuring the internal markets. Moreover, the assumption of a single, agreed-upon hierarchy based on merit and use is challenged, leaving the way open for an analysis that recognizes fundamental cleavages and class differences in opportunities.

However, like much of structural functionalism, dual systems theory is more descriptive than analytical. "It does not explain how labour markets came to be structured in the first place to segregate women from men" (Sokoloff, 1980:63). Like structural functionalism, it often has the effect of justifying, albeit on somewhat different grounds, the existing system. And like that approach, it tends to view job structures in relatively static terms, failing to deal with the changes in skills, occupational structures and participation rates. Because dual systems theory largely ignores factors outside the internal market, it does not consider the relationship between household economy, for women or for men. Nor does it address the question of differences in male and female wages within occupations and sectors. The division of labour by sex seems again to be attributed mainly to false ideas, custom and tradition.

Early versions of the more radical segmentation theories shared many of the same problems. Little attention was paid to workers' organizations or households; the occupational structure, as Rubery (1980:244) makes clear, was not examined in a dynamic historical context. For these radical theorists, however, segmentation could be largely explained by capitalists' need to divide and rule an increasingly homogenized labour force. And sex and race were considered to be additional bases for segmentation. The latter version from Gordon, Edwards and Reich (1982) began with an expanded account of history and of the political economy. Capital accumulation was identified as the driving force that creates constant pressure for the expansion of the capitalist system, for growth in the size of corporations and in the concentration of control, for the spread of wage labour and the replenishment of the reserve labour pool and for continuous changes in the labour process. Some aspects of mechanization, supervision, deskilling and specialization raised earlier by Harry Braverman (1974) were also explored. Both the household and the state were seen to

> serve some critical supportive functions, providing steady and continued access to wage labour, shaping the political space within which capitalists can enjoy and command whatever profits they achieve, and contributing to cultural and ideological perceptions that reinforce individualism (Gordon, Edwards and Reich, 1982:19).

Union activity was made integral to the analysis and the transformation of jobs received some consideration. Mentioned in the discussions of each historical epoch, the labour force participation of women was even connected to their household situations in the early sections of the book.

The authors did explain that their book is "an analysis of labor in capitalist production and not of all labor or work performed in the economy," that they "pay very little attention to household labor, for example, even though we recognize its critical historical importance" (Gordon, Edwards and Reich, 1982:13). The problem is not simply one of missing a factor. The exclusion indicates an approach which assumes that women simply can be added on in several sections to provide an analysis of sex differences. Households are seen to be not only external to the market but also peripheral to our understanding of that market. So, for example, unions appear consistently in the Gordon, Edwards and Reich text as unified, sexless, although in one place (Gordon, Edwards and Reich, 1982:52) the authors do tentatively suggest that the "neglect by the male unions helped contribute to the ability of corporations to isolate women." Protests play a central part in the explanation of

THEORETICAL APPROACHES

Black men's position but the women's movement remains invisible. Factors which influence the supply of Black labour are discussed but only in the case of single women in the early period are reasons for women's changing participation considered. This is also the only place where the alterations in the household and their relationship to the economy are raised. Once again, women are sometimes simply tacked on at the end of the analysis or treated as a special case of the otherwise normal labour force, and the lives of standard workers outside the market are ignored. Race differences appear to be similar to sex differences but the smaller impact of women's struggles, the greater difference between male and female wages and the allocation of some jobs exclusively to women are left unexplained. As Ruth Milkman (1980:102) puts it:

> This theoretical framework does not attempt to explain occupational segregation by sex as a distinct phenomenon, but sees it as one of several cleavages that divide the working class in advanced capitalist society.

Moreover, this framework fails to deal with the class differences among women themselves. In leaving out these important ingredients, the approach has spoiled the entire recipe.

In addition, while some workers (but not women workers in this perspective) are active in making their own history, the analysis is in general not dialectical. There are few contradictions except for the conflict between the employers, who want to increase their control, and workers, who desire to resist this. Yet workers frequently fight for things like seniority rights, or the exclusion of women, which have the effect of dividing the workers and weakening their position as a whole. And the drive for accumulation encourages capitalists to commodify objects previously produced in the home and to hire, at low wages, the women released from this labour. But the growth in the numbers of women available for labour force work becomes impossible to absorb, laying the basis for a crisis in legitimacy as well as in employment.

Dual labour market theory has demonstrated the importance of structural factors and divisions in understanding the segregation of the labour force, focusing the attention on jobs rather than on people. Radical theories have moved towards an historical analysis that comprehends worker resistance and continual change in the occupational structure and the labour process within the context of capitalist development. Sex, understood as meaning the position of women, is considered as a basis for segmentation but the sexual division of labour, as well as the interpenetration of household and

economy, remain outside the analysis as a whole. The approach, while contributing to our understanding of labour market structures and processes, is partial and undialectical.

Socialist Feminism [16]

While structural functional and segmentation theory focused on paid employment, much early socialist feminist theory concentrated on women's domestic labour. Like human capital theory, it frequently explained women's subordinate position in terms of their primary responsibilities for husbands and children. Like segmentation theory, it was often functionalist, understanding women's household work in terms of its usefulness to capitalists. And, like both structural functional and segmentation theory, early socialist feminist approaches often considered women in static, ahistorical ways, as passive victims of men and capitalists. However, in the struggle to come to grips with both the variation and the consistency in women's subordinate position, socialist feminism has laid the basis for an analysis that is sex conscious as well as class conscious, class conscious as well as sex conscious.

Rejecting the pride of place given to ideas, to early socialization and to employers' discrimination by feminists employing a structural functional perspective, socialist feminists sought the sources of women's subordinate position, and thus the division of labour, in the nature and conditions of their work, particularly in that work which seemed invisible to both bourgeois and marxist theorists. In Heidi Hartmann's (1981:2) phrase, marxism has been sex-blind, failing to deal with the sexual division of labour and largely ignoring domestic work. Early marxist feminists sought to correct this blindness, as Maxine Molyneux (1979) points out, by trying to fit women into the categories Marx applied to the capitalist production process.

Margaret Benston (1969), for example, used Marx's distinction between use value and exchange value to argue that women, as the producers of use value in the home, constitute a class under the historically specific conditions of advanced capitalism. Unlike the paid work of men, which produces exchange value as well as use value, the unpaid work of women, which produces only use value, is valueless from the standpoint of capital. Although some women might also participate in wage labour, such participation is in her view transient and unrelated to the group definition. As a result of their position in the household, women form a reserve army of labour that can be called on when needed for capitalist production and sent home when no

longer required. The structure of the household, Benston maintained, is functional for capitalism in many other ways, stabilizing the economy by offering tender loving care, by providing the ideal consumption unit and by allowing capital to purchase, through the wages of males, the domestic labour of women as well.

Other theorists like Mariarosa Dalla Costa and Selma James (1972) also argued that women form a class on the basis of their domestic labour, but they turned to Marx's distinction between productive and unproductive labour for their analytical framework. For them, women now perform productive work, that is, work that is productive of surplus value and therefore a source of profit. Women are responsible for the maintenance and reproduction of the commodity labour power. The housework of women appears to be a personal service outside of capitalism, but is in reality the reproduction of labour power, which is essential to the production of surplus value. The family is thus a social factory, with women the exploited workers.

The argument that women, in providing the care and feeding of men and children, are performing work that is productive of surplus value shifted the focus of what has become known as the domestic labour debate to another marxist category – value. Wally Seccombe (1974) argued that, since domestic labour is part of the labour that reproduces labour power, it creates value equivalent to the production costs of its own maintenance, despite doing so under privatized conditions. Alternative interpretations of the relationship between domestic and wage labour arose in the debate. Jean Gardiner (1975:58), for instance, argued that domestic labour does not create value but "does nevertheless contribute to surplus value by keeping down the necessary labour time, or the value of labour power, to a level that is lower than the actual subsistence level of the working class."

The attempt to use marxist categories, and thus to provide a materialist analysis of labour, made household labour visible, indicated the ways it is useful to the capitalist system and suggested that household and economy are interpenetrating parts of the same system. However, as Armstrong and Armstrong (1983a) and Molyneux (1979) point out, the attempt to fit women into these categories frequently altered the marxist definitions, limiting their usefulness without making the sexual division of labour more transparent. Without the concept of "productive labour" and the distinction between it and the concept of "useful labour," it is difficult to see how capitalism works. Since only labour exchanged directly for a wage is productive in marxist terms, and since such labour has specific characteristics, to define

domestic labour as productive is simply confusing. Since a wide range of behaviour produces use values, defining domestic labour as the production of use values is not very illuminating either, because this merely puts it in the ahistorical category of work. Nor does categorizing domestic labour as productive change the way it is evaluated by women and men. Increasingly, money is necessary for survival and increasingly money can only be acquired by selling the ability to work in return for a wage. The market has become the major source of power, of control, of change, and thus it sets the conditions in our society as well as the outlines of what is valued as work.

The argument that domestic labour creates value is fraught with similar difficulties. Essentially the criticisms of this argument boil down to the fact that domestic labour is not equivalent to wage labour and that it is this very difference – rather than the similarities – that gives domestic workers their flexibility in terms of entering and leaving the market. While those arguing that domestic labour creates value have not shown that the law of value directly governs the allocation of domestic labour, they have opened the door, as Seccombe's (1980) work makes clear, to an analysis which explores how the operation of the law of value in the market impinges on the household, influencing but not determining domestic labour time and content. It thus lays the basis for a theory that understands sex division within the context of the entire political economy.

There are additional and equally important criticisms of this approach. The early arguments virtually ignored women's wage labour, although part of the later value debate did look at women's movement in and out of the labour force. Patricia Connelly (1978), for example, made important theoretical and empirical contributions when she demonstrated that women satisfy both the preconditions and the principal condition of a reserve army; that is, female labour is cheap and available and women compete with each other for female jobs. In *The Double Ghetto,* we (Armstrong and Armstrong, 1978) explored the links between employers' interests and women's economic need. Both studies emphasized the interrelationship between women's two kinds of work, rather than stressing only the uses to capitalism. But when wage labour was considered, it was not usually examined in a dialectical way. The contradictions between domestic and wage labour as well as those inherent in both were not thoroughly explored. Peggy Morton (1972) had suggested that there are contradictory pressures to commodify and retain domestic labour, but such dialectical relationships remained relatively unexamined. More recently, socialist feminists have stressed that:

THEORETICAL APPROACHES

This double linking of women's domestic dependence and wage work means that there is no simple functional relation between the family and capitalist production. Each of the links has developed historically in a very uneven way, each necessarily in relation to the other, but frequently in a contradictory relationship (McIntosh, 1979:156).

And people have acted on the basis of these contradictions to create change. Seldom have women in particular or workers in general been passive victims; seldom have capitalists had it their own way and even if they had, the effects would not have been entirely in their interests. Women have struggled with and against men but early feminist theory rarely integrated such activity into its theoretical framework. As Jane Humphries (1977 and 1980) suggests, the family wage (to the extent that it existed) should be understood more as an objective fought for by working-class women and men than as an outcome of capitalists pursuing their interests. Ruth Milkman's (1980) examination of union history in the United States also clearly indicates that an explanation of segregation must look at the active exclusion of women from unions, the efforts of male unionists to prevent women from competing for their jobs, and employers' interests, as well as the link between household and economy. Such an explanation, she argues, must also consider the complex, contradictory nature of these struggles and their consequences.

While workers *as a class* do have an interest in building united opposition to capital, *individual* workers who derive immediate benefits from the segmentation of the labor market will want to protect their relative privilege.

Similarly, employers have contradictory interests. On the one hand, *as a class* they benefit from a divided labor force. On the other hand, rigid sex- and race-typing of jobs may create difficulties for individual employers in obtaining the labor supplies they require at minimal costs, precisely because wage differentials are likely to be the key underpinning of occupational segregation (Milkman, 1980:104, emphasis in the original).

The historical evidence from Britain and the United States presented by Johanna Brenner and Maria Ramas (1984) supports this argument, revealing the different strategies – and the consequences of these strategies – pursued by workers and employers in the past. Furthermore, women are divided among themselves, reflecting their different class interests. In other words, the analysis should be more historical and dialectical, less functional and static.

Other critics[17] argued that, in emphasizing work under capitalism, socialist feminists were ignoring the effect of biological differences and the persistence of male power (often called patriarchy). Sex differences create much more fundamental cleavages than do racial differences, cleavages that pervade the entire system. The whole is bound together by an ideology that grows out of and reinforces the segregation, an ideology far too often left out of the socialist feminist analysis. As Lydia Sargent (1981:xxi) explains in the introduction to her book on marxism and feminism,

> Radical feminists criticized marxists and socialists for ignoring the importance of patriarchy as part of the formation of people's consciousness and for ignoring the importance of people's psychological need to maintain sexist behavior.

Out of these kinds of criticism grew dual systems theory.

Critical of both radical feminism and marxist feminism, dual systems theorists[18] drew on both to develop what Rosalind Petchesky (1978:376) calls "the model of 'separate spheres.'" Zillah Eisentein (1979:22), for example, argued that marxism can expose the workings of capitalism, of exploitation, of class inequality but fails to explain the position of women in the home " as mother, domestic laborer and consumer," and that feminism reveals the foundations of patriarchy, while failing to deal with class differences. Capitalism creates the variation and patriarchy the persistence in women's subordinate position. There are seen to be two distinct, relatively autonomous systems, each with its own logic and its own history. The system of patriarchy, centred around the home and the reproduction of children, engenders the specific oppression of women. The system of capitalist production, existing outside the home, results in the class oppression of women. These two separate systems interact, sometimes contradicting and sometimes reinforcing each other.

Although dual systems theorists agree that patriarchy is a structurally independent system which plays the major part in women's oppression, they disagree on how patriarchy is to be defined. In her critique of dual systems theory, Iris Young (1980:174) suggests that there are two general approaches. One "understands the system of patriarchy as an ideological and psychological structure, independent of specific social, economic and historical relations." The other "considers patriarchy itself as a particular system of social relations of production (or 'reproduction') relatively independent of the relations of production that Marxists traditionally analyze." The first version, evident in Juliet Mitchell's *Psychoanalysis and Feminism* (1974), has

THEORETICAL APPROACHES

been attacked by Young (1980a and 1980b) and Hartmann (1981) among others, as ahistorical and universalistic, denying the cultural, historical and class variations in women's position at the same time as it leaves little hope for women's future. Hartmann (1981:12), whose position typifies the second approach, also criticizes Mitchell for failing

> to give patriarchy a material base in the relation between women's and men's labor power, and in her similar failure to note the material aspects of the process of personality formation and gender creation.

Hartmann (1981:15) goes on to claim that the material base

> lies most fundamentally in men's control over women's labour power. Men maintain this control by excluding women from access to some essential productive resources (in capitalist societies, for example, jobs that pay living wages) and by restricting women's sexuality.

However, by locating this material base in what they see as the two separate spheres of family and work, these theorists are tying their argument to the historically specific case of advanced capitalism. Their attempts to show how the family affects the economy end up illustrating the interpenetration of the two spheres and thus denying the very separation they posit. At the same time, their emphasis on the family as the locus of women's oppression downplays the importance of women's work outside the home which, as Young (1980:180) points out, takes a different form and has different consequences. It also fails to challenge the traditional marxist analysis of productive work, assuming as it does that marxism can, in this unchanged form, explain class inequalities and the position of women in productive relations. As Michéle Barrett makes clear in *Women's Oppression Today* (1980:61), this position "leads to a limited political strategy. In particular, it tends to the conclusion that class struggle requires economic change, whereas women's liberation requires a 'cultural revolution'." The sex-blindness of the theory of productive work remains untouched and another theory for the home is added. Furthermore, it is a marxist-defined mode of production that establishes the parameters for their "mode of reproduction" when their analysis becomes more concrete. In the end, the economic system prevails. Finally, dual systems theory cannot expose the logic of this second mode of production, explaining it only in terms of the unity of male interests.

Dual systems theory leads not to an exposure of separate spheres but to an analysis of the interpenetration of household and economy. While these theorists fail to establish patriarchy as an autonomous system with a logic of

its own, they do indicate the need for an analysis that understands sexual inequalities and cleavages as central in both the home and in the labour force. They also underline the need for an historical analysis of class and sex and of their interrelations, although they fail to undertake the project.

This Book's Approach

Growing out of the insights and problems in all of these approaches is a materialist analysis that relies heavily on marxist analytical tools but is conscious of issues and evidence raised by feminists of all persuasions. The attempt is made to move away from the manipulation of marxist categories to fit women's situation. Although aware that women's position is not simply different but also subordinate, approaches that see the sexual division of labour as a woman's issue, as a problem that can be tacked on at the end of an analytical framework or as a condition that exists only in the culture or the ideology are rejected. This also means that patriarchy, however defined, and capitalism, in whatever stage, are not assumed to be relatively autonomous systems, each with its own logic, but rather as the same system, one dominated but not determined by the drive for capital accumulation. Young (1980a:181) has outlined the project:

> We need not merely a synthesis of feminism with traditional Marxism, but a thoroughly feminist historical materialism, which regards the social relations of a particular social formation as one system in which gender differentiation is a core attribute.

As we (Armstrong and Armstrong, 1983a) have argued elsewhere, this means that sex divisions must be considered at all levels of analysis, as an integral part of the system in every historical period. It also means that biological differences must be included in the analysis. But these differences too must be examined from an historical, dialectical and materialist perspective. Bodies have histories that vary with material conditions and with resistance. The task has only begun.

And it must begin with an expanded concept of political economy. As Wally Seccombe (1980:30, emphasis in the original) explains,

> A mode of production can only adequately be conceived at the level of its production over time, its continuous production, that is, its *reproduction*. The replacement/restoration of all productive forces directly consumed within its dominant production sphere must therefore be included as an integral part of its conceptualization as a mode of production.

THEORETICAL APPROACHES

He (Seccombe, 1980:30) goes on to point out that marxist analysis has focused on how surplus value is extracted on the job site while "the specific way in which the labouring class secures and consumes its (necessary) part of the total social product and reproduces its capacity to work again" has been virtually ignored. Expanding the concept of political economy thus would mean going beyond the job site to examine the way workers as well as things and relations get reproduced on a daily and generational basis; to examine both the domestic and wage labour of women and men; and to examine the interpenetration of the nature, conditions and relations of work in and out of the labour force for both sexes.

But this reproduction of things, peoople and relations happens differently for women and for men. Capitalism, biology, ideology and the actions of women and men all play their part in ensuring not only that they participate in different ways but also that women are subordinate to men. Capitalism is premised on free wage labour, on the separation of most aspects of workers' reproduction from the production process, and women's reproductive capacities separate many of them out of the production process, for at least a brief period of time, to do their childbearing work. This establishes the basis for an elaboration of sex differences, a sexual division of labour that subordinates women and pervades all levels of human activity under capitalism. Such segregation also fundamentally divides classes.

The approach taken in this book is materialist both in the assumption that there is a real world and in the claim that material conditions set the parameters in any society. In this expanded view, "Productive forces must include both the technological means of production and the capacities of the producers" (Seccombe, 1980:33). Relations must include those between sexes as well as those between classes. In capitalist society, people gain their subsistence directly or indirectly either through owning the means of production or through selling their ability to work. Of those without access to either of these means, some are dependent on the state; some are dependent on others. These processes are thus dominant but not determining, and they interact and conflict with each other. The drive for accumulation is pervasive, impinging on all other aspects of life.

However, capitalists as a class, and capitalists as individuals, seldom have it all their own way. Neither do men. Contradictions are produced at all levels by the very workings of the system. Conflicts between capital and labour, between men and women, between the household and the economy, continually arise. In the process of attempting to resolve these conflicts, new

contradictions are constantly created, combatted, resolved, generating yet more contradictions. Struggles between women and men in families and in the market, as well as struggles between households as units and capitalism as a dominating force, arise out of contradictions in their relations to and control over the production of goods or services and the reproduction of people. Women, for example, are "freely compelled" to marry. To paraphrase Seccombe (1980:53), although women's condition is formally an open one, the great mass of women cannot escape a marital relationship, even though as individuals they are free to try. Many positions are inherently contradictory as well as producing contradictions as they develop. Conflict rather than consensus, struggle rather than passivity, capital accumulation rather than the drive towards equilibrium are the motor forces in capitalist history.

People are not only active in making their own history, they are also conscious. Everything cannot be reduced to nor is it determined by matter. Nor are ideas irrelevant, false or mere products of the material conditions. Nor are they passively received in a one-way socialization process. Central to dialectical materialism is the rejection of a false dichotomy between ideas and reality, indeed of all such separations. Their very relatedness is central to the framework. As Richard Lichtman (1975:51) explains, "Human beings are not active in their productive life and consequently conscious in the remainder of their existence. They are conscious in their productive activity and active in the production of their consciousness." Ideas, those learned early and those in the process of formation, are important in structuring the sexual division of labour but they cannot be separated from the material reality nor conceived of as transmitted, in a one-way process, only to the young.

The way that class should be included in this perspective is a much more difficult issue. While rejecting the argument that women form a class on the basis of their domestic labour or their bodies, this emerging theory has failed to articulate a way of analyzing women's class relations. However, the domestic labour debate has laid the basis for an expansion of the class concept, an expansion that would further our understanding of the fundamental cleavages within the broad classes of capitalist society. Such an approach would, given the expanded conceptualization of the political economy, take all women's and men's labour into account. Without denying that the most basic divisions are between those who own and control the means of production and those who own only their labour power – a primacy implied by the dominance of the wage system in capitalist society – it is possible to comprehend the antagonisms between the sexes and among those of the same

THEORETICAL APPROACHES

sex, by including all labour in the analysis. Those dependent directly or indirectly on the wage are objectively and subjectively divided by their material conditions, by their lived experience, by the work they do. Not just work for a wage (or the absence of work for a wage) but also the work required to transform that wage into consumable form and the work necessary to provide the next generation of workers must be included in the approach to class in order to understand the divisions between women and men and among women. Domestic labour would thus form an integral part of the explanation for men's interests just as wage labour would be a basic component in understanding women's class position and relations. Connecting domestic and wage labour within classes would also extend the analysis of the relationship between domestic and wage labour to the sex segregation in both areas of work. This is not, of course, a simple task. However, given that the microelectronic revolution is steadily moving labour back into the home and thus breaking down old distinctions between domestic and wage work, as well as challenging marxist visions about the basis of class struggle, such a development is urgently required.

Directly related to the problem of understanding class is the study of the labour process. Harry Braverman, like the radical segmentation theorists, maintains that the labour force is becoming increasingly homogenized. In *Labor and Monopoly Capital* (1974), he argues that there has been a general routinization and degradation of work, and a separation of conception from execution as employers seek to gain more and more control of workers and the labour processes. Technology is effectively employed by capitalists not only to replace workers and simplify tasks but also to reduce the control workers gain from their skills and their ability to pace their work. Workers, expelled in this process from jobs in the primary and manufacturing sectors, are drawn into the labour-intensive service industries. As the bulk of the clerical workers and as a significant part of the reserve army Braverman discusses, women have an important place in this analysis. Veronica Beechey (1982:54) points out in her critique of Braverman that

> *Labor and Monoply Capital* is one of the few texts to have recognized the importance of the sexual composition of the working class in the changing structure of employment in different sectors of production.

Yet, Braverman has been severely criticized:[19] for failing to examine the relationship between work in the home and in the labour force, for separating the analysis of the labour process from class relations and the state, "for

abstracting the labour process from the organization of the mode of production as a whole" (Beechey, 1982:55), for ignoring workers' struggles as well as the conflict between men and women in unions, for adopting a unilinear and oversimplified approach, for ignoring the creation of new skills, for incorrectly conceptualizing skill and for underestimating "the independent role of produce and labour markets, technology and trade unionism" (Wood, 1982:17) in the structure of the labour process. While many of these criticisms are legitimate (and some of them recognized by Braverman himself), researchers[20] have revealed a general trend towards routinization, deskilling and loss of control in a range of women's work, both in the home and in the labour force. Sally Hacker's work in particular indicates that technology does not play an independent role, that those who select the technology and organize the work play a crucial part in determining not only the nature and conditions of work but also the sexual division of labour. Hacker's (1982:261) quote from a study of AT&T, conducted by Joern Loewenberg, sets out the situation clearly.

> There are three reasons why work may be reassigned between the sexes, particularly from male to female: 1) preparation for displacement by computer or other mechanical process; 2) simplification of work; and 3) savings in wages.

Braverman's framework does need expansion, but it lays the basis for an analysis that connects the labour process and the sexual division of labour to the political economy as a whole.

Braverman's argument about the separation of conception from execution and the research growing out of it has also led some theorists to claim that a new class is emerging. Barbara and John Ehrenreich (1978:9), for example, maintain that "the technical workers, managerial workers, 'culture' producers, etc. — must be understood as comprising a distinct class in monopoly capitalist society," a Professional-Managerial Class whose function is "the reproduction of capitalist culture and capitalist class relations." Teachers and social workers, managers, engineers and scientists are seen to share a common relation to the economy and to share a social and cultural existence. However, there are two basic problems with this approach, when viewed with the sexual division of labour in mind. First, these occupations are fundamentally divided along sex lines and each sex within these broad categories has very different kinds and amounts of control. Second, there is a progressive but not smooth reduction in control and routinization of tasks, making these jobs more similar to those held by the rest of the working class. These

THEORETICAL APPROACHES

processes are happening first and most to those managerial and professional jobs, like teaching and nursing, that are at the bottom of the hierarchy and are dominated by women. Such developments challenge the kinds of class divisions set up in these approaches, the idea that professional and managerial workers are immune from these processes and united in their experience of them. While raising important questions about divisions within the working class as a whole, ideas about a new middle class rising out of the division of labour must take sex differences into account, and are significantly weakened by their failure to do so.

Many of the people considered to be part of this new class are employed directly or indirectly by the state. As James O'Connor (1973) has pointed out, the state has become more and more pervasive, providing employment and social security, education and health care, welfare and warfare, support for industries and regulations for everyone. How the state is to be conceived is very much a matter of debate but, as Rianne Mahon (1977:169) explains, "Most Marxist theorists of the state recognize the relative autonomy of the capitalist state." She goes on to say that

> The structure of the state is nothing but the mediated expression of basic socio-economic inequalities as these are manifested politically in the various forms and levels which the class struggle assumes at a particular point in time in a given society (Mahon, 1977:169).

It is both an instrument of the most powerful economic forces, a mediator of conflict between them and others and a location for these conflicts. Primarily interested in encouraging accumulation, the state also works to limit the worst consequences of that development and to maintain social peace.

But the current crisis is at the same time reflected in and influenced by state policies and programs. According to Hugh Armstrong (1977:290), "the state's role as guarantor of high employment and provider of social services increasingly has come into conflict with the requisites of private capital accumulation." The resulting cutbacks in services and in state employment affect wage and domestic labour. They also have a differential impact on women and men. Not only have many women found work in the state sector, but most of women's best jobs have been located there. As health and education services, for example, are reduced, women lose their paid jobs and assume the same responsibilities as part of their unpaid labour in the home. In their bid to shore up the private sector, state job creation programs provide direct subsidies to the primary manufacturing sectors, the areas traditionally employing large numbers of men. Organized labour in both sectors

is resisting. As Armstrong (1977:289) explains, the state's dual role as umpire and one of the players is made increasingly obvious.

At the same time, there is increased state regulation of the job site and the household. There are demands to outlaw abortions, to base unemployment insurance on household income, to slacken enforcement of equal pay legislation, to introduce wage controls, to force men to support their children financially, to limit strikes. Contradictory demands are being made from factions within the dominant class and from factions within the working class, demands that expose the state as the mediated expression of basic socioeconomic inequalities.

State policies help smooth out the uneven process of capitalist development but they have not eliminated crisis. Ernest Mandel (1968:350) explains:

> Capitalist production is production for profit. The periodical disproportion between the development of the capital goods sector and that of the consumer goods sector must be linked with periodical differences between the rates of profit in the two spheres. The causes of these periodical differences are to be observed in the different ways in which the basic contradictions of capitalism show themselves in the two sectors.

As investment slows during the inevitable depression, activity is first reduced in the capital goods sector. It declines later in the consumer goods industries and, within this sector, decreases earlier for those producing durable consumer goods. The subsequent drop in wages, in the prices of raw materials and equipment, encourage expansion. The "very logic of this stagnation creates the elements of recovery" (Mandel, 1968:350). According to Mandel, the recovery takes place in the reverse order, starting in the consumer goods sector, in those industries that have survived or grown during the crisis.

Mandel does not link this process to the sexual division of labour, but the industries that he argues will be hit first and most are those dominated by men. Although he does consider state expenditures, he does not discuss the impact of state cutbacks on its own employees, a high proportion of whom are women. Equally significant is his failure to link his examination of uneven development to the household economy in modern capitalism. However, it is possible to extend his theory of combined and uneven development to take into account the different work of women and men and the relationship between household and economy.

THEORETICAL APPROACHES

Mandel (1968:351) also explains that the new methods of production accumulate during the crisis, methods which become increasingly important to recovery and as recovery takes place. During the current crisis, a revolutionary technology has emerged, one that will encourage more uneven development in the economy and greater inequality between women and men. The resource extraction sectors, those which employ men almost exclusively, are already capital intensive so the technology will not have an enormous impact on jobs there. Within the manufacturing sectors, there are different degrees of capital intensity, with the most labour-intensive industries employing the highest proportions of women. Moreover, as Frank Stilwell (1981:29) makes clear in his examination of the crisis,

> What is different about the current wave of labour-replacing technology is that it is concentrated in the very sectors of the economy which historically have absorbed labour "liberated" by technological changes elsewhere. The service sectors have been the major employment growth area but it is here that much of the modern technological change is concentrated.

And these are also areas where women are concentrated. The technology that is an integral part of this crisis, and that may well be the basis for a recovery, will eliminate many women's jobs while creating few alternatives for them. It has already begun to do so.

This materialist analysis forms the theoretical background of this book. There is assumed to be a single system, one dominated by the drive for accumulation and characterized by a sexual division of labour that subordinates women to men. This sexual division of labour reverberates through the entire political economy, a political economy understood to encompass interpenetrating segments of household, economy and state. The concept of class is interpreted in relational terms but it includes all the labour of women and men. The labour process, and the changes in it — particularly those brought about by the selective application of technological innovations — are considered to be central to the understanding of class and of the sexual division of labour. This analysis relies heavily on marxist analytical tools but also draws on the theoretical and empirical insights of other perspectives.

In more concrete terms, the book begins by focusing on the production of commodities and services in the market and on the reproduction of things and relations there. However, the entire cycle of the reproduction of things, people and relations is examined in terms of the reinforcing and contradictory interrelationships within the household, within the formal economy

45

and between the overlapping spheres. Moreover, the political economy is examined as a sex-segregated whole, in which women and men both compete and collaborate, in the household and in the formal economy. From this perspective, people are active participants in creating their own consciousness, rather than passive recipients of ideas transmitted in the socialization process. Their ideas about themselves, about others and about the organization of their society are an integral but inseparable part of their daily activities. Such ideas are also active but not independent ingredients in the process of people making their own history, if not under conditions of their own choosing. It is understood that workers' interests are usually subordinate to those of capital, those of women often to those of men, and that the struggle over these interests often produces contradictory results. Such conflicts are frequently manifested in and mediated by the state. They perhaps become more obvious during times of crisis. My focus then is on structures and conditions rather than on ideas and attitudes, although, like production and reproduction, they are part of the same process.

This leads in turn to a focus on the conditions of work throughout the political economy. The drive to accumulate encourages employers to introduce technologies and managerial techniques that fragment, routinize and deskill work as well as separate manual from mental labour in order to increase control over workers and make each worker more easily replaceable. The dominance of capital and the drive to realize profits leads to the increasing commodification of things and services previously produced in the home, making more and more people dependent on the wage. But people are simultaneously forced onto the market to acquire the necessary cash and expelled by the decreasing demand for workers, a process which happens in different ways and in different sectors to women and men. And the state is simultaneously pressured to support the interests of capitalists and those of the rest; to provide services, employment and financial assistance to those expelled or excluded from the market, to train them for the market or repair them for further services there, to regulate or smooth over the worst excesses, at the same time as it is pressured to support and not to interfere with the accumulation process. The demands of capitalists more frequently prevail and the victories of others too frequently end up as losses. Services are cut. Support is transferred to the "productive" sector.

In sum, this book's approach is materialistic, historical and dialectical. It is sex-conscious as well as class-conscious. Building on the empirical and theoretical findings of those using functionalist theory, the dual systems

approach and segmentation analysis, it goes beyond the domestic labour debate to examine the interpenetration of the formal economy and the household in a dialectical rather than a functional way. It pushes the theoretical issues further than the questions of women's work to look at the sexual division of labour that pervades the entire system. It sets out to establish that all theoretical and empirical investigations of work must take sex differences into account and that the inevitable economic crises have a different impact on women and men.

NOTES

[1] This argument has been cogently developed by such authors as Eichler (1980), Oakley (1974), Roberts (1981) and Smith (1974 and 1979).

[2] For examples of such studies, see Gouldner (1954), Herman (1978) and Lewis (1964).

[3] See for example, Cohen (1977) and Meissner (1971).

[4] See for example, Kuch and Haessel (1979), McClendon (1976) and Ostry (1968).

[5] Extensive work was done in this area by such researchers as Skoulas (1974) and Spencer and Featherstone (1970).

[6] Nakamura et al. (1979), and Mincer and Polochek (1980), Boyd, Eichler and Hofley (1976), among others, documented many of these links.

[7] For detailed discussions of this critique, see Edgel (1980), Ehrensaft (1980), Sokoloff (1980) and Wajcman (1981).

[8] Klein and Roberts (1974) did some analysis of women's early union struggles. More recently, Ainsworth et al. (1982), Briskin and Yanz (1983) and White (1980) have provided a wealth of information on both the historical and contemporary involvement of women in unions.

[9] Gordon (1979) describes American women's fight for control over their bodies. McLaren (1977 and 1978) and Rasmussen (1976) provide fascinating Canadian data on similar struggles.

[10] See for example, Armstrong and Armstrong (1983b), Canada. Department of Labour (1960) and Seidman (1978).

[11] For a critique of the argument that women have only a secondary commitment to the labour force, see Armstrong (1980).

[12] Among the better-known critics of functionalist theory are Anderson (1974), Parkin (1972), Pease et al. (1970) and Tumin (1970).

[13] Fox (1980), Luxton (1981), Hamilton (1978) and Smith (1973) have all convincingly argued that there are important class differences among women.

[14] See for example, Land's (1976 and 1978) British research and that done by Zaretsky (1976 and 1982) in the United States.

[15] This argument is more fully developed by Armstrong and Armstrong in "Beyond Numbers: Problems with Quantitative Analysis" (1982b) and in *A Working Majority: What Women Must Do For Pay* (1983b).

[16] Socialist feminism is used here as a general term to refer to all theoretical approaches that use some form of marxist analysis. The term is often used in a more restricted sense to designate those who take a dual systems perspective.

[17] Hamilton (1978) in particular criticized socialist feminism for ignoring biological differences. Eisenstein (1979) and Hartmann (1976) put more stress on the exclusion of male power and of reproduction.

[18] See for example, Eisenstein (1979), Ferguson (1978), Hartmann (1981), Mitchell (1974) and O'Brien (1981).

[19] Wood (1982) has edited a collection that provides a broad range of such criticisms.

[20] The trend towards routinization is evident in the results of research done by Armstrong and Armstrong (1983b), de Kadt (1979, Glenn and Feldberg (1979) and Pollert (1981).

CHAPTER THREE

SETTING THE STAGE

THE SECOND WORLD WAR marked the end of the Great Depression as well as the beginning of what Andrew Gamble and Paul Walton (1976:81), in *Capitalism and Crisis,* term "the longest uninterrupted boom the capitalist world economy has ever experienced." The economic crisis of the 1930s had eliminated many firms, laying the basis for consolidation and for the restructuring of the labour force. Postwar agreements created favourable conditions for international trade and the organization of transnational corporations, primarily under United States hegemony. Raw materials were cheap and plentiful. The reconstruction of war-torn countries helped increase the demand for various commodities throughout the industrial world. Technology and productive materials developed during the war were readily adaptable to peacetime production. New forms of management and the detailed division of labour, particularly the increasing separation of manual from mental work, contributed to the rising rate of profit and maintained employers' control over the production process.

During the war, poor conditions and labour shortages in Canada had been the basis for the growing demands of an increasingly powerful union movement, especially in the mass production industries dominated by men. The federal government responded by establishing a National War Labour Board to make recommendations on wages and conditions. In 1944, anticipating more labour unrest after the war, the state

provided for a Labour Board with powers to certify a union which had a majority in a bargaining unit. The employer had to negotiate with the union thus certified. If the negotiations did not result in an agreement, either party could apply for conciliation. If there was still no agreement, a Conciliation Board could be set up. Strikes were banned until these procedures were completed (Lipton, 1967:268).

Combined with an agreement at the end of the war that provided for compulsory union dues but voluntary union membership (the Rand Formula), these initiatives set the tone for labour struggles and for state intervention. Supervised by the state, collective bargaining was to bring labour peace, with employers recognizing unions' rights to bargain and unions recognizing employers' right to manage.

After the war, there was no shortage of workers as military personnel returned home, as agricultural workers were pushed off the farm and as large numbers of immigrants entered the country. These labour pools helped to keep wages down and, in spite of the dramatic growth in union membership, few unions experienced early successes in demanding better terms.

State intervention did not stop with the regulation of unions, however. Remembering the disturbances following the First World War, and recognizing that unemployment was a permanent problem for which the state must take some responsibility if industrial stability was to be maintained, the Canadian government began as early as 1940 to introduce an unemployment insurance scheme. The 1941 Unemployment Insurance Act, as Carl Cuneo (1979:153) points out in his examination of that legislation's introduction, not only provided financial assistance to low-income workers during periods of temporary unemployment, creating "a more contented and better citizen," but allowed the government to accumulate capital for war purposes during a period of relatively low unemployment. In addition, as some Keynesians argued, it helped sustain demand by maintaining the purchasing power of the unemployed.

The government was very conscious of the fact that many of the new unemployed would be female. Among the issues considered by the Advisory Committee on Reconstruction, established before the war ended, were the "post-war problems of women." The final report of the subcommittee organized to deal with this question (Canada, Advisory Committee on Reconstruction, 1944) suggested the problems could be solved by (a) marriage, (b) opportunities for women on the farm, (c) positive expansion in household work if conditions improved, (d) new government services such as health

SETTING THE STAGE

insurance, (e) expansion in the distributive trades and service occupations, and (f) new industries such as the manufacture of plastic and household gadgets. Thus the state explicitly acknowledged the interpenetration of domestic and wage labour. Indeed, the subcommittee recommended that the state actively encourage women to substitute domestic for wage labour by introducing both family allowances made payable to women and training programs for household workers. The allowances were designed to make it more possible for women to stay home and to increase the value of their work there. Training programs were supposed to make domestic work more attractive, more skilled and therefore more enticing to women seeking paid work. Failing this, women could be slotted into the emerging women's jobs, many of which would be provided by the state.

At the end of the war, the federal government organized a conference with the provinces that set out the rationale for even greater state intervention and expansion.

> The problem is one of devising a sound and consistent programme of public improvements which will expand the productive wealth of the community and widen the opportunities for enterprise and employment. Also we must seek to manage the expenditures on such a programme so that they do not compete with private activity but will supplement it and contribute to the stabilization of employment whenever private employment declines (quoted in Blishen, 1969: 113).

The famous 1945 *White Paper on Employment and Income* clearly indicated that the government intended to manipulate levels of aggregate demand as a means of maintaining "a high and stable level of employment and income" (Canada, Minister of Reconstruction, 1945:1). In his study of medical care in Canada, Bernard Blishen (1969:113) found that

> Among the means of attaining these objectives was the suggestion "to provide, on the basis of small regular payments against large and uncertain individual risks, for such hazards and disabilities as unemployment, sickness and old age."

Thus, the stage was set for the introduction of state-organized pension, unemployment insurance and medical care programs, for stabilization policies, for state programs designed to reduce the uncertainties of the market while encouraging the capitalist accumulation process.

The state continued to expand after the postwar period. Between 1951 and 1971, total state spending increased fourfold, representing more than a

third of the Gross National Product (GNP) by 1971 (Armstrong, 1974:85). A wide variety of programs were introduced to assist employers directly.[1] Selective nationalization of less profitable industries also took place and subsidized sources of credit were provided to many corporations.[2] Not only did the state engage in direct support for industry but it also contributed heavily to the development of the necessary infrastructure, especially in transportation, communications and services, thus providing indirect assistance to the corporations as well.

Here, and in other areas, the state emerged as a major employer. The number of state workers grew enormously. By 1971, more than a million people were employed by the federal, provincial and municipal governments (Armstrong, 1974:124). A combination of forces — "the apparent failure of the free enterprise pattern to provide other forms of adequate health care," "the demands of consumers of medical care for some alleviation of the financial hazards of illness," "the emergence accompanying industrialization of major health hazards to whole communities and population groups over which the individual had no control" (Blishen, 1969:108,110,115), the implementation of a medical care insurance plan by the CCF government in Saskatchewan, the recommendations of the Royal Commission on Health Services, an emerging liberal ideology, and employers' desire for a healthy and stable workforce — culminated in a universal, contributory health scheme. Not surprisingly, the number of hospital workers mushroomed. In federal and public hospitals alone the number of employees tripled between 1951 and 1971. Since before the turn of the century, hospital workers, with the exception of doctors, were primarily female[3] and the majority of these new jobs went to women. The women were available, it was traditionally women's work and there was plenty of other work for men — work that was not generally open to women.

Most of the rapidly increasing teaching jobs also went to women, for similar reasons. Heavy immigration swelled the population during this period. The children from the baby boom began to reach school age in the early 1950s. The increase in school attendance represented "the largest absolute gain ever experienced in any decade" (Kalbach and McVey, 1971:245) since the turn of the century. But, as Kalbach and McVey point out in their demographic study, it was not simply the growth in the number of school-age children that accounted for the burgeoning enrolments. Alexander Lockhart, in his discussion of the education system during this period, explains that employers sought a disciplined, adaptable and educated workforce. For

the increasingly accepted human capital theorists, "knowledge" replaced capital as the critical input factor in production.

The popular acceptance of these human capital postulates, coupled with the (then) cold war fear of Russia's emerging technological sophistication, caused a major and rapid shift in public educational philosophy (Lockhart, 1979:226).

The movement, however, was not simply a response to capitalist needs and economic theorists' arguments. In a later introduction to his 1968 article on "The Future of Upward Mobility," John Porter (1979:65) describes "the dominant thought of the time," the idea that the more human capital any society had "the greater was its potential for further growth." Porter (1979:66) goes on to note that he "was among those who argued forcibly to expand educational opportunity to serve the principle of equality." There was wide popular support for an accessible education system that would create equality of opportunity, the equal right to become unequal. Students in the early 1960s took to the streets to demand, and get, a national student aid program. Instant universities were created and junior colleges sprung up across the land.

Yet the education system remained highly segregated by sex and class. In an extensive study of Ontario students, Marion Porter, John Porter and Bernard Blishen (1973:x)

> demonstrated that educational and occupational horizons of Ontario high school students are bounded by the class structure of the society in which they live; that, associated with that class structure, there is a wastage of bright young people from the educational process; and that girls, particularly lower class girls, see themselves destined for the labour force and excluded from the learning force in greater proportions than boys of the same class level and boys or girls from the classes above them.

The teaching staffs in these educational institutions also remained segregated. While women captured most of the new jobs in elementary schools and many of those in secondary schools, the additional jobs at the post-secondary level went primarily to men – except in those cases where people were required to teach "women's" subjects such as nursing.[4] More men had higher education degrees, and structural and legal restraints, as well as ideas about appropriate feminine pursuits, limited the number of women hired for these more prestigious jobs.

Along with hospital and education workers, the state also required people to monitor and administer a wide range of new programs. Clerical and

managerial work expanded rapidly. Most of the clerical work went to the large number of women who had been acquiring the necessary skills in secondary school.[5] By 1969, when Kathleen Archibald submitted her report on employment in the Public Service, the federal government was "the largest employer of women in Canada" and over 80 percent of these women held office or administrative support jobs (Archibald, 1970:9 and 23). Their concentration in clerical work meant that women were scattered throughout the civil service. By contrast, almost two-thirds of the men worked in just six departments – the Post Office, Defence, Transport, National Revenue (Customs and Excise), Veterans Affairs and Agriculture (Archibald, 1970:23). Men did, nevertheless, dominate the higher-level managerial positions in all areas (Archibald, 1970:24).

Clerical and service work also grew outside the state sector. As Harry Braverman (1974:281) makes clear in his study of the transformation of work in this century, monopoly capitalism involves not only the production and sale of goods in the market but also the increasing conversion of services into commodities and the invention of new products and services, "some of which become indispensable as the conditions of modern life change to destroy alternatives." In this process, and accompanying a growing concentration of corporations and the expansion of the circulation aspect of the economic system, managerial functions and paperwork increase enormously, especially as the assumptions of dishonesty, disloyalty and laxity lead each corporation to keep its own set of records (Braverman, 1974:303).

The growth of clerical and service work drew women into the labour market (Table 3.1). By 1971, over half of all female workers were employed in the finance, insurance and real estate or community, business and personal service sectors, using many of the skills they acquired at home and in school (Table 3.4). More than a third of the women in the labour force did clerical work (Table 3.2). Men captured most of the new managerial work and continued to constitute the overwhelming majority of workers in all other sectors, although women's share of jobs in the growing trade industry also increased (Armstrong and Armstrong, 1978:47).

This restructuring of the labour force saw the decline of the male-dominated agriculture sector and the expansion of the service, finance and trade industries, where women are more likely to find work (Tables 3.3 and 3.4). In terms of jobs, the primary sector declined absolutely as well as relatively between 1951 and 1971, the secondary sector roughly held its own in relative terms and the tertiary sector expanded enormously (Table 3.3). The

SETTING THE STAGE

demand for workers in traditionally female areas and in low-wage industries grew while the jobs in areas where males usually found work increased more slowly or even decreased (Tables 3.3 and 3.4).

New products, new appliances and new services changed the structure of domestic labour as well. No-iron fabrics, new finishes on floors, cake mixes and other partially prepared and frozen foods appeared on the market, at prices that made it cheaper to purchase these products than to do the work at home. Washing machines, clothes dryers, dishwashers, self-timing ovens, refrigerators with freezers, oil and gas furnaces, and power lawn mowers were produced for sale. While only a minority of households had such appliances in the early 1960s (Porter, 1967:102), by 1980 a majority of households had all but a dishwasher and more than one in four households had this labour-saving device (Canada Department of Finance, 1981:15). Restaurants also multiplied. In 1976, those families found in the top 20 percent in terms of family income consumed a third of their food and beverages in commercial eating places and many other families ate out too (Statistics Canada, 1980:116). Day care centres became more common although only a minority of employed women's children could be accommodated in them (Health and Welfare Canada, 1980). The extension of kindergarten to children in most areas of the country, the growing availability of hospital services for the elderly, the convalescing and the sick, the introduction of unemployment insurance and a range of social service programs transferred many responsibilities from the household to the state or private enterprise. Given the sexual division of labour in the household, these new products, appliances and services primarily altered women's work, although self-feeding furnaces, for example, also changed men's domestic labour. Unpaid household work certainly did not disappear, as Penny Kome (1982) and Meg Luxton (1980) among others have shown, but commodification did mean that more money was required by the household to purchase what were rapidly becoming necessities, as alternative means of performing these tasks and the skills required disappeared. Here too, production work declined as service work expanded, making it possible for one person to handle alone the necessary labour in the household.

Drawn in by the expansion in "women's jobs," women were also pushed into the labour market by the changing structure of domestic labour. The new products, appliances and services both made it possible to combine domestic and wage labour and made it necessary to do so.[6] The labour force

participation rates of women, especially of married women, grew dramatically. In 1951, just over 10 percent of married women were counted as participating in the labour force. Twenty years later, a third of all married women had paid employment or were actively searching for such work (Armstrong and Armstrong, 1978:152). Women's labour force participation rates have been rising steadily since 1966 (Table 3.5). A growing number of women were officially recorded as unemployed however, and more found only part-time work (Tables 3.5 and 3.6). Only a third of the women over fifteen years of age, compared to more than 60 percent of the men, had full-time employment. At the same time, the labour force participation rates of men were slowly, although somewhat erratically, declining as employers' preferences for workers with higher education encouraged many males to stay in school longer, and as pension funds and compulsory retirement regulations encouraged them to leave the labour force at an earlier age than had their predecessors (Table 3.5).

The large and growing number of married women searching for paid employment competed with each other for work in trade and in the private sector service industries where jobs were growing and where training periods and skill requirements were minimal. Wages remained low, in part because the large reserves of women available and the simplification of tasks made workers easily replaceable, in part because women were restricted by their household responsibilities, and in part because few workers were organized. According to Julie White (1980:122) only 11 percent of paid workers in the service sector were organized in 1966. By 1979, 6.2 percent of women in the trade sector belonged to a union (Labour Canada, Women's Bureau, 1983:8). The low unionization of workers in turn reflected the high proportion of part-time work, the seasonal employment and the high turnover rates characteristic of jobs in these industries.[7] Employers, too, played an active part in preventing unionization in areas where low wages were more important than labour peace, both because capital investment was low and other workers were readily available.

Between 1951 and 1971, jobs also grew rapidly in the finance, insurance and real estate industries (Table 3.3) but unionization and women's wages remained low. Large banks and insurance companies used a variety of techniques to resist moves to organize. The experience of women workers in British Columbia illustrates some of these strategies.[8] According to Edward Johnston, the Canadian Labour Congress director of organization, "There's an organized campaign in this country to make sure that banks don't become

unionized" (quoted in di Manno, 1983:54). And the huge supply of women with clerical skills has contributed to the success of these firms. The many clerical workers had little union protection and the relative salaries of stenographers, typists and clerical workers actually declined (Ostry and Zaidi, 1979:323). Productivity in these jobs was not high as the offices of the Fifties and early Sixties continued to employ equipment very similar to that used before the war. More work meant more workers, especially female workers.

Jobs were not growing rapidly in the manufacturing sector (Table 3.3) but this area had traditionally included large numbers of unionized workers. In 1977, "the manufacturing sector was the major contributor to union membership" (Statistics Canada, 1979:68), although union membership had been increasing in white collar occupations and declining in manufacturing jobs. Particularly in the large international corporations such as those in the automobile industry, employers gave in to union demands for large pay packets and hiring and seniority agreements, in order to compensate for dull, repetitive work and to protect their extensive capital investments. The corporations bought labour peace and a stable workforce out of high profits. The high productivity gained from the capital-intensive nature of the work contributed to these high profits and large corporations with considerable control over prices were able, particularly in prosperous times, to transfer costs to customers by raising prices. Most employees in these industries were male.

While a large number of the women working in the food and clothing industries were also organized these unions were weakened by the part-time and seasonal nature of the work, by the size of the companies and the capital invested, by the large reserve of women available and by the competition from imports. Rianne Mahon (1983:156), in her examination of these industries, found that "the experience of the textile and clothing unions is in a sense unique in that they were the first major group of workers to feel the impact of low-wage import competition." As a result of these factors, women's wages in this sector generally remained low, and there was little job security.

The majority of women union members, however, were not in the manufacturing sector. Most worked directly or indirectly for government. In 1978, approximately 20 percent of female union members worked in public administration; another 45 percent worked in community, business and personal service. Most of the latter group worked directly or indirectly for the state (Labour Canada, Women's Bureau, 1983:8). Unions grew both in

numbers and strength in the rapidly expanding public sector. During this period, many civil servants gained the right to strike and transformed their associations into unions that successfully fought for a bigger wage packet and job security clauses. Teachers and nurses were particularly successful (Ostry and Zaidi, 1979:323). Since there was a shortage of people with this specialized training, the workers here did not face competition from a large reserve. Unlike textile and clothing jobs, the work could not be exported. The high popular value placed on education and health, combined with relatively full government coffers in good times, also helped teachers and nurses improve their positions. The majority of these workers were women.

Jobs and union membership grew more slowly in the primary industries and in construction. However, here too predominantly male unions had greater success as their often transnational corporate employers were willing to exchange peace in good times for a stable workforce. Skill requirements also helped many of the male workers in these sectors to make significant wage gains. High demand for their products in an expanding economy was even more important in creating conditions for labour gains, and here too employers were often protecting high investments in capital equipment. As in other sectors, unemployment insurance helped both to smooth out the most obvious consequences of fluctuating employment and to give workers a sense of security in fighting for better wages. A relatively tight labour market, particularly for men in some sectors, provided a firm footing for demands on a range of working conditions.

During the boom years, jobs and union membership grew together in white collar occupations, especially in the state sector. Since women captured many of these new jobs, it is not surprising that they accounted for much of the growth in union membership. Indeed, in the 1970s, the percentage of female union members grew while the proportion of men in unions declined (Labour Canada, Women's Bureau, 1983:7).

As women's participation in the education system, in the labour force and in the union movement increased, so did their militancy. The modern women's movement emerged. Combined with the new ideas that accompanied this movement of women out of the home, these trends contributed to a variety of changes in state regulations directly influencing women's domestic and wage labour. The growing presence of women and their growing strength in the state and in the union movement meant that female concerns had to be taken into account. New legislation made divorce simpler,

SETTING THE STAGE

especially with the addition of separation and desertion as grounds for ending a marriage.[9] In many jurisdictions, marital property laws were altered to recognize the contributions of women's domestic labour.[10] Child-care expenses became tax deductible for employed women. Legal abortions became more possible and the dissemination and sale of birth control devices was legalized at the same time as the birth control pill was made widely available. Equal pay legislation, in some cases even extended to work of equivalent value, was passed in most jurisdictions and led to some significant gains for women. In 1978, for instance, the federal legislation on equal pay for work of equal value was the basis for a Canadian Human Rights Commission decision claiming that librarians (mostly women) should have their wages raised to match those of federally employed historical researchers (most of whom were male). Maternity leave was introduced in many areas and some pregnant women received benefits under the unemployment insurance scheme. Postal workers and state employees in Quebec even won additional maternity benefits beyond those provided by unemployment insurance. With the help of the new militance and the new rules, a few women gained access to "non-traditional" jobs and to a few seats in the board rooms of corporations. Following a ruling by the Canadian Human Rights Commission for example, Stelco hired nearly three hundred women as industrial workers (di Manno, 1983:52). The restructured labour force not only had new jobs but many more female members, and many of these women workers had fewer children, more legal rights, more formal education and greater union strength than their predecessors. They also had little choice about entering the labour force. Most needed the income.

Workers in general, and female workers in particular, were told they had indeed come a long way. But even during the boom years, there were signs of future decay. As Hugh Armstrong (1979:70) points out in his examination of job creation and unemployment,

> Like a glacier, the unemployment rate keeps moving ahead. There are cyclical variations to be sure, but the troughs and peaks both tend to get higher each time. Before 1958, postwar unemployment never reached 5.0 per cent; since 1970 it has never been that low.

For women, the unemployment rates grew more steadily, remaining higher than those of men until the 1980s (Table 3.5). And the experience of unemployment was not restricted to low-wage earners of either sex, as the government made clear when it introduced changes in the unemployment

insurance scheme. Only half of the labour force, the lowest income earners, were covered under the initial program. However, arguing that "everyone, to a greater extent than ever before, is vulnerable to a temporary interruption of earnings" and calling "upon the good will and responsibility of more fortunate, better placed Canadians toward those who through lack of education and opportunity are in less secure occupations," the then minister of Manpower and Immigration, Bryce Mackasay (1970) extended benefits to virtually all workers (not incidentally, forcing everyone to contribute). The commitment to full employment, so boldly stated in the 1945 White Paper, was replaced by an acknowledgment of higher and higher levels of "normal" unemployment. During this period, government expenditures grew steadily (OECD, 1983:Table R8) but the same could not be said of the Gross National Product (OECD, 1983:Table R2).

The dramatic changes in women's labour force participation rates were not matched by significant changes in the nature of women's work. The labour force remained highly segregated and, while the gap between male and female wages was somewhat reduced for union members,[11] the differences in male and female wages actually increased in some occupations.[12] At home, women continued to be responsible for much of the domestic labour,[13] and many married women took on an additional job in the labour force.
force.

Growing unemployment rates and continued inequality between the sexes were but two indications that the key to a sustained and continually improving economic future had not been found. Moreover, Canada was not alone in experiencing these difficulties. At the international level, there were signs of growing instability. The hegemony enjoyed by the United States during the immediate postwar period was increasingly threatened by the rebuilt European and Japanese economies. Increasing surplus capacity, competitiveness and varying rates of productivity among the western countries put pressure on rates of profit.[14] According to the Economic Council of Canada's (1983:9) recent study, *The Bottom Line: Technology, Trade and Income Growth,* there was a "deeply recessionary period from 1956 to 1961, during which growth in living standards was essentially zero" but fairly respectable productivity levels were still maintained. However,

> All of the major OECD nations experienced a significant slowdown in productivity growth over the period 1973-80.... The U.S. annual growth rate, starting from a much lower figure than Canada's, fell to only 0.5 per cent. Substantial productivity growth persisted in the United Kingdom, West Germany,

SETTING THE STAGE

France, Italy, and Japan, but the rates were only about one-half of what they used to be (Economic Council of Canada, 1983:9).

Profit rates fell along with productivity rates.

The declining rates of profit were manifested first in those economies with the most outmoded plants and equipment and the lowest levels of productivity increase (such as Britain), but by the 1970s the same phenomenon had appeared in the U.S. and other advanced industrial economies (Wolfe, 1983:12).

Yann Fitt, Alexandre Faire and Jean-Pierre Figier (1980:124) argue, in their examination of the world economic crisis, that "The development of scientific and technical methods has not modified the tendency of the rate of profit to fall; it merely reversed this tendency temporarily, from 1945 to 1960." Indeed, the Organization for Economic Cooperation and Development (OECD) (1983:10) maintains that, "For reasons that remain unclear, productivity of capital has shown a marked decline over the last two decades." Meanwhile, prices for many raw materials, especially oil, continued to rise and so did other prices, interest rates and some wages.

Capitalist enterprises and capitalist countries have been responding to these difficulties in a number of ways. As the OECD puts it:

In pursuit of higher profitability, a number of countries have sought directly to influence the relative shares of wage and non-wage incomes, or to lower the weight of non-wage labour costs.

The most sweeping strategies involved a new international division of labour as well as rationalization and intensification of work in home industries and the introduction of new technology. The processes were interconnected. Developments in communications technology and in microelectronics generally made possible both greater international control and greater concentration. At the same time, tasks could be simplified and labour thus exported to low-wage countries where workers are unorganized and governments willing to guarantee a docile and cheap labour force in return for investment. As a result, a new international division of labour has begun to emerge, with many of the labour-intensive aspects of production shifting to parts of the country and parts of the world where profits can be made from the intensive exploitation of labour.

This international restructuring of the labour force also contributes to the control of wages and resistance at home. The creation of an international

reserve of labour disciplines the workers in Canada, because employers can threaten to export the jobs or simply close the plant if workers raise their demands. A recent advertisement in *Maclean's* magazine provides just one example of more subtle pressure applied to workers. After graphically presenting the average 1981 salaries of workers in selected primary and secondary industries, and after claiming that pulp and paper workers "receive a higher weekly average pay than many other Canadian workers," the Canadian Pulp and Paper Association goes on to say that

> The challenge facing forest companies right now is stiff competition in world markets. Canada's pulp and paper often travels thousands of miles to compete on the home grounds of foreign producers. It is their standards of service and levels of costs that Canadian companies must match, or beat.
>
> All those involved in the industry — investors, workers, suppliers — have to take the long-term view and work together to build the competitive strength of Canada's number one manufacturing industry, pulp and paper *(Maclean's,* June 27, 1983:54).

Such industries employ primarily male workers and tend to have relatively high investments in capital equipment and other resources that encourage them to first try to change labour costs at home. In some of the areas where women work, such as textile, clothing and microelectronic parts industries (Duncan, 1981; Kelly, 1983), investments are lower, job exportation simpler, and threats from low-wage imports greater. In these industries, "continental rationalization, which pits organized Canadian workers against unorganized workers in the American South, and technological change, which already has produced changes in work organization, job content and the number of jobs, have become the major issues" (Mahon, 1983:157). Considerably weakened by these conditions, unions seem to have responded by trading political support of tariff barriers for "technological change" clauses in their collective agreements. Wages and working conditions remain poor.

In the public sector, it is more difficult to export jobs as a method of disciplining workers, lowering wages and reducing costs. However, as the crisis deepens, government social security, industry and employment support expenditures are increasing at the same time as the pressure on government to lead the way in disciplining workers, lowering wages, reducing union strength, cutting costs and increasing the labour reserve builds up from private sector employers. As Andre Gunder Frank (1981:120) points out in his *Reflections on the Economic Crisis:*

SETTING THE STAGE

The same argument is advanced everywhere: we need to hold down inflation because it hurts all of us at home equally (although inflation characteristically reduces real income from work and raises the value of real property) and particularly because inflation at home would price us out of the world market, cut our export capacity, and therefore create unemployment. The principle cause of inflation is, supposedly, high public spending and high wage demands (although wage costs are a small and declining component of selling prices, and the evidence shows that prices are pushed by the attempt to protect profits in monopolized industries). These arguments are used everywhere to defend the imposition of austerity policies, and to demand political restraint in public spending – except for defense and other business expenditures of course – and in "responsible" union wage demands, which are to be kept below the rate of inflation, with a resultant decline in real wages and income, especially at the lowest end of the income scale.

In Canada, this argument has been used to introduce wage restraints, cutbacks in government services, limited increases in social security payments and layoffs in many state sectors. As Allan Maslove and Gene Swimmer (1980:xx) explain in their study of wage controls in Canada,

> late in 1974 and over the course of 1975 the view that developed throughout the government, and indeed in the general population as well, was that wage and salary settlements were becoming the major factor in inflation and would destroy Canada's international economic position.

They go on to point out that "Virtually all actors in the controls decision reviewed the program inaugurated October 14, 1975 as a *wage control program*" (Maslove and Swimmer, 1980:xx, emphasis in the original). Talk of profit and price controls was designed to sell the program to the population. But because the controls were primarily a response to Liberal party supporters – "the financial press, the business community, and of course, a significant proportion of the electorate" (Maslove and Swimmer, 1980:xx) – profits were to be supported, not controlled. Union power also has been considerably reduced in confrontations between the state and public sector unions in several provinces. In both British Columbia and Quebec, the state has replaced collective agreements with decrees. The British Columbia government has also introduced legislation designed to further limit union strength and to make unionization itself more difficult. Quebec is talking about removing the right to strike from public sector workers. Arguing that the state's policy limiting wage settlements to 6 and 5 percent over a two-year period was largely responsible for the signs of economic recovery, Prime

Minister Trudeau promised in the summer of 1983 that no strike settled by Parliament would net workers more than 6 and 5 percent the *Toronto Star*, June 29, 1983). Ideology, pressure from employers and the state and legislative measures combine to reduce the strength and wages of public sector workers. Output per worker is increased by lengthening the working day and changing the conditions of work, that is, through intensification. While most jobs in the public sector cannot be easily exported, rising unemployment in general and the growing reserve in the female areas of teaching and nursing in particular, have considerably weakened union response.

In both the private and public sectors, employers have been reorganizing and rationalizing their workforce to increase both productivity and control. According to economist Cy Gonick (1983:37), employers "will pare down and reorganize their senior and intermediate management and other skilled employees who had hitherto been treated as fixed rather than variable costs." Most of the skilled and managerial workers are male, although the few women who did recently make it into these jobs will probably be the first to go. In addition, efforts to increase productivity, especially in the office, will eliminate many female jobs. Until the development of the chip, the growth in paper work had meant an increase in workers. With the new microelectronic equipment, more work means a new machine. Instead of exporting jobs to low-wage areas, efforts to combat the falling rate of profit in such areas focus on increasing the productivity of each worker. And the technology itself makes it possible to export the work involved in producing this new equipment (Kelly, 1983).

While the crisis has not infrequently been blamed on workers' greed and laziness, reflected in rising wages and falling productivity, the Economic Council of Canada (1983:4) maintains that "lack of worker effort does not play a significant part in the productivity slowdown." In keeping with a prominent trend in government and private sector strategy, the Council recommends the development of new technology and work organization to increase worker productivity and profits. While acknowledging that "Improving productivity will necessarily destroy jobs if total output remains unchanged" (Economic Council of Canada, 1983:4), the Council is convinced that rising productivity can mean a growth in output, increased aggregate demand and new jobs. Meanwhile, the focus is on increasing output per worker, and thus profit, as well as on encouraging trade growth. Unemployment, to a large extent, is left to take care of itself.

SETTING THE STAGE

There can be little doubt that this country is in the midst of a crisis.

In the last decade, Canada has encountered ferocious economic problems. Unemployment has soared to levels unprecedented since the Great Depression. Inflation has leapt to heights never before experienced outside wartime. And productivity growth has sunk to a rate so low that it has no historical parallel at all (Economic Council of Canada, 1983:1).

Profits have fallen. According to the OECD (1983:109), "Corporate pre-tax profits fell by one-third in 1982, the squeeze on mining and forestry as well as certain manufacturing branches being particularly severe." These are the areas where men work and it is job loss in these industries that accounts for much of the dramatic rise in male unemployment rates.

As Statistics Canada (March 1983:116) explains in its overview of recent employment development, "the 1980 downturn was concentrated primarily in the goods producing industries," and the trend has continued. "The most recent data available (third quarter 1982) indicate that the recession in 1982 was considerably deeper than the 1980 downturn, with the GDP (Gross Domestic Product) for the year 1982 falling below the level attained in 1981." In 1982, there were over 40,000 bankruptcies (Canada Consumer and Corporate Affairs, 1983:69). Many of these were in small business, where many women found employment. Worker resistance, strengthened in an earlier period by tighter labour markets, rising productivity and sustained profits in many sectors, has been eroded. The decline of the primary and secondary sectors, where men have traditionally found employment, has continued. At the same time, the new jobs in the tertiary sector, where growing numbers of women have found work, are disappearing as a result of the new technology, the reorganization of work and cutbacks in the state sector. Statistics Canada (March 1983:118) reports that, for the first time since the war, "employment in the service-producing industries also declined in 1982, consistent with the decline in the sectors' output level." At the same time, women's labour force participation rate failed to grow for the first time in thirty years.

The restructured labour force that emerged during the boom years is once again being transformed. An ideology of restraints, of the need for control, of limits on individual and collective struggles or improvements, is spreading. It is within this context — of falling profits, restructuring at a national and international level, a conservative ideology, restraints on state spending as well as on worker resistance, and a revolutionary technology — that the segregated labour of women and men must be examined.

NOTES

[1] These programs are listed in Phidd and Doern (1978), Appendix F.

[2] Economist David Wolfe (1977:253) makes this point in his analysis of the issue.

[3] See Coburn (1974) for a discussion of female hospital workers in this early period.

[4] See Armstrong and Armstrong (1978), Tables 7 and 8.

[5] This process is documented in Armstrong and Armstrong (1978), Chapter 2.

[6] For a more detailed presentation of this argument, see Armstrong and Armstrong (1982:223-227).

[7] See Armstrong and Armstrong (1983b).

[8] These strategies are described in The Bank Book Collective (1979).

[9] See McKie, Prentice and Reed (1983) for details on changes in divorce legislation.

[10] See Kronby's *Canadian Family Law* (1979:125-128) for more details on marital property laws in various provinces.

[11] In *Women and Unions,* White (1980) argues that women union members have wages more similar to those of men.

[12] McDonald (1977) documents the growing gap in male and female wages, although other authors have argued that the relative positions remain unchanged.

[13] Clark and Harvey (1976), Kome (1982), Luxton (1980) and Meissner *et al.* (1975) all demonstrate the continued segregation of domestic work.

[14] Wolfe (1983:12) expands on each of these points in his article on the economic crisis.

CHAPTER FOUR

LABOUR FORCE WORK

BEHIND THE CHANGES IN THE labour process, behind the restructuring of work nationally and internationally, at home and in the labour force, behind the economic crisis itself, is the search for profit. Capital is constantly restructuring, declining and rebuilding – at one and the same time, overcoming and creating crisis. Development is not linear, smooth or strictly predetermined. Moreover, as Doreen Massey and Richard Meegan (1982:12) point out in their examination of job loss in the United Kingdom, "The 'imperatives of capital accumulation' can produce in different economies and political circumstances and in different industries, very different responses." Not all industries, and not all occupations, are shrinking in these hard times. Not all job loss indicates that an industry is declining. Jobs may disappear because a firm has rationalized production, reducing capacity until a recovery takes place and workers can be rehired or until the firm goes out of business. But jobs may also disappear because new investment in the technology of production has increased the output of each worker, reducing the expenditures on wages while increasing profits. In both these processes, the employer may be in a better position after jobs are eliminated. However, economic recovery is unlikely to recreate jobs for former employees in these sectors. In Ernest Mandel's (1968) terms, it is a process of combined and uneven development, one that varies with the relations between employers and employees as well as with those between firm and firm, with the creation

and employment of technologies, with the organization of production, with the availability of resources and with changing ideologies.

Mandel and others have, however, confined their analysis to the formal economy and to a labour force undifferentiated by sex. But the process of development is, in addition, one that involves the combined and uneven development of domestic and wage labour and that has different consequences for the work of women and men. It thus also varies with the sexual division of labour and with the relations between the sexes. Indeed, economic crisis may exacerbate both the uneven development and the gap between the sexes.

In order to begin such an analysis, this chapter examines the differential impact of the economic crisis on the particular industry and occupation categories used in Statistics Canada's Labour Force Survey. Unfortunately, the data are often sex-blind, because Statistics Canada does not always take the different experiences of women and men into account in establishing questions, categories and responses. And domestic labour is largely unrecorded by the state's data collection agency. Such difficulties with the data cannot be ignored and they are more fully considered in the appendix on methodology. The shortcomings in the data have the effect of camouflaging rather than exaggerating differences, however. The data that are available for the period 1975 to 1982 indicate uneven development by industry and occupation and, consequently, for women and men. There is every reason to believe that this analysis underestimates the extent of uneven development, particularly between the sexes.

The investigation is further limited by the need to consider short periods of time and very recent information. What appear as relatively small percentage changes may indicate that quite a large number of women or men have been affected. Morever, small changes are frequent harbingers of much larger future trends. If the crisis is to be monitored and the unequal consequences of this economic situation understood and perhaps modified, it is necessary to consider carefully what often begin as small movements but which may well grow into a fully restructured political economy, one in which women have lost more than men.

Uneven Industrial Development

The tables presented in Chapter 3 outline an overall trend of declining primary and growing tertiary industries, accompanied by declining male and

growing female labour force participation rates. At the same time, part-time work has increased more rapidly for women than for men, and the female unemployment rate has consistently been higher than the male rate. The most recent data, however, indicate that the steady growth in the female labour force participation rate has abruptly halted while the male rate has continued to decline (Table 3.5). Moreover, male unemployment rates have suddenly shot ahead of women's and many more men are taking part-time work. Such gross data suggest that the crisis is hitting men more severely and that they are losing out to women. But when the data are broken down in some detail, it becomes clear that men's job loss is concentrated in those industries where few women work, and that it is more the firm than the females that are putting men out of work. Furthermore, when women do compete directly with men for scarce jobs, it is the women who are more likely to lose.

The variations in employment trends for women and men reflect the uneven impact of the crisis on different industries. Table 4.1 estimates what employment distribution would have been in 1982 if every industry had maintained its share of jobs. The primary, manufacturing, construction, transportation, utilities, finance and religion sectors all provided, in 1982, less than their 1980 share of employment. With the exceptions of finance and religion, these are industries dominated by men (Table 4.2). While women constitute more than two-fifths of the employed, they account for less than one-fifth of those working in seven of the eleven industries showing a reduction in their share of jobs. By contrast, those sectors that increased their proportion of jobs – namely communications, trade, state-funded operations and private sector services (Table 4.1) – are industries that have traditionally employed large numbers of women (Table 4.2). Except in wholesale trade and local governments, women constitute 40 percent or more of those employed in the fourteen industry divisions exhibiting increases in their share of employment (Table 4.2). In these sectors, women captured more than their 1980 share of the work, suggesting that segregation was increasing. Furthermore, in those industries with a declining share of the market they acquired less than their 1980 share of the jobs; that is, in those dominated by men. This suggests that when women compete with men, the women are the first to go. The following sector by sector examination of employment and unemployment patterns lends further support to this argument.

Primary Industries

The primary industries – agriculture, forestry, fishing and mining – have been and continue to be, male-dominated. Men still constitute over 70 percent of those employed in agriculture (Table 4.2) and close to 90 percent of those working in other primary industries (Table 4.5). But women have been increasing their share of jobs in agriculture and mining while the concentration of men in these industries has been declining, particularly in mining in recent years (Table 4.2). This would suggest that women have been making some gains in the so-called non-traditional fields. The movement of women into the forestry industry, however, has not only been halted but reversed during recent hard times, perhaps suggesting that in this sector at least, women are the first to go. Moreover, it is clear that close to half of the women in the fishing, mining and forestry industries are doing clerical work and another large group are employed in other white collar occupations (Table 4.3). By contrast, more than half of the men are engaged directly in primary production. In other words, most of the women have moved into the offices of these industries rather than into the male preserves on the oceans, in the mines and in the forests. As for the women in agriculture, over a third of them, compared to a tenth of the men, hold part-time jobs (Table 4.6). Many of these are women who work on their husbands' farms and who are now, due to changes in Statistics Canada questions and coding, counted as part of the labour force.

There continues to be little direct competition between women and men for jobs in these industries and it is men who continue to do the overwhelming majority of the primary production work. Therefore, when jobs, particularly full-time jobs, in these areas disappear, they will be jobs lost to men. If the proportion of full-time jobs lost in the current crisis is calculated by industry, it becomes clear that primary industries have significantly reduced their workforce (Table 4.8). Together, they accounted for close to 12 percent of all full-time jobs lost between 1980 and 1982. Moreover, almost all of the jobs that disappeared had provided full-time work for men.

Consequently, the unemployment rate, especially for men, shot up in these industries, rising from 9.3 in 1980 to 17.3 in 1982 (Table 4.10). Job loss was sudden, visible and severe as mines, mills and fisheries curtailed production, primarily in response to falling demand. Unemployment was particularly high in the forest industry (Table 4.10), where a very small proportion of women are employed. Mining towns were also hard hit. Men out of

paid work in Sudbury alone accounted for more than 1 percent of all male unemployment across Canada. Taken together, men without paid work here constituted more than 9 percent of all unemployed males, a figure that contrasts sharply with the slightly more than 1 percent of unemployed women who last worked in these sectors. Moreover, while unemployed women were almost equally concentrated in clerical and primary occupations within these industries, unemployed men were overwhelmingly concentrated in primary occupations (Table 4.12).

What these data indicate then is that, with the possible exception of the fishing industry, men have been thrown out of work mainly by cutbacks in production, resulting primarily from the falling demand that is part of the economic crisis. Women's unemployment rates are lower because fewer worked here in the first place and because cutbacks were larger in resource extraction than in office work. However, the fact that women's unemployment is almost equally distributed between primary occupations and clerical work suggests that they have disproportionately suffered where they directly compete with men. Given the extent of unionization in these industries, it seems likely that seniority rules would mean that women, as the most recently hired in non-traditional work, would be the first to be let go (Table 4.14). Finally, since layoffs are more a result of rationalization during crisis than of intensification or technological change, it seems more likely that a recovery in demand will lead to an increase in particularly male employment. Clerical job loss here, on the other hand, as we will see in a later chapter, may well be the result of technological change and an economic recovery may mean more machines rather than more female workers.

Manufacturing

The proportion of women and men working in non-durable manufacturing has been steadily dropping since the mid-1970s as jobs shifted to other countries and, within Canada, to the service industries. The proportion of both sexes employed in durable manufacturing rose until 1980, only to drop sharply as the crisis deepened and as foreign competition became more important.

Manufacturing jobs are more significant in male employment, with over one in five men, compared to one in eight women, employed in these industries. The chief difference is in the durable manufacturing sectors (Table 4.2), although work is highly segregated in both areas. In the manufacturing industries too, many women are in the offices rather than on the line.

Almost 30 percent (Table 4.3) of the women have clerical jobs while women constitute less than a quarter (Table 4.4) of those actually doing processing work. Moreover, when the data are broken down in greater detail, the ghettoization of women and the limited direct competition between the sexes become more obvious. Uneven development within each category has produced differing consequences for women and men.

Although a third of the workers in the non-durable manufacturing industries are women, more than three-quarters of those in clothing, more than two-thirds of those in knitting mills and half of those in leather are female (Table 4.5). It will be remembered that these are the industries particularly susceptible to low-wage imports. A quarter of all the women employed in non-durable manufacturing, compared to less than 4 percent of the men, are concentrated in the clothing industries. With the exception of the food and beverage industries, where approximately equal proportions of men and women work, men are much more widely dispersed in the non-durable sector.

More than half of the men, but less than a third of the women in manufacturing are employed in the durable sector. Only in electrical products — another industry threatened by the export-processing zones and their low-wage labour — and in miscellaneous manufacturing do women account for more than 30 percent of the workforce (Table 4.5). Close to 20 percent of the men here are producing cars and trucks and many of the other industries in this sector depend directly or indirectly on transport manufacturing. Cutbacks in the demand for cars and competition from foreign firms are thus likely to have a greater impact on male employment.

The jobs that are lost are also likely to be full-time male jobs. Few people of either sex work part-time in manufacturing although it is much more common for women than men, especially for women working in the non-durable industries (Table 4.6). Between 1980 and 1982, women's share of part-time work rose sharply in the durable sector and dropped almost as sharply in the non-durable sector. It seems unlikely that women would successfully compete with men in the durable industries and lose to them in the non-durable ones. A more probable explanation is the uneven development of part-time work in specific industries, but the absence of detailed data makes it impossible to test this hypothesis.

What is clear is that full-time jobs in manufacturing have been rapidly disappearing (Table 4.8). Jobs lost in durable manufacturing industries accounted for a third of all job reduction between 1980 and 1982. Jobs lost

in the manufacturing sectors taken together account for just about half of all the full-time positions lost during this period. While close to half of those disappearing from the non-durable sector were lost to women – in spite of the fact that women made up just over a third of those employed there – the overwhelming majority of those disappearing in the durable industries were lost to men. In fact, more than a quarter of all unemployed men last worked in the manufacturing industries (Table 4.11). Some part-time jobs were created in non-durable industries (Table 4.9), but three-quarters of them went to men. Not surprisingly, given these figures, women's unemployment rates in manufacturing were higher than those of men (Table 4.10).

Like the primary sector, manufacturing industries have cut back during the crisis, laying off large numbers of workers, particularly male workers, who had held full-time jobs. Some of this reduction is obviously related to falling demand during the crisis, and therefore some of the jobs will be restored should a recovery take place. The restored jobs, like the disappearing ones, are likely to provide full-time male employment. However, competition from abroad as well as new technological developments have led to a restructuring and relocation of some durable sector industries, most notably the automobile industry. This restructuring involves technological change that may permanently eliminate male jobs while increasing output and profits. In the clothing and textile industries, where women work, the competition from abroad in terms of both labour and products is also likely to create a permanent job loss. Alternatively, as promoted by the 1983 federal budget, technological change in these industries could make them more productive, more capital intensive, more competitive. One consequence would be a permanent job loss for women, even if there is a recovery. Moreover, women's high unemployment rates and men's greater success in capturing part-time work suggest that women have been, and will be, the losers when they directly compete with men for scarce jobs in manufacturing.

Construction

Economic crisis and technological change have contributed to the declining proportion of men employed in the construction industry (Table 4.2). The relatively steady proportion of women employed here and their increasing share of jobs in this sector reflect more the growth of paperwork in the construction industry than the movement of women into the highly unionized, traditionally male trades. While almost three-quarters of the men working

in the construction industry do some kind of construction work, close to three-quarters of the women there hold clerical jobs (Table 4.3). Less than 10 percent of the women are actually involved in construction occupations and they account for less than 2 percent of the construction workers (Table 4.4). Although women were able to capture a growing proportion of part-time work up to 1980, as the crisis deepened they lost even these jobs to men (Table 4.6). Construction work, both full- and part-time, is still men's work, perhaps increasingly so as the crisis continues.

Close to one in ten of the full-time jobs lost between 1980 and 1982 were lost to men working full-time in the construction industry (Table 4.8). In what appears to be an astonishing victory for women, there was actually a slight increase in full-time work for women and in part-time work for men (Table 4.9). Moreover, this is one of the few industries in which women's unemployment rates are significantly lower than men's (Table 4.10), and women account for only a tiny proportion of those unemployed in these industries (Table 4.11). Given the high rate of unionization in these industries and the seniority rules that operate in most of them, it seems unlikely that the few women who have recently managed to acquire jobs in the construction trades will keep them in times of high unemployment, let alone gain some while large numbers of men are unemployed. A much more likely explanation, supported by the data on segregation within the industry, is that office work has not declined as rapidly as construction work proper during the crisis. The fact that over half the unemployed women in the construction industry are seeking clerical jobs (Table 4.12) indicates that some contraction has taken place here, however, and suggests that these jobs have not been immune to reduction. To the extent that job loss here reflects rationalization during a crisis, many of the full-time male jobs are likely to reappear if a recovery takes place. Few of these jobs can be exported and both unionization and segregation help ensure that the overwhelming majority of these jobs will be restored to men. To the extent that the jobs lost to women doing clerical work in the construction industry reflect the introduction of the new microtechnology, the full-time female jobs are unlikely to grow.

Transportation, Communications and Other Utilities

The proportions of women and men in the utilities industries remained relatively constant between 1975 and 1982, as demand in these industries changed little during the crisis. While the proportions of both sexes in the

communications industries have grown since 1980, those in transportation have declined slightly. These latter trends probably reflect, to a large extent, the growth in microelectronics, a development which has helped in the short term at least, to create some jobs in the communications industry (Table 4.7) and to replace some workers in the transportation industries (Table 4.8). In the case of transportation, intensification and crisis-induced cutbacks in the movement of people and goods probably also contributed to the reduction in jobs.

Significantly, transportation industries are dominated by men and almost 7 percent of all men hold jobs here (Table 4.2). Women's concentration in this sector had been increasing until 1980 but began to decline as conditions worsened. Still, less than 2 percent of the female labour force is employed here. On the other hand, women are much more prominent in the expanding communications industry, where 40 percent of the workers are female. Half of the women in the broad utilities category are in the communications industries (Table 4.5) and over two-thirds of them do clerical work (Table 4.3). A growing number of men and women hold part-time jobs in these industries, but, since 1980, there has been a large drop in the share of part-time work going to women (Table 4.6). Not only have men been capturing more of the part-time work but women's hours in their part-time jobs have been reduced (Table 4.13).

Once again, a predominately male industry reduced full-time employment but many of these jobs reflected rationalization during the crisis and may well reappear if recovery takes place. Given the segregation within these industries, the increasing proportion of part-time jobs going to men probably indicates that many full-time male jobs are being replaced by part-time ones, perhaps temporarily, in hard times. Of course, it may also indicate that in a crisis economy more men are willing to take and are able to get part-time work, work that previously went to women. While segregation protected some women from job loss and while women took just over half of the new jobs in the communications industry (Table 4.7), it should not be assumed that women were entirely protected from falling employment. They lost more full-time jobs in transportation than their share of the industry would warrant (Table 4.8), suggesting that the women lose more in male-dominated sectors. Moreover, women's unemployment rate in the transportation, communications and other utilities sector as a whole was the same as that of men (Table 4.10). And two-thirds of the unemployed women in these industries were concentrated in clerical occupations where jobs are

less likely to reappear with a recovery and where workers are increasingly being replaced by machines.

Trade

The impact of the crisis on employment in the trade sector was slower and less visible than in the goods-producing areas and technology is just beginning to reduce the number of jobs in these industries. Moreover, the employment patterns in wholesale and retail trade have been quite different. So have the consequences for women and men.

Wholesale trade is dominated by men. Three-quarters of the workers are male (Table 4.2). Both the proportion of men working in wholesale trade and their share of jobs in these industries increased between 1980 and 1982, reversing the earlier trend (Table 4.2). Men even managed to capture more of the part-time work (Table 4.6). Some new full-time jobs were created and, not surprisingly, these went to men (Table 4.7).

By contrast, full-time jobs disappeared in the retail industries and two-thirds of them were lost to women (Table 4.8). In relative terms, women have been losing ground in this sector, where large numbers of women are employed and where they compete more directly with men. Although many more women found employment between 1980 and 1982, women's share of jobs in the retail industries did not increase. Indeed, as the recession deepened, the proportion of women working in retail trade declined while the proportion of men increased (Table 4.2). Moreover, women retained their previous share of the jobs only by taking almost two-thirds of the part-time work (Table 4.9). This was less than their overall share of part-time work, however, and their share of part-time work consequently declined (Table 4.6). Women with part-time jobs also got fewer hours of paid work (Table 4.13).

The crisis appears to be pushing more men to seek both full-and part-time work in the trade industries, where they have been able to compete successfully with women in recent years. Women's unemployment rates in these industries remain higher than those of men (Table 4.10).

It is difficult to tell whether or not a recovery would see the reappearance of women's full-time jobs in the trade sector. Since men must be taking some jobs that previously went to women, there is no guarantee that they will not be able to continue to do so if times get better. The low rate of unionization in these industries means that, in many areas, there are few rules to follow (Table 4.14). Furthermore, as we shall see in a later chapter,

technological change might allow the purchase of new machines and a reorganization of work rather than employment of more workers, particularly female workers.

Finance and Business Services

With the exception of some trust companies, profits have not been falling in most financial institutions and business services sales have been rising. Some real estate agencies have suffered, however, as rising unemployment, falling incomes and, for a while at least, high interest rates reduced housing purchases. The introduction of new microelectronic equipment contributed to the small boom in business services and probably prevented greater job growth in financial institutions while eliminating some jobs in insurance. Reflecting these developments, the proportions of both sexes employed in the business service industries have grown steadily since 1975. The concentration of women in the financial sector has remained constant in recent years although that of men has declined slightly. These patterns in turn reflect the segregation within each sector.

A higher proportion of women than men work in finance industries and women dominate the sector (Table 4.2). However, more than 60 percent of the women in finance do clerical work (Table 4.3), and they account for over 90 percent of the clerical workers in the industry (Table 4.4). Men are more widely distributed, although close to 40 percent of them hold managerial, technical or professional jobs within the finance industry. Women and men are also segregated by industry within the broad finance category. More than half the women work in the more profitable finance sector while more than half the men hold jobs in insurance carrier and real estate companies, and many real estate companies are experiencing difficulties (Table 4.5). Part-time work has been increasing for both sexes, although women hold three-quarters of the part-time jobs and more than one in ten women, compared to one in twenty men, do part-time work in this industry. Men, however, have been acquiring a larger share of the part-time work in recent years (Table 4.6).

This segregation helps explain the employment patterns for men and women in these industries. Male full-time jobs have disappeared (Table 4.8). It seems likely that much of this loss reflects the decline in the real estate industry. These jobs were not lost to women, whose full-time work did not increase. Rather, women picked up most of the new part-time work,

although they acquired fewer of these jobs than their previous share would warrant. Meanwhile, women's unemployment rate remained higher than that of men (Table 4.10), they accounted for nearly two-thirds of the unemployed in the industry (Table 4.11) and those who did manage to keep or get part-time work had fewer hours of paid employment (Table 4.13). Once again, male unemployment reflects the changing job structure during the crisis, not job loss to women. Unemployed men last worked in different jobs within the broad finance and business services sector (Table 4.12). Nor have women here escaped the impact of the crisis. A higher proportion of them are seeking jobs in these industries and they are losing some of the part-time jobs to men. In addition, a recovery in the housing market is likely to have a more beneficial effect on male employment while the new technology will continue to reduce women's clerical jobs in the industry.

Business services jobs are growing at approximately the same speed for both sexes and women and men are almost equally concentrated in these industries (Table 4.2). Women's share of both full-time and part-time work is almost the same as their share of overall full- and part-time employment. Full-time job creation in these industries is second only to hospitals and just over half of this additional work went to women (Table 4.7). Part-time work also grew and women acquired a share of it proportionate to their 1975 share of part-time work in the industry (Table 4.9). Lack of detailed information makes it difficult to tell whether or not women have been competing successfully with men to gain their share of jobs. If patterns here are consistent with those in other sectors, a more likely explanation is that both male and female jobs are growing here.

The State Sector

The previous chapter documented the enormous growth in the state. As Hugh Armstrong (1974) points out, it is difficult to determine precisely how many people are employed directly or indirectly by governments. Many of the people working in the industries already discussed have their wages paid or subsidized by the state. The utilities sector, for example, includes Ontario Hydro and B.C. Telephone; transportation covers Air Canada and that oldest of welfare recipients, the Canadian Pacific Railway. It is impossible to sort these industries out with the data available from the monthly Labour Force Survey. However, some industry divisions used by Statistics Canada clearly involve primarily state workers. There can be little doubt about those working in federal, provincial and local governments. And

LABOUR FORCE WORK

while there is some private enterprise involved in education, hospitals and doctor's offices, the overwhelming majority of the employees in these industries receive all or part of their incomes from public funds.

These industries are separated out for discussion together under the general rubric of the state sector because jobs here are related in a different way to the economic crisis. During crises, demands for these services increase rather than decrease. Profits play little direct part in decisions about employment in this sector and productivity is difficult to measure. Work here is generally labour-intensive. Working conditions and the number of jobs are determined by political decisions as well as by the struggles between employer and employees. Workers are highly unionized and a large proportion do what is defined as technical, professional or managerial work. On the one hand, there is pressure on the state to expand employment, both as a measure to counteract unemployment in other areas and as a means of providing services to those without work. On the other hand, there is pressure to practise "restraint," reduce public spending and lead the way in disciplining the workforce and intensifying the labour process. The consequences of these decisions and of the labour struggles in this sector are particularly momentous, given that the state is the largest employer in the country and that it establishes many of the conditions for other worker-employer relations. This sector is particularly important to this study because a high proportion of state workers are women and because the state has provided women with many of their most recent and best jobs.

Jobs in education and health are primarily women's jobs, increasingly so since 1975 (Table 4.2). Although before 1980 there was some decline in the proportion of women working in both areas and of men in education, these trends were reversed between 1980 and 1982, with the concentration of women and men increasing in education and health sectors. There was also a reversal of the trend in part-time work. While the numbers of both sexes working part-time continued to increase, men have been able to capture more of the part-time jobs since 1980 (Table 4.6). Not only are most of the jobs in the state sector women's jobs but women also do most of the work classified as technical, managerial and professional in the broad service industry category that includes health and education (Table 4.4). Indeed, a much higher proportion of women worked at this level in the service sector than in any other industry (Table 4.3).

More than 40 percent of all new full-time jobs created between 1980 and 1982 appeared in the education and health industries (Table 4.7). Not

surprisingly, given women's dominance in these areas, women acquired most of the new full-time jobs. It was the full-time work that accounted for the slight increase in women's proportion of all jobs in these industries, since their share of new part-time jobs was less than their 1980 share of all part-time work in education and health. Nevertheless, with just over 30 percent of all new part-time work appearing in these industries (Table 4.9), and with approximately one-quarter of all women employed in education and health working part-time (Table 4.6), part-time jobs here were still very important in women's employment.

In spite of the fact that women captured most of the new jobs, their unemployment rate in the broad service category (which includes education and health) rose, remaining higher than that of men (Table 4.10). Moreover, over 60 percent of those searching for work in the service industry were female (Table 4.11). And, as was the case in other industries, the number of women underemployed continued to increase as more worked part-time and those working part-time had their hours reduced (Table 4.13). Over 20 percent of all women working in the business and personal service industry had less than twenty hours of work each week.

Jobs in federal, provincial and municipal governments also grew, accounting for over 10 percent of all new full-time jobs created between 1980 and 1982 (Table 4.7). More men than women are employed directly by government but the concentration of women in these jobs is slowly growing and their share of jobs increasing while the concentration of men has remained relatively constant in recent years. This pattern is explained by the fact that women acquired all of the new full-time jobs in the federal government and two-thirds of those in municipal government. Meanwhile, male full-time jobs decreased slightly at the provincial level, where female full-time work increased and men took more of the part-time work. These patterns may indicate that affirmative action has had some effect. They may also mean, however, that jobs have increased in the traditional female areas and declined in those usually occupied by men. There is little detailed information available from the Labour Force Survey on segregation within public administration but the data that are published suggest that segregation provides at least part of the explanation. Close to 60 percent of the women, compared to 10 percent of men, do clerical work here (Table 4.3), and the majority of unemployed women are seeking this kind of work (Table 4.12). Women perform a smaller proportion of the managerial, professional and technical work in public administration than they do in the service sector

LABOUR FORCE WORK

(Table 4.3), and the proportion of unemployed managerial women is higher than that of men in public administration (Table 4.12). Moreover, women's unemployment rate has continued to grow during this period and was more than two percentage points higher than men's in 1982 (Table 4.10). Their share of unemployment was also higher than their share of employment. While women may be making some small gains by acquiring a higher proportion of the jobs, it appears that few of these gains are at the expense of men and that women still need many more jobs than they get.

Almost 90 percent of all additional jobs going to women were created in education, health and public administration. Approximately 115,000 additional state jobs went to women, 11,000 to men, and these include only those jobs clearly identifiable as created by the state. Without these state sector jobs, women's unemployment rates would have soared, while they made only a small difference in terms of the number of men with jobs. Moreover, most of the women with technical, professional and managerial jobs were employed by the state. Without them, their position relative to men would be significantly worse. Women appear to have made recent gains here, perhaps as a result of affirmative action programs in hiring. However, few of these programs apply to layoffs. Given the seniority rules governing many of these women, cutbacks are likely to mean women will be the first to go. Indeed, reductions in the state sector mean that women have lost whatever protection segregation gave them from the crisis. And recovery is unlikely to recreate jobs quickly, since the number of jobs will be a political decision rather than one based primarily on the demand for services.

Religion and Recreation

Jobs in religion and recreation have been relatively static in recent years, with neither sector employing very many workers (Table 4.2). Women had been moving into religion but the trend was reversed between 1980 and 1982. All of the full-time job loss was felt by women (Table 4.8) and more of those with jobs had only part-time work (Table 4.6). When jobs in religion begin to disappear, the more recently hired women are the first to go.

Recreation has been a larger employer of both women and men. Moreover, it has been employing increasing numbers of men and women although the earlier job growth has slowed since 1980. Between 1980 and 1982, women's share of all jobs increased slightly (Table 4.2), since they took two-thirds of the new full-time jobs (Table 4.7) and a quarter of the additional

part-time work (Table 4.9). Men, meanwhile, increased their share of part-time jobs. Once again these data may indicate that women are successfully competing with men for jobs in recreation. Lack of detailed data prevents a thorough investigation to determine whether or not jobs in women's fitness, for example, are increasing more than those for men. However, men's greater success in acquiring part-time work that had previously gone to women may indicate that, in some areas at least, women are losing as jobs become more difficult to find. This is one of the few areas, though, where recovery may lead to more jobs for both women and men and where new technology is less likely to have a dramatic effect.

Personal Services, Private Households and Miscellaneous Services

The proportion of workers employed in the personal service industries grew in the late 1970s but failed to do so as the crisis deepened in the 1980s. This category includes shoe repair shops, barber and beauty shops, laundries, accommodation and food services, and funeral services, as well as some other personal services, especially in private households. Women dominate these industries but their concentration in these jobs has fallen slightly, just as that of men has increased by a small margin. Rather than grow like their labour force participation, women's share of jobs remained constant, perhaps reflecting a movement of men into women's service jobs as unemployment in other areas rises. On the other hand, here too the greater success of one sex may primarily indicate that jobs were disappearing in particular industrial sectors. Many full-time jobs did disappear and two-thirds of them were lost to women (Table 4.8), but some new part-time work was created and women took 60 percent of it (Table 4.9). This may indicate that many women's full-time jobs were reduced to part-time work rather than given to men. However, women did lose a larger share of full-time work and gain a smaller share of part-time jobs than their numbers would warrant. This suggests that in some jobs at least, men were more successful when there was competition between women and men.

Work in private households has not been decreasing (Table 4.2). As was the case in the Great Depression, people may be more willing to take jobs in this low-wage sector as unemployment rises in other areas. The overwhelming majority of workers here are women and the work has become even more highly segregated in recent years (Table 4.2). If men work here, they work

part-time. Eighty percent of men employed in private households have part-time jobs. Yet women do more than 90 percent of the part-time work, with slightly more than half of the women holding part-time jobs (Table 4.6). Not surprisingly, two-thirds of the new jobs that appeared were part-time and all of the new jobs went to women (Table 4.9). Whether or not this means that women successfully competed with men for these low-wage jobs is difficult to tell without more detailed information. The result, in any case, is a greater ghettoization of women into low-wage work.

While personal service and private household industrial divisions are dominated by women, the miscellaneous services are dominated by men, who make up almost 60 percent of the workers. Included in miscellaneous services are labour and trade organizations, photographic services, automobile and truck rental, machinery and equipment rental, blacksmithing and welding shops, other repair services and services to buildings. The Census data indicate that there is a high degree of segregation within the industry but the Labour Force Survey data do not generate this kind of detailed information. Jobs have been growing in these industries but women have been losing ground. Before 1980, they were increasing their share of the work, but the pattern was reversed in the two subsequent years (Table 4.2). These industries were an important source of job creation, but three-quarters of the new full-time jobs (Table 4.7) and more than half of the new part-time work went to men (Table 4.9). Work here became increasingly male and the women lost out in relative terms.

Patterns in Industry Divisions

The overall pattern in the labour force is one of combined and uneven development, of declining goods-producing industries and a growing service sector, of falling male and rising female employment. Male jobs have disappeared primarily as the result of cutbacks during the crisis and are mainly concentrated in the goods-producing industries. Although some jobs have been eliminated as a result of technological restructuring, many will be recreated as production increases and worker strength grows during a recovery. Female jobs have increased primarily as a result of state expansion, but government restraint programs may permanently eliminate these jobs. Female jobs have disappeared as a consequence of cutbacks, of the introduction of microelectronic technology and of competition with men. Few are likely to reappear. The gains women made in such male preserves as fishing,

transportation and miscellaneous services have been largely eliminated as the crisis deepens. Men have been successful in those areas such as retail trade where they directly compete with women and men are beginning to take over the traditionally female part-time work in some areas. Women's unemployment rates continue to rise and remain higher than those of men in all but a few male-dominated areas where many men are unemployed and few women work. In all industries where they directly compete with men, women have a higher share of unemployment than they do of employment. When the data are broken down by occupation, as they are in the next section, the same patterns of disappearing jobs and female loss appear.

Uneven Occupational Development

An analysis of occupational data provides a somewhat different perspective on women's labour force position. With the sole exception of occupations in fabrication, women's share of all jobs increased. Occupations remained, however, highly segregated (Table 4.15). There were more jobs in traditional female occupations and more women took them. Yet there were some indications of gains for women in male fields. Their concentration in managerial jobs grew significantly, and grew more than the comparable rates for men (Table 4.15). While jobs for women in management seemed to offer the clearest indication of desegregation, there were signs that some women had moved into other traditional male areas as well. However, women's unemployment rates were higher than those of men in every occupation where there were enough women to make the data reliable (Table 4.26). In addition, the impact on women's employment was not consistent across all occupations, suggesting that even if some women made gains, these gains were not equally distributed. The rate of increase in women's share of any particular occupation varies considerably, nowhere exactly matching the increase in their share of employment.

Managerial and Professional Occupations

Included in the broad managerial category are jobs in managerial, administrative and related occupations, and both professional and technical jobs in natural sciences, engineering and mathematics, in social sciences and related fields, in religion, teaching, medicine and health as well as those in artistic, literary, recreational and related fields. Seventy-three percent of women in managerial and professional jobs are concentrated in the service sector while men in this occupational group are much more widely distributed across

industries (Table 4.16). Less than half of all men with professional and managerial jobs are in the service sector (which includes health, education, recreation, accounting, advertising and legal operations as well as personal services); almost a third are employed in the combined manufacturing and public administration industries. The data on unemployment also indicate that women and men last held different jobs in different sectors (Table 4.17). One in ten of the unemployed women last did managerial or professional work in the service sector, compared to one in twenty-five of the unemployed men. More than 70 percent of unemployed managerial and professional women last held employment in the service industries compared to less than half of the men (Table 4.18).

When the managerial and administrative jobs are separated from the professional and technical occupations, the segregation and the changing patterns, are more obvious. Managerial and administrative jobs have accounted for the largest increase in both female and male employment since 1975 (Table 4.15) and the concentration of women in these jobs grew more than that of men. Almost half of all full-time job growth between 1980 and 1982 was found in this occupational category and more than two-thirds of these jobs went to women (Table 4.19).

Outside of management within government, female "managers" were almost as likely to be found in the relatively lowly "occupations related to management" as in managerial occupations proper, while male "managers" were much more concentrated in the higher-level jobs. Moreover, since executive secretaries are included in the "other managers and administrators category," it seems likely that many of the women classified in the higher-level jobs are secretaries to the executives rather than executives, falsely inflating the figures on the number of women with "managerial" jobs. Indeed, Census data indicated that 20 percent of the increase in female managers between 1971 and 1981 was concentrated in the detailed occupation group that includes executive secretaries.

The proportion of women in this category working part-time rose steadily between 1975 and 1982, suggesting that many of these women did not acquire positions of power (Table 4.22). By contrast, the same proportion of men were working part-time in 1982 and in 1975. In the intervening years, the concentration of men working part-time here actually declined. Women captured a higher proportion of new part-time than new full-time jobs in this occupational category (Tables 4.19 and 4.23). Over 70 percent of new part-time managerial jobs went to women. Perhaps more significantly,

women's unemployment rates in managerial and administrative work were a full two percentage points higher than those of men in 1982 (Table 4.26).

Segregation continues, in spite of the fact that women captured more of the managerial and administrative work, especially in the lower-level jobs in this category. Nevertheless, women's position seems to have improved, relative to that of men. This may be accounted for in part by the cutbacks in higher-level male management jobs that are reported in the newspapers but invisible in the broad categories of the Labour Force Survey. In other words, women's position may not have improved so much as men's position has deteriorated, a process which is in turn related to the segregation. Furthermore, women's movement into jobs related to management may be due more to a reclassification of some clerical work resulting from the new technology than to women moving up the hierarchical ladder. With the machines filing and retrieving, recopying and editing, those left with employment may now be called executive secretaries and, not incidentally, removed from unions in the process. On the one hand, women have probably been insulated from the impact of management "rationalization" during the crisis by their segregation into the lower-level jobs; on the other, microelectronic technology has reorganized some of their work, reclassifying but not significantly improving their jobs.

The distribution of professional and technical jobs in the natural and social sciences displays a somewhat different pattern. The concentration of both sexes grew between 1975 and 1980, stabilized in the later period for those in natural science and grew slightly in the social sciences(Table 4.15). Women are much less likely to be found in the natural sciences than in the social sciences (Table 4.21). They are still virtually absent from the most significant of these jobs for men, architecture and engineering, and make up only about one-quarter of the workers in most other natural science fields. By contrast, in only one social science field, law, is their share as low as about one-quarter and they dominate the library field. To a lesser extent, women also dominate social work, where almost half the women in social science are to be found.

Close to one in five of the female social scientists and one in ten of the female natural scientists had part-time work, while only 6 percent of the men in both professions held part-time jobs (Table 4.22). The new part-time work in social sciences went to women (Table 4.23) although this did little to change their previous position relative to men (Table 4.15). Men got most of the part-time natural science jobs, however. The numbers of women without

LABOUR FORCE WORK

work in the social sciences is now large enough to be statistically reliable, suggesting that female unemployment has increased in this occupational category. The data on unemployment rates by occupation (Table 4.26) indicate that women still have much more difficulty than men finding work in both the natural and social sciences.

Here, too, segregation continues but women seem to have made fewer gains than in the managerial occupations. Job growth has slowed in these professions and this slowdown has halted women's progress considerably. Men are more than twice as successful as women in acquiring new full-time social science jobs and part-time natural science work. The declining construction industry, with its concomitant reduction in demand for engineers, surveyors and architects, may explain the loss of full-time male jobs in the natural sciences (Table 4.20). If jobs begin to disappear in the social sciences, however, women are less likely to be protected by segregation from job loss.

Professional occupations in the broad teaching and medicine categories exhibit yet another pattern. For both women and men, their concentration decreased between 1975 and 1980 only to rise again in the following two years (Table 4.15). While men returned to or surpassed their 1975 levels in 1982, the concentration of women in both teaching and medicine was lower than in 1975. In recent years, however, over 50 percent of the new jobs in teaching were full-time and all of them were filled by women (Table 4.19). More of the additional jobs in medicine were full-time but fewer of them went to women. A smaller proportion of women had jobs in teaching and medicine but the overwhelming majority of teachers and nurses or other hospital workers were still female. Moreover, women were twice as likely as men to have jobs in teaching and more than four times as likely to have jobs in medicine (Table 4.15).

Once again, the more detailed information (Table 4.21) indicates greater segregation. Over 70 percent of the women in teaching, compared to 54 percent of the men, worked in elementary and secondary schools, while two-thirds of those teaching in universities were male. In medicine, almost 90 percent of the nurses and therapists were female; over 80 percent of those in diagnostic and treatment occupations were male. Close to 80 percent of the women in medicine, but only a third of the men, worked in nursing, therapy and related occupations.

Work for women in both occupational categories is increasingly part-time. By 1982, more than one in five female teachers and more than one in four female medical workers had part-time employment (Table 4.22).

Approximately 19,000 men worked part-time in these occupations, compared to 161,000 women. While women's part-time jobs have been increased, their hours have been reduced. By 1982, the proportion of women teaching less than twenty hours was three times as high as the proportion of men (Table 4.24). More of the women in medical jobs were also working fewer hours while their male counterparts were clustered around the thirty-hour cutoff for part-time work. Over 40 percent of the new jobs in teaching were part-time and women captured almost 90 percent of them (Table 4.23). In medicine, however, only 28 percent of the additional jobs provided part-time work, with 85 percent of these going to women. In spite of the growth in women's jobs, women's unemployment rates in both occupations grew more than, and remained higher than, those of men (Table 4.26).

In these times of continuing government restraints, it is difficult to explain why the trends in teaching and medicine towards reduced employment for women, particularly full-time employment, and towards expanding full-time jobs for men, should be reversed between 1980 and 1982.[1] Growing enrolments, especially in elementary schools and in French immersion programs, may be increasing work in traditionally female areas. Many of these additional female teachers may also be giving private lessons or instructions in crafts after school.[2] That jobs in medicine accounted for 16 percent of the new full-time jobs for women and 8 percent of all their additional part-time work is even more difficult to understand (Tables 4.19 and 4.23). No change took place in the sex distribution of the work – suggesting there was no universal move towards desegregation. The proportion of women and men who were self-employed remained almost constant so increasing privitization does not explain the growth of women's jobs in medicine. Whatever the reason it is clear from the data that sex segregation continues and that future reductions in government expenditures will have a different impact on male and female workers.

While the proportion of males in artistic, literary, recreational and related professional occupations has increased, the percentage of women in such work remained constant between 1980 and 1982. With the exception of occupations in the performing and visual arts, women's share of jobs came closer here than in any other occupational category to matching their share of the labour market as a whole (Table 4.15). However, a steadily growing number of women found only part-time jobs. Fully 30 percent of women, compared to less than 16 percent of men, had part-time employment (Table 4.22) and two-thirds of the additional part-time work went to women (Table

4.23). More than one in five female employees works less than twenty hours a week (Table 4.24).

The proportion of unemployed men who last held jobs in the artistic and recreational fields has declined while women's share of unemployment has increased (Table 4.25). This trend, which is the reverse of the one observed in most other professional work, may be explained by the more direct competition between men and women in this work. Women have acquired a fair share of the jobs here but as unemployment rises, they lose out to men. Women's unemployment rates also remained higher than and grew more than those of men. The small growth in self-employed men[3] may also have contributed to men's greater success in finding employment.

In summary, then, close to 90 percent of all new jobs created in the broad management and professional occupational group were full-time, with most of these going to women doing managerial and administrative work. Other patterns varied considerably from occupation to occupation. With the exception of the natural sciences, women took the largest share of new part-time work. The hours of part-time female workers were, however, reduced, except in artistic jobs. Measured against the growth in the female share of overall employment between 1980 and 1982 (Table 4.15), their share of managerial and teaching jobs grew more rapidly, while their share of natural science jobs grew less rapidly. Meanwhile their share of jobs in medicine and religion remained constant, and their share of social science jobs actually declined. These variations in patterns may well be explained by a still segregated labour force, a segregation which means that some women in women's jobs are protected from the crisis while some men in men's jobs are more vulnerable. They may also mean that changing job structure and content favour the employment of women. They do suggest that when men and women compete directly for scarce jobs that have been open to both sexes, women lose. The movement of some women into traditionally male professional and managerial work separates them more from the overwhelming majority of employed women who do clerical, sales and service work. However, it is also clear that barriers continue to apply to women as a group. Female university graduates are, for example, much more likely to be unemployed than their male counterparts. As unemployment remains stubbornly high, women may become more vulnerable to competition from men. Indeed, their unemployment rates in all these jobs remain consistently higher than those of men.

Clerical Occupations

Clerical work has, throughout most of the century, been women's work. And, while the proportion of women in clerical jobs is declining, their share of this work is increasing (Tables 4.15 and 4.21). Men may be getting a smaller proportion of clerical jobs, but more of them are doing this work – a reversal of the previous five-year trend (Table 4.15). Full-time clerical jobs continue to disappear, and at an accelerated rate (Table 4.20).[4] More men than women lost full-time work but the reasons for job loss may be very different for each sex. As well as such jobs as typing, bookkeeping, filing and reception, the clerical category also includes material recording, scheduling and distributing occupations. Thus, shipping, receiving and stock clerks, as well as mail carriers, are counted as clerical workers, and are traditionally male. Moreover, male and female clerical workers were concentrated in different industries (Table 4.16). Male clerical workers were much more likely to be employed in the utilities and manufacturing sectors; women in finance and service industries. Over 60 percent of the women in clerical jobs did stenographic, typing, bookkeeping and account recording work (Table 4.21). Only 20 percent of the men in clerical occupations held these kinds of jobs. Unemployed female clerical workers were also much more likely than males to be in the service and finance industries (Table 4.18). Only in public administration and trade were similar proportions of men and women classified as unemployed clerical workers and the data on segregation suggest that women and men probably last had work in different jobs within these industries as well (Table 4.21).

Although full-time clerical jobs have declined, part-time work in these occupations accounted for over 20 percent of all new part-time employment. More than 90 percent of these new jobs went to women (Table 4.23). The pattern of decreasing hours for part-time workers found in the professional occupations was repeated here as well (Table 4.24).

The introduction of new microelectronic technology probably had an impact on both male and female clerical jobs (albeit different machines and different jobs). However, it should be noted that many men were unemployed in the sectors that have been hit hard by the crisis – manufacturing and transportation – while many women were unemployed in sectors where the crisis has had less impact. This suggests that the technology, rather than the crisis, has been a major force in putting female clerical workers into the

LABOUR FORCE WORK

ranks of the unemployed. It also suggests that their job loss will be permanent.

Sales Occupations

The sales category includes work in both services and commodities, covering jobs ranging from supervisors in insurance companies to those in grocery stores, from service station attendants to delivery people and sales clerks. Over the seven-year period between 1975 and 1982, the proportion of women doing sales work changed little, declining only slightly in recent years (Table 4.15). The proportion of men employed in sales jobs, on the other hand, dropped by a full percentage point in the first five years, rising again in the two subsequent years. As was the case in clerical work, there was an actual reduction in full-time jobs between 1980 and 1982, but unlike the pattern in clerical occupations, women bore the brunt of this job loss. More than 60 percent of those losing full-time work were women (Table 4.20). Within the sales occupations, women's unemployment was somewhat more concentrated in the trade sector (Table 4.18). However, 8 percent of all unemployed women, compared to 5 percent of all unemployed men, last held jobs in the trade industries (Table 4.17).

These differences between women and men in unemployment concentration reflect the occupational distribution evident in the more detailed data (Table 4.21). Women and men are equally concentrated in the jobs involving the sale of commodities and women's share of these jobs is almost the same as their share of the labour force. It is probably here, where they more directly compete with men, that hard times ensured that women lost full-time jobs. Men were a much higher proportion of other sales workers and were more concentrated than women in these particular occupations. These jobs are also the ones that are more likely to continue to be full-time.

In both clerical and sales work, full-time jobs declined while part-time jobs increased. Part-time sales work grew steadily for both women and men, and at an accelerated rate in recent years (Table 4.22). Women captured the majority of part-time work that became available between 1980 and 1982, but many of them – more than a quarter of all female sales clerks – usually worked less than twenty hours a week (Table 4.24). Indeed, over two-thirds of part-time sales workers were women (Table 4.22), and 39,000 sales women usually worked less than nine hours a week in 1982.[5]

Women lost more of the full-time work in sales occupations and gained more of the part-time jobs, many of which offered very limited hours of work. Less segregated in the occupations involving the sale of commodities, women were also less protected from the impact of the crisis and from male competition.

Service Occupations

Included in this broad category of occupations are those involved in the provision of protection, lodging and accommodations, apparel and furnishing, food and beverages as well as personal and other related services. There has been a growing demand for workers in these areas. More than one in ten of the new full-time jobs (Table 4.19) and almost one in five of the part-time ones were created in the service occupations (Table 4.23). On the other hand, jobs have not kept up with demand for employment. In 1982, more than a tenth of unemployed males and over a fifth of unemployed females last worked in service jobs. A higher proportion of males were unemployed in both fabricating and construction occupations but only in clerical jobs were more women recorded as unemployed (Table 4.25).

Not surprisingly, then, an increasing proportion of women and men do this kind of work (Table 4.15) and a decreasing proportion of workers have been unemployed here in recent years (Table 4.25). Men's concentration has been growing faster than women's and although women represent a declining proportion of the unemployed, the reduction in the percentage of males seeking service jobs was greater than that of women. Nevertheless, women took three-quarters of the new full-time jobs (Table 4.19) and 60 percent of the new part-time work (Table 4.23), in the process increasing their dominance of this occupational group (Table 4.15). These seemingly contradictory patterns may be partially explained by what has been happening to men in other areas. The sudden increase in male unemployment in the primary sectors could account for the relative decline in their unemployment in service occupations. The other trends can be understood in terms of the continuing and growing segregation.

As the detailed data on employment make clear, women predominate in all occupations in the service category except those classified as protection and "other" (Table 4.21). Nearly 13 percent of all employed women prepared food and beverages or did personal service work. Only 3 percent of male employees had jobs in these occupations. In addition, well over a third

LABOUR FORCE WORK

of all women doing service work held part-time jobs (Table 4.22) and the majority of new work here was part-time. By 1982, 11 percent of all women with service jobs usually worked nine hours a week or less; another 15 percent usually worked between ten and nineteen hours. The proportion of men with such short hours was approximately half the size (Table 5.24). The data on unemployment also indicate that women and men out of work are not often directly competing for jobs. While 22 percent of all unemployed women last held service jobs within the service industry, only 9 percent of unemployed men did so (Table 4.17). Unemployment rates for both men and women have risen sharply, with women's rates a full percentage point higher than men's (Table 4.26).

The crisis seems to have had little impact on the service sector although it was beginning to decline by late 1982.[6] Segregation continues; indeed it has grown. Consequently, the trends in employment and unemployment have varied somewhat by sex. More of the new work was women's work but most of it was part-time and much of that had reduced hours. As output in the service sector continues to decrease, so will jobs for women.

Primary Occupations

With the exception of jobs in agriculture, primary occupations are male occupations and three-quarters of those employed in agriculture are male (Table 4.15). Almost all women in primary occupations are in farming (Table 4.16), and most of them are in what are called other farming, horticultural and animal husbandry jobs, usually as farm workers (Table 4.21). Less than two-thirds of male primary workers are in agriculture (Table 4.16), and a higher proportion of them are farmers rather than farm workers (Table 4.21). The percentage of both women and men employed in agriculture has been steadily declining in recent years.

In farming, forestry and mining, full-time jobs have disappeared and have not been compensated for by any increase in part-time work (Tables 4.20 and 4.23). Women fared somewhat better than men, gaining some full-time work – a process that is probably explained by the increasing bankruptcy of farms owned by men and the subsequent shift in the nature of the work available. But, since three-quarters of the unemployed women in primary occupations last did agricultural work, compared with only 27 percent of unemployed men in this category, losses in farming have been less important for men than the decline of employment in other primary sectors (Table 4.18).

While women gained some full-time agricultural work, their loss of part-time jobs here was twice that of men. As a result, the proportion of women employed part-time in farming declined between 1980 and 1982 and the proportion of men increased. This too may reflect the growing number of bankruptcies for male farm owners, whose wives lost their part-time jobs as workers for their husbands. But, it should also be noted that 35 percent of women, compared to 11 percent of men (Table 4.22) still had only part-time work. Hours in these part-time jobs were reduced for both sexes, with 27 percent of women and 10 percent of men employed for less than twenty hours a week in 1982 (Table 4.24).

Segregation continued in primary occupations, even if women made some small gains in farming. The high job loss meant little to women but accounted for 12 percent of all full-time jobs lost to men. The crisis has had a differential impact on occupations, reducing jobs most in those areas where men work.

Processing Occupations

Processing, fabricating and machining work is men's work. When women do get these jobs, they are concentrated in the manufacturing sector (Table 4.16) doing women's work. Three-quarters of the women in processing jobs, compared to one-third of men, work in food, beverage and related occupations (Table 4.21). Another 18 percent of these women are in textile processing jobs where 6 percent of the men in the group are employed. In product fabrication, the concentration is even more obvious, with 58 percent of the women and 6 percent of the men in textile manufacturing. While close to three-quarters of those in textile fabrication are women, 98 percent of those doing repair and mechanical work are men (Table 4.21).

The data on unemployment suggest a fluctuation in demand for particular kinds of male and female workers rather than direct competition between women and men. Although women's share of unemployment has been declining in these occupations (Table 4.25), their unemployment rates have remained consistently higher than those of men (Table 4.26). Women's highest rates of unemployment are found in the processing occupations, with more than one in five of the women counted as part of this particular labour force unemployed. With the sole exceptions of forestry and logging, women's unemployment rates throughout processing and machining are higher than all male unemployment rates, clearly indicating that women are

LABOUR FORCE WORK

not the major cause of men's job loss. Indeed, these figures support the reverse argument — that men are pushing women out of work. Both male and female unemployment is highly concentrated in the processing jobs in the manufacturing sector (Table 4.17). Among processing workers the largest concentration of all unemployed men is located in this sector, but 92 percent of the unemployed women in processing, compared to 69 percent of the men, last worked in manufacturing (Table 4.18).

As is the case in other occupations, part-time work increased in processing more narrowly defined, although there was no such growth in machining and fabricating. The jobs lost were full-time and the new part-time jobs went primarily to men (Tables 4.20 and 4.23). The proportion of both women and men working part-time in processing and fabricating increased, with women's concentration increasing more than men's. Nevertheless, women got a smaller share of all part-time work in factories (Table 4.22). Over 95 percent of all men continued in 1982 to work at least thirty-five hours a week (if they had a job at all, of course), although the proportion with these hours has dipped slightly (Table 4.24). The figures for women meanwhile declined to 82 percent in processing and 86 percent in fabricating.

Unemployment has risen sharply in the manufacturing sector, putting both women and men out of work. However, the segregation has meant that the sex affected varied from job to job, from sector to sector. The consistently higher female unemployment rates and women's declining share of part-time work suggest that when women and men directly compete, the women lose.

Other Occupations

Work in construction, transport, materials handling and other crafts is also men's work, and the relative positions of women and men have shown little change (Table 4.15). Only in printing and related occupations do women constitute more than a quarter of the employed (Table 4.21). In general, their numbers are too small to be reliable. The statistics for the larger categories indicate that less than 3 percent of all employed women hold these kinds of jobs, compared to more than 20 percent of all employed men (Table 4.21). Between 1980 and 1982, full-time jobs disappeared in all these occupations, accounting for 38 percent of all full-time jobs lost (Table 4.20). Most of these jobs were men's jobs. Male unemployment rose dramatically.

In the only occupation where women's numbers were large enough to be reliable (materials handling), women's unemployment rate exceeded that of men (Table 4.26). Two-thirds of the unemployed women in materials handling were concentrated in the manufacturing sector, compared with 44 percent of the unemployed men (Table 4.18).

Although full-time jobs disappeared, some part-time jobs were created (Table 4.23). Women took half of the full-time work in other crafts, and close to 30 percent of it in materials handling. In spite of acquiring some of the new part-time work, women's share of part-time work in other craft occupations declined. So did the proportion of women doing part-time work in transport (Table 4.22). The part-time work that was created was primarily men's work, indicating that it is the jobs, rather than the workers, that are part-time.

The Crisis and Segregated Jobs: An Overview

The crisis has severely curtailed production in the primary and manufacturing industries, eliminating full-time jobs in farming, forestry, mining, machining, construction, transport, materials handling and other crafts, processing and fabricating occupations. In all these areas, more than three-quarters of the workers are male. At the same time, full-time work has expanded in finance, service and public administration sectors, creating professional, managerial, administrative and service work where a high proportion of women have traditionally found employment. Trade industries responded to the increasingly hard times and to the new technology by reducing full-time sales jobs and creating part-time work. In both processes, women were primarily affected, losing most of the full-time jobs and capturing most of the new full-time and part-time work. Full-time clerical jobs also declined, especially for men, while part-time work grew significantly for women. In general, the differential impact of the crisis on various sectors and the continuing segregation of the labour force helped to protect many women's jobs.

Nevertheless, female unemployment continued to rise, staying ahead of male unemployment rates in all occupations where there were enough women to make the statistics reliable. In those areas such as sales and fabricating occupations where they were more likely to compete with men, women suffered the greater loss in full-time work. As the crisis continues, more men may begin to seek traditionally female jobs and part-time work.

There are some indications that this has already begun to happen. In the early months of 1983, male employment increased only in part-time work. These part-time jobs were in managerial, administrative, professional, technical, clerical, sales and service jobs,[7] areas that have traditionally provided part-time female work.

However, there also seem to be some contradictory patterns. Although men took the majority of new full-time professional work in the social science and artistic fields, women took most of the rest of the full- and part-time professional work. The earlier trend towards more full-time employment for men and more part-time work for women was reversed in the teaching and natural science occupations. Perhaps more startling, women took two-thirds of the new full-time jobs in managerial and administrative occupations. Since a large part of the women's movement has focused its efforts on encouraging women's entry into managerial and professional work, the apparent improvement in women's position in these areas may be partially explained by these struggles. On the other hand, that men took the majority of full-time work in at least two professional areas where they compete directly with women and that they did this in spite of a significant decline in male labour force participation rates suggests there has been no universal move towards equal opportunity. Furthermore, the growth in women's share of managerial and related occupations has largely taken place in administrative work and may be partly explained by the redefinition of clerical work. In teaching, rising elementary school enrolments and new programs may have created more female work. In natural science, the floundering construction industry probably accounted for most of the loss in full-time male employment.

In general, detailed occupational and industry data indicate that the labour force remains highly segregated, and that many women were protected from the most obvious consequences of the economic crisis. However, more of the women who took jobs found only part-time work, and many of those who kept their part-time jobs had their hours and their pay reduced. Male unemployment has been more visible because it has happened in large centres to large numbers of full-time workers at the same time. Women's unemployment has been less obvious because unemployed women are more scattered over a range of occupations and are less concentrated in large goods-producing industries, because they are more likely to drop out of the labour force and the statistics, and because the crisis is more likely to result, at least initially, in underemployment in part-time jobs with reduced hours

of work. Women have not been unaffected by the crisis and, as we shall see in Chapters 6 and 7, when the new technology, the government job creation programs and the government restraint policies in other areas are considered, it seems likely that women will carry much more of the burden in the future.

NOTES

[1] For details on this earlier decline in women's full-time teaching jobs, see Armstrong and Armstrong (1983b: 225).

[2] During this two-year period, the proportion of women classified as paid workers declined slightly from 97.2 percent of those with teaching jobs to 95.9 percent, and thus the self-employed proportion increased slightly. The male percentage in paid employment remained at a constant 98.4 percent. Calculated from unpublished Labour Force Survey data.

[3] The proportion of self-employed men grew from 22.8 percent in 1980 to 23.7 percent in 1982. Calculated from unpublished Labour Force Survey data.

[4] See Armstrong and Armstrong (1983b: 255).

[5] Calculated from unpublished Labour Force Survey data.

[6] See Statistics Canada, *The Labour Force* March (1983:116).

[7] Calculated from unpublished Labour Force Survey data.

CHAPTER FIVE

HOUSEHOLD LABOUR

ECONOMIC CRISES ARE not restricted to the formal economy because households and the formal economy overlap. Workers are also consumers and this consumption requires labour. During crises of overproduction, employers reduce wages and the number of employees. Goods find fewer buyers. The household reduces expenditures on goods and services and increases labour to compensate for falling incomes. State programs help sustain buying power in the short term but over the longer haul, they do not fill the gap created by lost wages. When the state also cuts back on the proportion of the budget going to social services and limits income support programs, an even heavier burden is placed on the household. Given the sexual division of labour, much of this extra work falls to women. However, with what Ernest Mandel (1964:52) calls the "progressive socialization of all economic life," women have fewer means at their disposal, fewer ways of making up for lost income. Women's work is less flexible than it was during the last Great Depression. This chapter examines the impact of the crisis on women's household labour, arguing that women's work will increase as a consequence of and in response to changing economic conditions. But it also argues that alternatives to wage labour and state services are now severely limited for women as well as for men. This, in turn, places restrictions on the formal economy and on state cutbacks.

Unemployment

Unemployment clearly has an impact on the household. In March 1983, there were 1,658,000 people officially counted as unemployed;[1] that is, people who had actively looked for work and were available for work. There were also an estimated 335,000 persons – up by 45,000 from a year earlier – who did not seek work for "labour market-related reasons and the number of people reporting they wanted work but did not look for work for non-labour market-related reasons" was up by 23,000 to 140,000.[2] In other words, there were nearly a half a million additional people who wanted paid employment but were not included in the unemployment statistics. The actual numbers who experience unemployment at some time during the year is even larger. Statistics Canada's annual averages for 1981 estimated 898,000 unemployed but 2.6 million people were officially counted as experiencing some unemployment during the year.[3] In March 1983, 633,000 women were officially counted as unemployed and the increase in those reporting "labour market-related" reasons for not looking for work was concentrated among women over twenty-four.[4] Unemployment is not only rising for women, it is pushing many of them out of the labour market.

Although the numbers unemployed are enormous, various government agencies have argued that the consequences of unemployment are not as serious a problem as they were a decade or more ago. Employment and Immigration's Task Force on Labour Market Development (1981:15) argued that "hardship associated with unemployment is today much less than it was even 15 years ago." Statistics Canada's *Canadian Statistical Review* (January 1983:vi) takes a similar line:

> Unemployment clearly affects the economic well-being of many families. However, from the data presented here, it appears that this impact may be less serious now than 10 years ago, for the following reasons: first, an even larger majority of the unemployed are no longer the traditional sole breadwinners of families; second, there has been a substantial increase in the number of families with two or more earners; and third, government transfer programs such as unemployment insurance provide a larger measure of protection against loss of income in case of unemployment.

What this conclusion seems to imply is that unemployment in general is less serious because many of the unemployed are women rather than "prime age males," that women's unemployment is not very significant and that men's

unemployment causes less hardship because their wives are working and, in any case, they can all live on unemployment insurance. But the numbers collected by Statistics Canada itself indicate that unemployment creates severe problems for many households and that women's unemployment cannot be so easily dismissed. Eighteen percent of those wives officially counted as unemployed in 1981 – and it should be noted, married women are the least likely to have their unemployment recorded – did not have husbands who were employed full-time.[5] Even those with employed husbands do not necessarily escape hardship. A study published by Statistics Canada and based on their data concludes that "the families of unemployed wives are more needy than either the families of wives not in the labour force or of currently working wives, particularly for wives in the older age groups" (Nakamura *et al.*, 1979:54). The May 1982 issue of *The Labour Force* points out that, "With respect to unemployment rates, it is of interest to note that by far the highest rate (21%) was registered by women whose husbands were also unemployed" (Statistics Canada, 1982:100). Moreover, since more than one in four employed women and many of the employed children have only part-time jobs and part-time pay, their employment will do little to stave off the hardship created by the man's job loss, especially given higher male wages. Finally, of those families with at least one member unemployed, over 40 percent had unemployed heads.[6] In most cases, this means that the person with the highest earnings is without a paycheck.

Of course, the unemployment of women who do not live with a man, unemployed or otherwise, is much harder to dismiss with the arguments offered by Statistics Canada. In 1982, 188,000 single women and an additional 54,000 women who were widowed or divorced were officially counted as unemployed. These women accounted for 19 percent of all the unemployed.[7] They may not be the traditional breadwinners that concern Statistics Canada but their loss of wages will not be supplemented in most cases by other income earners.

It may well be the case that unemployment insurance provides a larger measure of protection now than it did in the past[8] – given the increase in the number of people covered by unemployment insurance – but this does not mean that unemployment does not cause economic hardship. Not all unemployed people are eligible for benefits and many who apply are disqualified or disentitled. In recent years, such refusals have averaged more than a million annually.[9] Even for those who receive regular benefits, the money is inadequate, especially as the duration of unemployment increases. Average

benefits in 1982 were $154.46 a week,[10] considerably below the $300 a week that Canadians feel is the least amount of money necessary for a family of four.[11] According to the *The Montreal Gazette* (March 27, 1984),

> A tightly budgeted menu plan for a family of four drawn up by an inner city "food action" study group shows that, if a family is living on unemployment insurance, it takes 70 per cent of that income to eat properly.

Unemployment not only increases economic hardship, it is also a major cause of poverty, as the Social Planning Council of Metropolitan Toronto (1982:41) points out in its policy statement on employment programs.

> The percentage of poor family units that had at least one person in the labour force and some unemployment was double that of non-poor family units with at least one person in the labour force and some unemployment.

The Council also found that, in Toronto,

> for the past six months almost half of the individuals and families applying for welfare have done so because their unemployment insurance benefits have run out. Employable recipients now make up almost half of the 42,419 municipal welfare recipients in Metro (Social Planning Council, 1982:42).

In another study of social welfare programs in Ontario, the Council argues that "Poor job protection in the low wage sector in a declining Ontario economy probably explains why unemployment is the single greatest reason for people to require General Welfare Assistance." With rising unemployment, General Welfare Assistance "has become a replacement for unemployment insurance for many who want to work but can not find jobs" (Social Planning Council, 1983:68). While it may be the case that unemployment insurance provides a cushion for some against the worst economic effects of unemployment, it is clear that a high proportion of the more than two million who experienced some unemployment in 1983 were in dire straits.

Of course, employment during an economic crisis does not guarantee an adequate standard of living. A recent study done by Derek P.J. Hum for the Ontario Economic Council indicates that 2.5 million men, women and children live below the poverty line and many of these have paid work. A worker earning the minimum wage throughout 1980 brought home only 88 percent of what a family of four would have received in welfare payments, payments which themselves are just over half as much as Statistics Canada has determined is necessary to reach the poverty line (reported in the *Toronto Star*, September 8, 1983). Most of those earning minimum wage (Armstrong and

Armstrong, 1983b) and most of those single parents trying to support a family on the minimum wage are women. Indeed, many other families are also feeling the pinch. Charlotte Montgomery reports in the *Globe and Mail* (July 23, 1983:11) that, according to Statistics Canada figures, "Well-paid jobs which have long been the backbone of the comfortable middle class" are steadily shrinking.

Declining or suddenly dropping incomes are not the only effects of rising unemployment and continuing crisis. As the Social Planning Council (1980:26) points out in its *Working Papers on Full Employment,* "Research is quite conclusive with respect to the positive correlation between the degree of economic deprivation suffered and the extent of the social and psychological impact." The consequences vary, but those with and without employment face increasing non-economic difficulties. These problems are felt and dealt with primarily in the household.

The uneven development of the formal economy is more evident during crisis and the impact is not uniform across households. However, as the crisis continues, as wage restraints take hold in many sectors, and as fewer jobs are secure, more and more households reduce their expenditures and experience the other consequences of hard economic times. Unemployment exaggerates the effects of the crisis, increasing the tension and the work in the home. While no member of the household escapes, women bear the greater burden of this increasing workload.

Household Budgets

Stretching the food and clothing dollar is women's work. More than half of the married women in Canada are in the household full-time and over a quarter of those with paid employment have only part-time work.[12] There can be little doubt that these women take primary responsibility for domestic work. Nor can there be much question of who does the domestic work in the households of the close to a million and a half single, separated, widowed or divorced women. As for those married women who work full-time outside the home, there is no evidence that the job of feeding and clothing the family has been taken over by their husbands or children. Statistics Canada does not collect information on domestic work but Gallup Polls suggest that, while there has been a significant increase in the proportion of Canadians who think men should share in the housework, there has been little change in the amount of work husbands actually do in the home (cited in Luxton,

1983:28). Meg Luxton's (1983:36) follow-up study of households in Flin Flon indicates that some husbands are taking on a larger share of the work but this usually involves "helping out" their wives. They did not do the "on-going management tasks and they rarely took responsibility for pre-task planning."

If there is a man in the house, he usually provides the major source of family income when he is employed; but it is usually a woman who must make the household income cover the expenses for food and clothing. When she too earns money, her income is usually allocated to such expenditures (Edwards, 1981), and she is responsible for stretching the declining dollars. Making ends meet is women's work.

Theoretical explorations of women's domestic labour and empirical work on the Great Depression suggest that women compensate for shrinking household budgets by intensifying their labour, especially by baking goods and making clothes rather than purchasing ready-made articles. Today, however, even those women who have the time, the energy, the skills and the facilities to make things from scratch will find it very difficult to save money by doing so. Between 1980 and 1982, the Consumer Price Index for all items rose by 26.3 points. During the same period, the index for flour rose by 107.5; for bakery products, by 44.4. In other words, it was relatively more expensive to buy the flour to make the bread than it was to buy bread readymade. Women who peeled and cooked their own potatoes were also spending relatively more than those who bought frozen french fries, since the index for potatoes rose by 197.6 and that for frozen french fries by 23. The price of prepared and partially prepared foods in general grew by only 30.9 points compared to, for example, a 123.5-point growth in the index for onions and a 64.8 increase for carrots. Even the increase in restaurant meals (23.4) was considerably less than that for, say, peanut butter (175).[13] In terms of food, more hours spent cooking will not result in more dollars for other goods and services.

Women could not save much by making clothes for themselves or the kids either. The index for women's and children's clothes rose about half as much as the overall index and less than the price of clothing materials and related services. However, the index for piece goods and notions rose very little, so some money could be saved by repairing those things that could be repaired. But many of the new products that falling prices have encouraged women to buy, such as polyester socks and sweaters, cannot easily be darned or mended.

HOUSEHOLD LABOUR

Women could save by washing sweaters by hand rather than taking them to the dry cleaner, although dry cleaning prices have risen less than the overall index. They could also reduce expenditures by firing the cleaning woman if they are in the minority of households that have one. Money can be saved too by eliminating recreational activities for adults and children and by decreasing babysitting costs for non-necessary activities. What many seem to have done is reduce expenditures on home furnishings, furniture, radios and appliances as well as on piece goods, linens and domestics.[14] All these cutbacks serve to increase women's work, not by intensifying their labour in the production of goods but by increasing the cleaning, washing and child care, the service aspect of their job in the household. Rather than devoting more time to baking, women spend time planning their shopping, cleaning and meals, carefully watching the Wednesday papers for specials, organizing menus around what is on sale and saving the clothes and dishes up for fewer washes. That this is a major way women can cope with declining incomes is reflected in a survival pamphlet, prepared by the British Columbia Federation of Labour, for the unemployed. Suggestions include looking for specials and practising comparative shopping, using the Canada Nutrition Guide as a means of selecting cheap, nutritious foods, buying in bulk and reading government pamphlets on the preparation of inexpensive cuts of meat, poultry, fish and vegetables (n.d. [1983]:9). This extra stress on wives may explain why Grayson (1983:33) found in his study of laid-off Ontario workers and their families that "for the wives of the unemployed, the economic impact of job loss is acutely felt," while economic factors seem to be less important in their husbands' response.

At the same time, the pressure increases for women to take or keep their paying jobs. The prices that have risen the most are those for energy, shelter and transportation.[15] These are all necessary expenditures for the family, they all require payment in money and they cannot be significantly reduced or easily replaced by women's intensified domestic work. Although women's household work, especially their management and service work, increases with declining incomes, this work is less and less flexible. There are fewer and fewer ways for women to compensate for shrinking incomes except by seeking more wage labour. Fewer and fewer women have alternate means of survival.

Some women are now adding to household income by working for pay in the home. They sew clothes, type, babysit, do a range of tasks that allow

them to bring in cash without leaving the house and their domestic responsibilities there. It is impossible to tell how many women are now doing this "homework," since many hide their labour from government officials of any sort.[16] It seems likely, however, that women will increasingly take on this kind of work as family incomes decline. Since such work is low paid, without fringe benefits or any other kind of protection, this trend would mean more and worse work for women.

Tension and Violence

According to the Canadian Mental Health Association (Kirsh, 1983), unemployment is increasing depression, anxiety and mental illness as well as child abuse, suicide, alcoholism, disease, divorce and crime. Although these patterns are most likely to appear among the unemployed, those who keep their jobs do not escape entirely from these consequences of an economic crisis. The attacks on acquired union rights, the pressure from the reserve army of unemployed, the reduction in job security, wage restraints, the lack of alternative job prospects and the fear of being replaced by the new technology all serve to increase the strains on the employed as well. Nor are women who are full-time housewives immune. One American study concluded that, "The low-income homemakers, financially dependent on the efforts of other people, showed the highest distress" (cited in MacKay, 1983:33). In his 1974-1975 study of families of unemployed male workers in Northeastern Quebec, Dejardins found

> a clear increase in cases of depression among the dependents and that increase was both larger and occurred faster than in laid-off workers. It was especially pronounced among the unmarried adult children (quoted in *The Montreal Gazette,* April 2, 1983).

Both women and men are unemployed or risk unemployment and both women and men experience the social and psychological effects of hard times. It is women, however, who primarily take on the work of handling the increasing tension in the household. Women are the tension managers. Luxton (1980:48) found in her study of Flin Flon women that, in addition to housework tasks, "the housewife must enter into a far more complex and profound relationship with her husband, for she must also ensure his general psycho-emotional well-being." The job is much harder in tough times. The employed man has fewer ways to fight back at work and fewer alternatives to staying on the job. Unemployed men in particular lose their social contacts

at work and often withdraw from other friends and relatives because of their "diminished self-confidence, the lack of understanding that others may display, and the lack of finances to engage in social activities" (Social Planning Council of Metropolitan Toronto, 1980:24). In her examination of those unemployed during the Great Depression, Mirra Komarovsky (1940:37-38) found frequent personality changes in the husband. He often became apathetic, intolerant or dominant. At the same time, his authority was challenged more and more by the children, particularly by adolescent children, and by his wife. The husband's authority may be even more difficult to maintain if the children and his wife both hold paying jobs. Moreover, when men are unemployed, they are home more, creating more work. As the Social Planning Council of Metropolitan Toronto (1980:24) explains,

> social interaction patterns can be upset since the loss of a job and income may diminish the unemployed person's status and authority. Shifts in roles within the family, coupled with changes in the unemployed person's personality, can provoke considerable stress and in extreme cases can lead to family breakdown.

All these processes increase the workload of women, although women may be less and less capable of handling the job as more and more of them share men's labour market experiences. They may also resist doing so, especially if there is an unemployed man at home and the woman has a paid labour force job. With no one to do the work, the household may simply explode, a consequence that would further threaten a system that relies on household stability.

The increasing tension not infrequently leads to violence and the violence is directed primarily against women and children. As the House of Commons Standing Committee on Health, Welfare and Social Affairs *Report on Violence in the Family* (1982:3) makes clear, "Although husband battering does exist one cannot compare its incidence to that of wife beating." The violence is widespread. While the extent of violence is very difficult to measure with any accuracy, Linda MacLeod (1980:21) estimates that "Every year, 1 in 10 Canadian women who are married or in a relationship with a live-in lover are battered." And their numbers may be increasing. In her article on violence against women in the home, Barbara Roberts (1983:14) presents some devastating statistics:

> In Ontario in 1981 over 10,000 women and their children fled to women's shelters due to wife battering, and many others went to other places of refuge.

The 19 transition houses in Quebec sheltered nearly 5,000 women and their children that year.

Traditional male attitudes contribute to the widespread wife battering, as the Ontario legislature's investigation of the issue points out, but "The coincidence of drinking with some attacks does not mean that alcohol causes the violence." Nor do most batterers suffer from "an identifiable mental illness" (Ontario, Legislative Assembly, 1982:1 and 2). The "primary causal factor in maltreatment may be current emotional stress" (Jayaratne, cited in Paltiel, 1982:20). And economic hard times clearly increase emotional stress. A Toronto study found that "Eighty per cent of wife-beaters reported to Metro Toronto police were unemployed" (cited in MacKay, 1983:33). While the violence increases, the opportunities for escape are reduced. Rising unemployment and falling wages for women mean they have fewer alternatives to accepting the battering at home.

Child abuse is also increasing. According to the Children's Aid Society of Metropolitan Toronto (reported in the *The Montreal Gazette,* October 15, 1983:G-6), "the number of cases opened in the first six months of 1983 increased 15.6 per cent over the same period last year." The CAS director cited the economy as a major factor in the increase. Both women and men batter children but it is women who must care for the children after they are beaten. Moreover, violence against women, even if the children are not physically touched, increases the child-care work, since the children in such households have a "high incidence of somatic, psychological and behavioral dysfunction" (Hilberman, cited in Paltiel, 1983:19).

Growing tension and increasing violence change the nature and conditions of women's work in the home. Divorce or separation may result, further increasing women's workload since they usually retain responsibility for the children and have to bear this responsibility alone on a smaller income. While economic crisis may contribute to the breakup of the household, there are also contradictory pressures keeping people together, since both husbands and wives may find it economically more difficult to live on their own. Some families, as Komarovsky (1940:xxi) found, may be brought closer together; others will stay together in an increasingly unbearable union.

Youth Unemployment

Tension, expenses and work also increase in the family as more and more older children stay or return home. Youth unemployment has mushroomed, their official unemployment rate rising from 14 to 20 percent between 1980 and 1982. Since there are no jobs and very few alternative means of support, growing numbers of older children are relying on their parents. There were 29,000 more single children 15 years of age and over living in families in 1982 than there were in 1980. In addition, the number of other relatives attached to families increased by 13,000 during the same period.[17] Statistics Canada does not indicate what the relationship of these individuals is to the family, but it seems likely that many of them are offspring who have married and returned home.

While older children may be expected to do some housework and to pay some of their own expenses, there is little indication that their contribution in either area is large. Instead, their presence usually means more clothes to wash, more food to cook and more mess to clean up. They are also likely to increase the tension, as children old enough to support themselves are forced to remain dependent. Here, too, the increased household workload will fall on women and the extra expenses may place even more pressure on women to get or keep paid employment.

Government Restraint Programs

Convinced by Keynesian economic theory, pushed by popular demand and employers' need for a healthy, stable and educated workforce, governments at various levels have introduced social programs that provide family allowances, medicare, pensions, unemployment insurance, compensation for workers, housing subsidies, homes for the aged, the retarded, the disabled, for battered wives and children, support for those without wage labour, for day care centres, for education, retraining, and for cultural and recreational programs. Never without critics, many of these social programs were facing sustained attacks in government circles as early as the mid-1970s. Alternative economic theories gained prominence as inflation and unemployment grew together, while profits declined and the crisis deepened. Corporations as well as smaller employers began to push for greater privatization of services and for a transfer of funds from support for social programs to grants for industry. As early as 1975 in Ontario, the

Report of the Special Program Review (cited by the Social Planning Council of Metropolitan Toronto, 1982:89) recommended governments cut back their expenditures on human services. Since then, the federal and provincial governments have begun to adopt this policy, giving lower and lower priority to social programs.

The process has not been even across provinces or programs. In some cases, collective action has been able to ward off reductions. Some cutbacks have been postponed by impending elections but, in general, social programs are suffering a decline. Few have sustained their relative position to other expenditures and may be further reduced in the future. In his analysis of federal financing plans, Bill Blaikie (1982:40) argues that

> Canadians, depending on which province they live in, may experience a proliferation of extra-billing by physicians, initiation of hospital user fees, massive increases in tuition fees, cutbacks in health and education programs, and layoffs of related staffs, or some combination thereof.

In Ontario, the process is well underway:

> The litany of cutbacks in Ontario is a long one. It has affected not only colleges and universities and hospitals, but also services and income to the poor, culture and recreation, primary and secondary education, residential facilities for seniors, mental health services, services for children, daycare services to families and nursing services (Social Planning Council of Metropolitan Toronto, 1982:27).

In British Columbia,

> Almost no area has escaped the inhuman "down-sizing" of vitally needed community services. Among the programs cut or eliminated: child-abuse teams; family service workers; legal aid; grants to the handicapped; consumer counselling; funding for community health groups; the list goes on and on. Bill 24 undercuts Medicare; Bill 8 disbands the Alcohol and Drug Commission; Bill 9 eliminates regional planning ... (Defend Educational Services Coalition, 1983: unpaginated).

While this dismantling of the welfare state has been discussed by a number of authors,[18] little attention has been paid to the consequences of this retreat for women's household work. As the services decline and their costs rise, more and more of the work, if it is done at all, will be done in the household, primarily by women.

If the old, the sick, and the mentally and physically handicapped are not cared for by the state or by a charitable organization, they are cared for at

home, by women. User fees for medical services mean that fewer people will seek out doctors and go to hospitals, even though their health is deteriorating. The length of time people are permitted to stay in the hospital to recover from an operation has been reduced, and so have the number of pediatric and rehabilitation beds.[19] If children and those requiring rehabilitative care are not in the hospitals, they are looked after at home by women. As the services in the hospitals decline, women are expected to be available to provide bedpans for the children in the orthopaedic ward and sick pans for those recovering from tonsil operations. Outpatient clinics are growing for a wide range of operations, sending the children and adults home when they still require a great deal of surveillance or even nursing care.

Fewer facilities for the old also increase women's household burden. The application of the government formula limiting increases in pensions means that the income of many pensioners has not kept up with inflation. Cutbacks in residential and nursing facilities also push the elderly to rely more on the services of relatives. Moreover, as the allocation to programs such as New Horizons, which supports projects designed and carried out by retired Canadians, fails to keep up with increasing numbers of elderly, more and more attention will be sought from especially female relatives.[20] Women bear a double burden here, because they are the majority of the elderly, of those living primarily on pensions (Collins, 1978) and of those providing the care when the state cuts back.

The state is also moving the disabled and handicapped out of institutions and back into the home. While there are many negative aspects to institutional care and many positive ones to de-institutionalization, the process, as Melanie Panitch (1982:11) points out in her examination of the issue, often simply means that people are being dumped out by the state. "Without adequate resources and a flexible support network in the community, someone leaving an institution is not being de-institutionalized" (Panitch, 1982:11). They rely, when they can, on the household and this usually means that women are responsible for the work.

Education and day care cutbacks also mean more work for women. According to the Canadian Council on Social Development (1983), there has been a 15 percent decrease in publically funded day care spaces since 1980. The federal government has launched an investigation of day care facilities and their future funding but both the Alberta and British Columbia governments have refused to participate, according to *CBC* radio, on the grounds

that more public funding of day care would undermine the family. Cuts in education budgets also mean that noon-hour supervision, special programs after school, as well as special services for gifted children or for those with learning disabilities, have been reduced or eliminated. Recreational and athletic facilities are also decreasing their services or increasing their fees. Children not at school or the skating rink and children who need special help will get it, if at all, primarily from women in the home. All of these cutbacks not only mean more work, they also mean that women are more restricted in their job search.

Reductions in welfare payments also have a particular impact on women, since they are a high proportion of welfare recipients. Here, too, there are wide variations by province. In Nova Scotia, Bill 61 "removes eligibility for financial assistance to sixteen- to eighteen-year-old mothers under the Family Benefits programme" (MacDonald, 1983:16). Pressure from various groups forced the withdrawal of other legislation that allowed the state to apprehend a child if the parent "failed to provide adequate food, clothing and shelter" (MacDonald, 1983:17). Young mothers denied public assistance are frequently forced back into their parents' household, increasing the workload there. In Quebec, the $149 a month paid to unmarried, able-bodied recipients aged eighteen to thirty is obviously inadequate for anyone's needs.

Cutbacks in a variety of other programs will have a particularly harsh impact on women, although these reductions may not increase their workloads. If the federal government proceeds, as the Social Planning Council of Metropolitan Toronto (1982:67-68) predicts, with its plan to tighten regulations for and reduce spending on unemployment insurance, history teaches us that women and young people will be the first disqualified.[21] Cutbacks in housing subsidies will also hurt women in specific ways. As Janet McClain and Cassie Doyle point out in their study *Women as Housing Consumers* (1983:11 and 13), in 1976, 83 percent of lone parent families were headed by women and "Women heads of families under age 34 represent the highest proportion of those in the lower income study." These women constitute a group particularly in need of government support for their housing needs. Reductions in all community services will also be felt particularly by women, since they and their children constitute the overwhelming majority of those using the services.

It is impossible to survey here all the provincial and federal cutbacks in social services and to examine their consequences for women. What should

be clear from these examples is that restraint programs are well underway in most jurisdictions and where they are not, increases have failed to keep up with growing need during crisis. Moreover, cutbacks in state sector services usually mean increases in household work. In some cases women have successfully resisted proposed reductions; in others, their labour force responsibilities make it impossible for them to undertake the extra work. As fewer and fewer women are in the household full-time, there will be more and more limits on how much additional work they can absorb.

Women's Bodies

State policies also affect the control women have over their bodies, and here too, women are facing the prospect of worsening conditions. In 1977, the Committee on the Operation of the Abortion Law concluded

> that the abortion law was not operating equitably across Canada – that there were sharp disparities in the availability of safe, legal abortions, and health threatening delays. The Committee also found there was a continuous exodus of Canadian women to the United States to obtain, at a high price, the abortions to which they were supposedly entitled in their own country (Oliver, 1983:37).

The complicated procedures, the limited number of hospitals with therapeutic abortion committees and the vague definition of danger to life and health have always meant that the cumbersome law did not actually give women the right to abortion on demand. The decision was not primarily in the hands of the pregnant women.

Recently, even the long-established committees that operate under this law in the hospitals have come under attack by "right-to-life" organizations. And when Dr. Henry Morgentaler tried to establish abortion clinics in Winnipeg and Toronto, the police were sent in. Women, and some men, have responded strongly to these assaults. According to Lorne Slotnick (1983:7), a *Globe and Mail* reporter, "Long months of organizing have paid off for abortion rights advocates in Toronto, who have mounted a quick, effective and militant response to the July 5 police raid on the Morgentaler clinic." The number of legal abortions has not been growing in Canada in recent years,[22] perhaps as a result of increasingly limited access to abortion facilities. "Canada had the lowest abortion rate of 12 countries surveyed by Statistics Canada" (*Montreal Gazette,* December 6, 1983:A-8), and the rate of increase

is decreasing. It remains to be seen if the collective response will be strong enough to reverse this trend.

The growth of pornography, chillingly dramatized in the National Film Board's movie *Not a Love Story*, provides another example of both changing conditions and collective response. Although Malamuth and Check (cited in Kostash, 1982:49) have demonstrated that, when "effects of pornographic violence were assessed in responses to a lengthy questionnaire the findings indicated that heightened aggressiveness persists for at least a week," governments have been hesitant about limiting access to pornographic movies now available on pay TV and for home videos. There have been demonstrations of various sorts across Canada protesting inaction and the issue is still far from settled.

The crisis may be affecting women's bodies in other ways as well. The number of stillbirths and of perinatal deaths – foetal deaths of twenty-eight or more weeks of gestation – has been rising in recent years.[23] That these losses are increasing in spite of advances in medical knowledge may be related to the growing strain, the growing violence, the declining medical services and the poor nutrition associated with economic crisis.

Women have fought for and claimed a victory on government regulations of maternity leave, yet these laws too may be limiting women's choices during the crisis. The length of maternity leave varies from jurisdiction to jurisdiction, but the most common period is seventeen weeks (Labour Canada, 1983a:37-38). Of course, some union contracts permit longer leaves and some jurisdictions allow a short extension. In most cases however, a woman must return to work within four or five months of the birth of her child. In times of high unemployment, fewer women can risk giving up their jobs, even if they want or need to stay home with the baby and even though this means taking on a double load soon after the birth. Maternity leave regulations, coupled with growing economic need, may go a long way towards explaining the growing labour force participation rate of women with very young children. In 1981, 45 percent of the women with a child under the age of three was in the labour force.[24] But Labour Canada's (1983a:1) study of maternity and child care leave warns that women may respond by avoiding having children at all.

> It is increasingly clear that without an improved and forward looking set of provisions for maternity leave and income maintenance the future work force may become "mighty scarce." Research shows that in Canada, and internationally, women bear the double brunt of working for pay and raising a family.

HOUSEHOLD LABOUR

Many laws and policies fail to recognize the pressure of and need to reconcile economic and family responsibilities. Consequently many women may well continue to have serious reservations about pregnancy and childbirth. As the crisis deepens, women may find themselves less and less in control of their bodies, and more and more subject to the decisions and laws made by others. Even those laws designed in response to women's concerns may have a contradictory effect, further limiting women's choices while providing some protection.

Changing Ideology

The abandonment of Keynesian economics, the growth of "pro-life" movements and the lack of concern over rising female unemployment are not unrelated to the spread of a conservative ideology during the crisis. According to Patricia Hlucky *(Maclean's,* September 28, 1983:54-55), the gulf between male and female toys is widening, with parents buying cuddly "Cabbage Patch" dolls for the girls and tough and military GI Joes for the boys. The Vatican has announced that wives should be paid a wage for working at home (reported in *The Montreal Gazette,* November 25, 1983:A-7) and its ban against birth control continues. Closer to home, an advisor to the Ontario government on women's issues publicly stated that the time was not ripe for equal pay for work of equal value (reported in the *Toronto Star,* September 16, 1983:D3). At a Labour Canada Conference on equality in the workplace, held in Toronto in the spring of 1981, a popular economist argued that equal pay could not be sought during times of crisis. Equality, it seems, is only for the good times.

Perhaps more disturbing is the attempt, within social science, to reinstate biological determinism of sex differences in behaviour. Sociobiology, devoted to providing a biological basis for human behaviour,[25] is rapidly growing in popularity both in and out of academic circles. More sophisticated versions of these theories "suggest that the human brain is programmed before birth by sex hormones, so that males and females show different degrees of aggressiveness and different reproductive behaviour" or differences in intellectual abilities (Lowe, 1983:15). Some attribute these differences to brain lateralization. Much of the research is based on animal, particularly rat behaviour, but this often gets lost when the research is

reported. *The Montreal Gazette* (November 10, 1983:A:20), for example, begins a story with the following paragraph: "Researchers at Duke medical centre believe the lack of a mother's touch triggers a survival mechanism in babies that results in slower growth." The head on this story reads "Lack of Mother's Touch 'Triggers Slow Growth'." You have to read the entire story to find out that the research was based on a study of rats.

While researchers such as Marian Lowe (1983) have raised fundamental questions about the legitimacy of such research, the studies are proliferating. As the crisis deepens, more and more "evidence" of children's need for their mothers and of sex differences in child-rearing capacities as well as in intellectual abilities may be presented, justifying both the segregation of women's work and their rising unemployment. A headline in *The Montreal Gazette* (May 9, 1984) reads "Pregnant women who stay on job may be risking harm to the unborn." While it turns out that one doctor has vaguely speculated that "It might be that this [working outside the home] leads to effects on the fetus as great as those to which doctors are paying so much attention," such media coverage clearly implies that women's bodies make them unfit for labour force work. Here, too, women have not been passively accepting the move to the right, but their strength will have to grow if they are successfully to resist the "scientific proofs" of their biologically determined roles.

Household Technology

Technology has been transforming work in the home for decades. New equipment and services have reduced but not eliminated women's work in the household, making it possible for one woman to do alone what it took many to do, or at least many more hours to do, in the past. Technological change in the market has helped employers remove many workers and much of the work from the household, transforming the people into wage labourers and the products of their labour into goods for exchange in the market. But the new technology may reverse the trend towards work outside the household while retaining the products of labour as goods for exchange and the people as wage labourers. It may fundamentally alter the nature and conditions of work in the home.

The future of work, the impact of the microelectronic technology and its relationship to the crisis are more fully discussed in the following chapters. What should be noted here are the specific changes that could affect women

HOUSEHOLD LABOUR

in the household. The Vanier Institute of the Family (1982:13-15) has compiled a list of the computer technology already available, or soon to be available, in the home. According to their account, information retrieval and electronic transaction terminals allow people to punch in for information on "current news, real estate prices, encyclopedic references, restaurant and travel information, community information and so on" and read it off their television set. The general purpose computer and the electronic transaction terminals can be programmed for individual purposes and can communicate with other computers. They can store information, edit, arrange, file and even correct written material, and control household appliances. Of course, they can be used for games, music and graphics as well. These machines are also able to communicate with an outside data base. Single purpose or dedicated logic units are designed to perform a single function such as monitoring sleeping children, washing machines, sewing machines, microwave ovens and heating systems. They can provide a security system, linking the household directly to fire, police and medical services.

With such technology, people can work, learn, play and order their food from home, never leaving to go to the bank for funds since the money can be electronically transferred. As C.C. Gotlieb (1978:Chapter 3) points out in his study of computers in the home, even the postman won't come there anymore. The machines could plan the menus and the shopping, watch the kids while they sleep, teach them and entertain them while they are awake and tell you when to put the roast in and when it is cooked. It thus has the potential of dramatically reducing women's work in the home. But it could also further deskill it, removing the more challenging part of the job, leaving women to load and unload the machines. Moreover, such technology would further isolate women in the home with the children. Fewer excursions would be necessary to do the household work and the contacts women have with others in the supermarket, at the bank and the butcher would disappear. As a result, stress, depression and tension would likely increase.

While the isolation would reduce the social control and social support provided by the community, it would not necessarily increase privacy. Indeed, there is some fear that computers will allow the careful monitoring of more and more human household activities, since the links work both ways and since records can be kept forever and readily retrieved by a wide range of people.

Although many people are now purchasing computers for their homes, they may well resist such a total invasion. The telephone that permitted a

view of the person at the other end has so far failed to sell. Whatever the extent of the transformation to the new technology, it is clear that there will still be work for women to do in the home, although it may well be much more tedious and isolated. Women and men both face high unemployment. Both experience the interpenetration of the formal economy and the household. But their different work and pay in both areas mean that the consequences are different for each sex. Women bear more of the burden of increasing domestic work and of handling the rising tension. They are much more often the victims of increasing violence during hard times, and they more often have to cope with its results. Their right to control their own bodies is threatened by state policies and a growing conservative ideology. The new technology may decrease their domestic workload but it may also deskill it without eliminating it. Moreover, women may well end up more isolated, and therefore more vulnerable and less able to fight back. In the household, too, women's position is deteriorating as the crisis continues.

NOTES

[1] See Statistics Canada, *The Labour Force Survey March 1983* (Cat. no. 71-001) (Ottawa: Supply and Services Canada, 1983), Table 43.

[2] *Ibid.*, pp. 144-45.

[3] See Statistics Canada, *Canadian Statistical Review October 1983* (Cat. no. 11-003E) (Ottawa: Supply and Services Canada, 1983).

[4] See Statistics Canada, *The Labour Force Survey March 1983, op. cit.*

[5] See Statistics Canada, *The Labour Force Survey May 1982* (Cat. no. 71-001). (Ottawa: Supply and Services Canada, 1983), p. 99.

[6] Calculated from Statistics Canada, *The Labour Force Survey December 1982* (Cat. no. 71-001) (Ottawa: Supply and Services Canada, 1983), Table 104.

[7] Calculated from *ibid.*, Table 95.

[8] In the *Canadian Statistical Review* (1983:6), Statistics Canada notes that the apparent growth in benefits may reflect changes in data processing on unemployment insurance benefits.

HOUSEHOLD LABOUR

[9] See Statistics Canada, *Statistical Report on the Operation of the Unemployment Insurance Act* (Cat. no. 73-001) (Ottawa: Supply and Services Canada, 1982), Table 13.

[10] See Statistics Canada, *Statistical Report on the Operation of the Unemployment Insurance Act* (Cat. no. 73-001) (Ottawa: Supply and Services Canada, 1983), Table 9.

[11] The Gallup Poll was printed in *The Montreal Gazette*, April 30, 1983.

[12] While over half the married women were in the labour force in 1982, only 46 percent had paid employment. Twelve percent of all married women, 26 percent of employed married women, had part-time jobs. Calculated from Statistics Canada, *The Labour Force, December 1982 op. cit.*, Tables 60 and 85.

[13] Calculated from Statistics Canada, *Consumer Prices and Indexes April-June 1982* (Cat. no. 62-010) (Ottawa: Supply and Services Canada, 1982), Table 8.

[14] See Statistics Canada, *Canadian Statistical Review op. cit.*, Section 10, Table 3.

[15] See Statistics Canada, *Consumer Prices and Price Indexes, op. cit.*, Table 8.

[16] Some data on homework has been collected by Johnson (1982) and Lipsig-Mummé (1983).

[17] Calculated from Statistics Canada, *The Labour Force Survey December 1980* (Cat. no. 71-001) (Ottawa: Supply and Services Canada, 1981), Table 65, and *The Labour Force Survey December 1982* (Cat. no. 71-001) (Ottawa: Supply and Services Canada, 1983), Table 65.

[18] See, for example, Doern (1981 and 1982), Hepworth (1982), Moscovitch (1982) and Shragge (1983).

[19] For evidence on these reductions, see Statistics Canada, *Hospital Annual Statistics February 1981* (Cat. no. 82-232) (Ottawa: Supply and Services Canada, 1981), Table 18.

[20] These programs are considered in detail in Statistics Canada, *Social Security. National Programs. Other Programs 1982* (Cat. no. 86-511) (Ottawa: Supply and Services Canada, 1983), 11.

[21] For substantiation of this argument, see Armstrong (1980).

[22] Statistics Canada, *Vital Statistics Vol. 1 Births and Deaths* (Cat. no. 84-203) (Ottawa: Supply and Services Canada, 1982), Table 1, clearly indicates this lack of growth.

[23] This increase is documented in *ibid*.

[24] Statistics Canada, *The Labour Force May 1982* (Cat. no. 71-001) (Ottawa: Supply and Services Canada, 1982), p. 86.

[25] For a critique of sociobiology, see Lowe (1983).

CHAPTER SIX

STATE PROGRAMS, VOLUNTEER WORK AND PART-TIME JOBS

For most of us, microelectronic technology in the household means video games or perhaps some of the more exotic applications, discussed in the previous chapter, that may some day be available. We forget about the digital watch on our wrist, the tiny calculator in our pocket, the clock radio beside our bed or the microwave oven in our kitchen. The new technology is not some future possibility. It is part of our lives today.

This new technology is an integral part of the formal economy and of the current hard times. It is a cause, an effect and a solution to the crisis. It has already begun to transform work, to eliminate jobs and to alter the labour process. Although this transformation is well underway, the consequences will become much more obvious when the new equipment is fully in place.

As a major part of its strategy to fight the current economic difficulties, the state has been actively promoting the further development and application of this microtechnology. At the same time, the state is reducing expenditures on social programs, leaving more and more of the service work in the formal economy to be done by unpaid volunteers or low-paid part-time employees, most of whom are women. It has, however, tried to offset what are defined as the short-term consequences of the transition by developing job creation programs, most of which benefit men.

This chapter examines the consequences of these state programs, of volunteer work and of part-time jobs for the future of women's work. The next looks at the probable impact of the new technology. There were

STATE PROGRAMS, VOLUNTEER WORK & PART-TIME JOBS

200,000 fewer full-time jobs in 1982 than there were in 1980 and the trend is likely to continue, especially for women. The segregation that has provided some insulation for women in the past is likely to lead to greater vulnerability in the future. Both government restraint programs and the new technology will hit women's work first and hardest. Not only will jobs for women decline but so will their union membership and with it, their ability to resist. The future is not predetermined by the technology, by the goverment or by employers, both because people organize to resist and because contradictions arise as each group pursues its interests. But predictions are possible given that the interests of employers usually prevail, that the technology has been developed largely by and for them and that women's strength is limited by their double workload and a patriarchal ideology. Such predictions, as depressing as they may be, can provide the basis for collective strategies designed to alter these powerful trends.

Government Job Creation and Job Retraining Programs

The federal government's approach to the future of work is reflected in its studies of employment and in its programs for job creation. In both areas, "prime age males" are the focus of concern and what is considered "normal unemployment" or the "equilibrium rate of unemployment" bears little relation to the full employment goal of the government's 1945 *White Paper on Employment and Income* (Canada, Minister of Reconstruction). Women are not ignored in these studies and programs but, lumped together with other "special problem groups" such as the handicapped, youth and Native Canadians, they take a distinct second place to that other minority group, prime-age males. Moreover, while the government has become deeply involved in job creation programs, a policy which itself indicates that the problem is jobs not people, it remains convinced that it should provide only some stimulating support to that real job creator – the private sector – and that the problem, especially for women, is one not of demand deficiencies or job shortages but of limited skills and training.

This approach is evident in two state reports, produced when the crisis was well underway, on the future of work. *The Task Force on Labour Market Development* (the Dodge Report), prepared for the Minister of Employment and Immigration, begins by rejecting the "single-minded pursuit of a goal of low unemployment" and argues that attention must instead be focused on "policies designed to improve the functioning of the labour market" (Employment and Immigration Canada, 1981:7). Translated, this means

that increasingly high levels of unemployment are acceptable and that policies should be directed towards labour market forecasting and retraining, towards people rather than jobs. The Report recognizes that workers come in two sexes, but it sees this as a major part of the problem.

> Although there is little direct evidence, it is reasonable to infer that the rising relative unemployment rates of youth and adult women in the past fifteen years have been related to the ability of the economy to absorb the extraordinarily large numbers of new entrants and reentrants to the labour market with limited experience and, in many cases, with limited training. Moreover, hiring practices and procedures may have further restricted job opportunities to a narrow range of occupations (Employment and Immigration Canada, 1981:11).

Too many women, and too many women with too little training, are seen as a major factor in rising unemployment rates. The growing demand for workers in the traditional female job ghettos and women's increasing need for income receives little attention. While the *Report* argues that women, like Native Peoples, the disabled, youths and older workers "encounter barriers to both entry and progression" (Employment and Immigration Canada, 1981:4) and that "the traditional approach has neglected to deal adequately with problems internal to social and labour market structures" (Employment and Immigration Canada, 1981:92), it still emphasizes retraining, counselling and employer wage subsidies. Affirmative action programs and family support policies are also suggested but wage inequality, the advantage to employers of a segregated market and the future consequences of this segregation for women's employment receive little attention.

The Parliamentary Task Force on Employment Opportunities for the '80s or Allmand Report (Canada, House of Commons, n.d. [1981]) also stresses lack of skills and assumes a basic labour force made up of prime-age males. Women are considered with other special needs groups who would benefit from government encouragement of affirmative action in the private sector and from policies that require firms getting government contracts to make efforts to hire certain numbers of women. A national advertising program showing women working in non-traditional fields, retraining for women who face unemployment as a result of the new technology and work sharing as well as more part-time work are recommended.

Both reports argue that women should receive special treatment to make their opportunities more equal to those of men, but both attribute rising unemployment rates primarily to women's "decision" to enter the labour force and women's unemployment and segregation to their lack of skills.

STATE PROGRAMS, VOLUNTEER WORK & PART-TIME JOBS

Neither report produces any evidence to demonstrate that women lack the training or that growth in the female labour force created unemployment, perhaps because there is little evidence to support the case. There is no direct relationship between rising participation rates and rising unemployment rates (Table 3.5). Labour force growth does not necessarily create unemployment. Indeed, it may reflect job growth and thus be associated with falling unemployment. Nor does an end to the growth necessarily mean that unemployment will fall. Between 1981 and 1982, the female labour force participation rate remained constant but the unemployment rates for both women and men rose sharply. During the same period, male participation rates continued to decline (Table 3.5). Moreover, "women are on average better educated than their male counterparts" (Armstrong and Armstrong, 1983b:23). Of the population fifteen years of age and over in 1983, 1,150,000 females, compared to 915,000 males, had a post-secondary certificate or diploma. This is the education level that is assumed to provide the best preparation for the labour market. Another 803,000 women and 834,000 men had some post-secondary education. In addition, more women (4,995,000) than men (4,487,000) had completed high school. It is true that more men (1,045,000) than women (743,000) had a university degree but that difference alone could hardly be credited with accounting for the segregated market. The evidence also suggests that many women work at jobs that are significantly below their skill levels (Armstrong and Armstrong, 1983:150-159). Although the problems are jobs and segregation, the solutions offered emphasize changing the workers and view the labour force as either sexless or basically male.

These approaches have been translated into government job creation programs that are primarily directed towards providing short-term jobs in the private sector for males in their prime and towards retraining programs for jobs that may never appear. In an information bulletin released in February 1983, Employment and Immigration Canada listed eleven job creation programs, three of the four largest directed towards increasing employment in industrial sectors dominated by men. With $500 million in federal funding, the largest program (New Employment Expansion and Development, or NEED) is designed to create productive employment for people who have exhausted their unemployment insurance or who are on social assistance. While these criteria seem unbiased in terms of sex, the list of possible projects does not. According to the government advertising, eligible activities include "construction of small craft harbours or fisheries facilities, parks

improvement, reforestation, modernization of production plants, improvement or adaption of facilities for the handicapped and tourism development" (Employment and Immigration Canada, 1983a:1). It is men who work in these areas and therefore they are most likely to benefit from the programs. Moreover, since men are more likely to be considered eligible for and to collect unemployment insurance, there are more male exhaustees to qualify for this program (Armstrong and Armstrong, 1983b:103-108).

The second largest job creation program (Canada Community Development Projects or CCDP) is intended to "contribute to, maintain or increase" jobs in areas for groups "suffering continuing high unemployment." The guidelines call for support of affirmative action principles but the projects listed as eligible are the "development of solar energy equipment, construction of wharves and the restoration and development of recreation facilities" (Employment and Immigration Canada, 1983a:1), once again areas traditionally dominated by men. Government estimates of female participation in these programs range from 32 percent to 27 percent, considerably below the female percentage of the unemployed or of the labour force.[1]

In the Summer Canada program women had a better chance of competing with men for jobs in "the provision of tourism information, the compilation of a home restoration handbook, working with physically handicapped children or the operation of a mobile vision clinic" (Employment and Immigration Canada, 1983a:2). Indeed, the government estimates that women constituted 60 percent of the participants in 1981-82.[2] However, this program involves short-term jobs for summer students rather than longer-term employment programs or even relief from unemployment in general.

The fourth largest program is the UI/Job Creation scheme, which is designed to channel $170 million in unemployment insurance funds and $40 million from Consolidated Revenue into job maintenance during 1982-83. Participants have their normal unemployment benefits supplemented when they voluntarily work on approved projects. Once again, not an obviously discriminatory program, but with projects primarily in forestry, fishing, agriculture and tourism, few women are likely to benefit. Little information is available on the sex of recipients in most programs but according to a study (Employment and Immigration Canada, 1983b:4) of the work-sharing scheme that falls under UI/Job Creation, "Work Sharing mainly affects prime age workers" and "about two-thirds of the employee-participants have been male." Yet, unlike the other two employment programs discussed above, 70 percent of the Work Sharing agreements were

STATE PROGRAMS, VOLUNTEER WORK & PART-TIME JOBS

concentrated in the manufacturing sector (Employment and Immigration Canada, 1983b:3), where large numbers of women work and where even larger numbers are unemployed. If women cannot acquire a fair share of the jobs created here, they are likely to get very few of those created in agriculture, fishing, forestry and construction.

It could be argued that several of the other job creation programs are directed specifically towards women and other disadvantaged groups. However, when *all* the money set aside for the Local Employment Assistance Program (LEAP), the Program for the Employment of the Disadvantaged (PED), the Canada Community Services Program (CCSP), the Community Employment Program (CEP), the Portable Wage Subsidy (PWS), the New Technology Employment Program (NTEP), and the Local Economic Development Assistance (LEDA) is added together, it amounts to only *about half* of what is to be spent on NEED alone. Moreover, considering that these funds have to be shared with older men, with youth, with the handicapped, with Native Canadians and with corporations, it seems unlikely that women will reap the majority of the benefits in terms of jobs. In her article on job creation programs, Bronwyn Chester (1983:36) maintains that "This year, however, women have not been a target group for the CCDP, although EIC is purportedly aiming for 34 per cent female participation." She goes on to point out that the Local Employment Assistance Program, which has provided long-term training programs and job creation for women in the past, has had its budget frozen for the next three years. This leaves, she claims, only the poorly funded Canada Community Services Program favouring women.

In late 1983, the government announced a restirring of the alphabet soup of government job creation programs, "representing a consolidation and reinforcement of a number of earlier initiatives." The new strategy set out two priorities: "the creation of jobs for those in immediate need, and the development of a work force trained and ready to meet the challenges of a new age of technology." Four major programs are to have special emphasis on "helping the nation's youth, disabled persons, Native Canadians and women entering or reentering the labour force" (Employment and Immigration Canada, 1983c).

The examples given for projects that fall under the largest program, Canada Works (with a 1983-84 budget of $865.2 million) include a construction project for improving McNab's Island in Halifax harbour as a tourist attraction; a salvage operation in Quebec involving the restoration and

rehabilitation of land damaged by a budworm epidemic; and a salmon enhancement project on a river in New Brunswick. None of these projects is likely to involve a high proportion of women and there is little indication that steps have been taken to ensure them equal access. The second largest program has approximately a quarter of the funding going to Canada Works. This Local Employment Assistance and Development program (LEAD) provides support to hard-hit communities through established community groups or organizations. Examples of eligible groups include Boards of Trade, Chambers of Commerce, Indian Band Councils and economic development associations. Eligible projects include the expansion of a body shop and mobile tire repair service, a fishing tackle manufacturing operation, a pet shop, a furniture manufacturing company, and an aluminum repair shop. While not explicitly excluded, women are unlikely to benefit proportionately from these types of projects. They certainly do not feature prominently in the eligible groups. Moreover, their unemployment is less concentrated than that of men in specific communities. The other two programs have less than $30 million in funding and are designed to provide skills and motivation for the employment disadvantaged. The Jobs Corps program appears to be primarily directed towards those with physical and mental handicaps, although those with inadequate training or other disadvantages are also to be included. The larger of the two programs, Career-Access, seems to be mainly planned for youth and the elderly. People who are returning to the labour force after a long absence are, however, also included. Women may fare better under these two schemes but it is difficult to see how they will increase women's employment opportunities. Even if women do benefit in large numbers from the retraining schemes, it is uncertain that these new skills will get them jobs. In traditionally male areas, they will be competing with the large numbers of experienced but unemployed males. In traditionally female areas, they will compete with large numbers of women who already have the required skills.

When the problem is jobs rather than people, solutions directed towards changing the people do little to alter the situation. Although they represent nearly half of the labour force, women still are lumped with the handicapped, the Native Canadians, the youth and the elderly. Only a small minority of the labour force remains, but it is effectively the target for most of the job creation programs. As Employment and Immigration Canada (n.d.[1983]) explains in its response to the National Action Committee's critique of the policy,

It is true that CANADA WORKS is getting much emphasis right now and many activities tend to be more "male" oriented, but the objective of the program is to deal with cyclical unemployment, *not* to deal with or redress imbalances suffered by females.

The government has been responding to the crisis by establishing research projects and job creation schemes. Most of these have focused on the problems of "prime age males." Not overtly discriminatory – indeed the new schemes select women as a target group – they nevertheless concentrate on the areas of large and growing male unemployment. Continued segregation means that women will probably be further disadvantaged, especially as the crisis deepens.

Restraint Programs

On the one hand, the state is responding to the crisis by creating employment, primarily for men. On the other, it is introducing restraint programs, which mainly affect women. Because of the sexual division of labour, wage freeze policies, as well as cutbacks in government jobs and services, hurt women more than men. These policies are only now beginning to take effect and have not begun to show up in the published data but there is strong evidence to suggest that they will do so in the near future.

Although there has been some controversy surrounding the size of the pay gap between women and men and the reasons for the differences in their employment income, there has been little debate about the existence of significantly different male and female wages. In 1981, half of women with paid jobs earned less than $6 an hour. This was the case for fewer than a third of paid male workers.[3] At the other end of the scale, women accounted for less than 30 percent of those earning more than $18 an hour. Since women, on the average, continue to earn less than men, government wage restraint programs which limit increases to 6 and 5 percent ensure that the unequal pay (and fringe benefits) are reinforced, not challenged. As the Social Planning Council of Metropolitan Toronto (1982:9) points out,

> Wage restraint is a program to freeze the existing distribution of incomes in society. This program is reinforced by policies that: keep interest rates high; stagnate economic development; and reduce public goods, services and transfer incomes going to Canadians by way of government expenditure restraint.

It is true that most of the restraint legislation does include provision for special treatment for high and low earners. In Ontario, for instance, the

Explanatory Note to Bill 179 (2nd Session, 32nd Legislature, Toronto, 1982) says that

> 'Merit increases or other increments are restricted to the extent that they would put a person's salary over $35,000 a year, but low income earners may benefit from a provision which allows full-time employees to receive an increase of up to $1000 (if normal increase provided in the Bill would be smaller). Part-time workers may receive a similar increase on a pro-rated basis.

Such provisions are possible but not required, and will do little for those earning slightly more than what is defined as low income. A decision of the Ontario Inflation Restraint Board has shed more light on the effectiveness of such provisions for women workers. In late 1983, it ordered seventy-three of Ontario's lowest-paid hospital workers, most of whom are women and all of whom make less than $18,000 a year, to pay back up to $1000 each. In arbitration, they had been awarded an 11 percent increase, which exceeded the general provincial limit but which would only bring them up to the lowest rates paid in other hospitals. Responding to union claims that this decision indicated discrimination against women, Ontario Treasurer Larry Grossman said that the workers may be able to avoid the rollbacks. However, they can keep their raises "only if other workers settle for less than five percent this year — or if Sesenbrenner Hospital can supply the funds from other cutbacks" (Diebel, 1983:42). Since most of these other workers are women, the lowest-paid women can only increase their wages if other women are willing to do without. Such policies can do little to narrow the gap between male and female wages. In addition, there is evidence to indicate (Diebel, 1983:43) that the highest-paid workers, most of whom are men, have been receiving much more than a 6 or 5 percent increase.

Almost twice as many women as men work in jobs covered by government wage policies. In Quebec, the figures are even more startling. Two-thirds of the workers in the public sector are female and most of these workers saw their salaries cut temporarily by 20 percent and then frozen until 1984. In the federal civil service, women accounted for 65.6 percent of those earning less than $20,000 a year in 1982 and 68.6 percent of those in that salary group in 1983. Meanwhile, the female proportion of those earning $60,000 and over declined (Public Service Commission of Canada, 1984:62). Government wage restraint programs primarily affect women and reinforce if not increase the gap between male and female wages.

Women face not only falling real wages but also loss of jobs. Between 1980 and 1982, over three-quarters of the net gain in jobs for women was in

education, health and public administration, in government-funded work. If provincial and federal government restraint programs are effective, jobs in these sectors will be reduced. In fact, this has already started, at least at the provincial and municipal levels and among school boards and hospitals. Since women are the majority of the workers here, especially of the new workers, most of those losing their jobs will be women. In the federal civil service, two-thirds of all the public servants laid off in 1983 were women (Public Service Commission, 1984). In Quebec it is estimated that approximately 10,000 teaching jobs at the elementary, secondary and CEGEP levels will be eliminated as a direct result of government-imposed decrees. There were only 21,000 more teaching jobs throughout Canada in 1982 than in 1980. Thus, the Quebec reduction alone will wipe out almost half of that gain and it is clear that most of the loss will be borne by women.

Similar patterns are evident in British Columbia where the government plans to lay off a quarter of the public servants. While the government's promise to respect most seniority rights will restore some sense of security and independence to those who will retain their jobs, it will not alter the fact that women, as the most recent entrants, will bear the brunt of the job loss. Moreover, the elimination of child-abuse teams, of family service workers, of consumer counselling and of community health groups primarily affects women, who constitute most of both the workers and the clients in these areas. In addition, the decision to abolish the Human Rights Commission may also be seen as a direct attack on women since it is mainly women who have sought recourse from discrimination and harassment through this agency. The elimination of the Employment Standards Board could also have a profound effect on women's paid work. Our research (Armstrong and Armstrong, 1983) indicates that minimum standards mainly determine the conditions of work for women. If these minimum standards are no longer enforced, as Bill 26 intends, then even those women who keep their jobs will have little protection from any arbitrary action. The Bill is so sweeping it may permit employers to fire non-union employees who get pregnant.

State cutbacks further limit women's ability to resist through union activity. While women's union membership was still growing in 1981, the last year for which figures are available, the layoffs in the state sector will probably bring this growth to a sudden halt. In 1981, the majority of women who belonged to unions were paid directly by the governments. Thirteen of the eighteen labour organizations reporting 15,000 or more members in 1981 were public sector unions,[4] and they accounted for almost

50 percent of all unionized women. If governments proceed with cutbacks of up to 25 percent of public sector workers, women's union membership will sharply decline.

Governments have already significantly reduced the power of these unions, removing their collective bargaining rights by imposing contracts and decrees. Wage restraint programs have also limited their bargaining rights. In Quebec, the Liberal party platform explicitly states that it intends to remove the right to strike from many public sector unions. Women's union membership has never been very high in the trade, finance and private service sectors (White, 1980). If their strength in the public sector is reduced, then their ability to fight for their rights will be severely limited.

It should not be assumed, however, that the future is predetermined by government policy. Female-dominated unions in Quebec and British Columbia have been resisting despite enormous odds. In British Columbia, the Solidarity Coalition and Women Against the Budget have united a wide range of women's groups and community organizations in which women are prominent. They have raised a variety of social concerns in addition to the right to collective bargaining, seniority clauses and decent wages. The organizational skills and politicization they have developed will not quickly disappear.

What has primarily prevented women's employment situation from deteriorating as rapidly and as obviously as that of men has been direct and indirect employment by governments. As governments cut wages and jobs, women will suffer more. What has helped prevent women from facing worse conditions of work are the minimum employment standards and the human rights commissions. Without them, women will be much more vulnerable. Women have found their best pay, their best jobs and their most rapid promotions in the public sector. Losses here mean more than rising female unemployment. They also mean that women's position relative to men will deteriorate.

Volunteer Work

Restraint programs have also meant that, as hospitals, schools and social service centres cut back on expenses, more and more of the work is done by volunteer workers. As Oli Hawrylyshyn (1978:76-77) points out in his study of volunteer activity, there is "very little hard data on agencies, volunteers, their tasks and their time input." Statistics Canada conducted a

comprehensive survey of volunteer activity in 1980, but there are no comparable data available for later years. However, it is clear from the data available that women do most of the work in the areas where government services have been cut back and in the areas where the work could and probably should be done by paid workers.

Hawrylyshyn (1978:71) defines economic volunteer services as "those activities which were done by a person outside the market but may have been accomplished by hiring a third-person from the economic market." Included in this group are health and rehabilitation, welfare and social services, education agencies and correctional service agencies. In 1980, more than 63 percent of the volunteer workers in the health, education, and social welfare fields were women.[5] Over a quarter of these women worked more than a hundred hours a year. By contrast, the number of men working these hours in health and education were too small to make the statistics reliable.[6]

According to Hawrylyshyn (1978:73) the most common types of work performed by volunteers are supervision, friendly visiting, parole counselling, child care, clerical work and driving people to services. Sixty percent of volunteers do this kind of work and it accounts for 58 percent of volunteer time. A typical advertisement of the Montreal volunteer bureau includes the following requests:

> Urgently needed – 19 to 15 female volunteers able to converse in French, to assist in the nurse's office of a large co-educational institution in the North Shore area. Any necessary training will be provided. The ability to relate to 12 to 18 year olds is a necessity. The work carries a commitment of half a day per week over the school year.

> A school for handicapped children in Ville St. Laurent needs volunteers every Tuesday from 9:30 to noon helping pupils aged 6 to 13 with their various activities. If you are patient and love children this would be a rewarding way to spend a morning a week (*The Montreal Gazette*, September 21, 1983:E9).

Clearly these are primarily women's jobs – jobs that require some training and skill – jobs that, under other circumstances, would be paid. The work still must be done. As the state ceases to pay women to do the work, women do it on a volunteer basis because they recognize the inadequacy of the services, because they cannot find paid work, because they want to keep up their skills and their sanity while unemployed. That the government recognizes this and has no desire to interrupt the trend is evident in the regulations for the NEED program, which state explicitly that the funds cannot be used for

work currently done by a volunteer. The estimated value of volunteer work was $2.0 billion a year in 1980, or 1.3 percent of all wages and salaries (Ross, 1983:ii). Hiring such workers would go a long way towards decreasing women's unemployment. Instead, the trend seems to be towards increasing reliance on unpaid work, particularly of women. And, in performing this volunteer work, women may be ensuring that paid jobs will not appear in these areas.

Men will also feel the impact of government restraint policies. And it is difficult to tell just how many women will lose their jobs as a result of these programs. However, the evidence suggests that women will be hurt more than men.

Part-Time Work

The steady increase in the number of women employed part-time and the reduction in hours for those already working part-time, is documented in Chapter 4. There is every indication that this trend will continue as employers seek to save money, during crises and good times, by paying people to work short hours without breaks or benefits, and as work becomes more readily learned and workers thus more easily replaced. Moreover, the new technology will make it easier and cheaper to calculate pay, select workers and keep other necessary records, all factors which in the past have added to the cost of employing more workers for fewer hours or on a less regular basis. In addition, as employers invest more capital in the new technology, and as this new technology makes it simple and profitable to work more hours a day or around the clock, more of the work may become part-time and more of it will be done in shifts.

The Allmand Report (Canada, House of Commons, n.d.[1981]) and the two recent studies – one written by Julie White (1983) for the Canadian Advisory Council on the Status of Women and the other, the Wallace Report, produced by the Commission of Inquiry into Part-time Work (1983b) – all recommend that more part-time jobs be made available for women. The White and Wallace studies both demonstrate the steady increase in part-time work. Indeed, the Wallace Commission (Labour Canada, 1983b:21) points out that the numbers actually working part-time were far larger than the data based on averages suggest. While an average of 1.5 million people worked part-time during 1981, more than 2.4 million

people worked part-time at some period in that year and there were 2.7 million part-time jobs filled. Both studies document the low pay, limited fringe benefits, unionization and possibilities for promotion as well as the segregation found in most part-time work. And they both recommend that part-time workers be treated more equitably by pro-rating their pay, pensions and fringe benefits to those of full-time workers.

While there can be little argument with the call for more equitable treatment, the call for more part-time work should be challenged. The fundamental problem with these approaches is revealed in the struggle to find a definition for part-time work. It is difficult to define, not only because it exists in such great variety, but because there is no necessary length to the working day, week or year. These discussions assume that part-time work is different from full-time work, that it should be distinguished from full-time work, that some workers should continue to work full-time, and others to work part-time. And, perhaps more importantly, that some workers should receive less pay, fewer fringe benefits and less seniority, even if they are rewarded on a pro-rated basis. However, the problem is not so much shorter hours as it is lower pay and fewer benefits. Instead of recommending more part-time work for some, they should be recommending shorter hours but adequate pay and fringe benefits for everyone.

The evidence produced by the Wallace Commission suggests that shorter hours for everyone would go a long way to solving the problem of rising unemployment, unequal workloads for women and men and the disadvantages faced by many other groups. Included in the section on the advantages of part-time work (Labour Canada, 1983b:33-34) are the following: "women's concern for maintaining career interests and job skills while they raise a family," "the emerging awareness that men should have the opportunity to devote some of their time and energy to childrearing, housekeeping and other interests," the family's need for more than one income, the desire and necessity of the elderly, students and the handicapped for wages, the lack of jobs for the unemployed and the reduction of fatigue and stress. All these factors could be used more convincingly to argue for shorter work hours for everyone. According to a recent Gallup Poll, 69 percent of Canadians would approve of a shorter work week designed to spread the work around and help reduce unemployment. However, 68 percent said they would be unwilling to accept lower wages (reported in the *The Montreal Gazette*, Thursday, September 22, 1983:A-8). As the last chapter made clear, many could not, regardless of willingness, survive on reduced wages. Moreover, it

is clear from previous chapters that most of those working part-time are and would be women, that there has been little change in the division of household labour, and that the separation of part-time from full-time work perpetuates the difference between women and men in and out of the labour force. To support the expansion of part-time work, under any conditions, is to support the continuation of segregation, of unemployment, of unequal incomes and of a double day for women.

It should be noted that White directly challenges this position in her study. She presents two basic arguments to support her perspective. First, she contends that "changes in the labour market have no necessary relationship to the socially determined role of women" (White, 1983:22) because shorter hours for men in the labour force or longer hours for women in the labour force have not produced a significant alteration in the household division of labour. While few still argue that a new division of labour has appeared along with women's movement into the labour force, their lower wages, their shorter hours and their interrupted participation patterns reinforce their responsibility for domestic work. Removing some of these barriers would not automatically and instantaneously create a new equality but retaining them will prevent the development of a more equitable division of labour. Women working shorter hours than men will still have less pay and more hours to devote to domestic work. Part-time work is clearly not the only or even the major factor in women's inequality, but it is a factor. It may not be an original cause, but it certainly helps perpetuate the differences in women and men's work.

White's second argument concerns the hours worked by part-time workers. "It is not apparent that even much shorter full-time hours would meet the needs of those who presently work part-time" (White, 1983:23), she contends, because the average employment for part-time workers is fifteen hours a week. Such an argument assumes, like many government reports, that it is the people rather than the jobs that are the major factor in determining these hours. Yet White also shows how women's domestic responsibilities restrict the time and energy they have available to spend in the labour market and how the conditions of work discourage longer-term involvement. Such evidence suggests that the hours are at least as much related to the work in and out of the home as they are to the preferences or choices of the women. Moreover, the thirty-hour week she uses as a yardstick has no magic quality. Shorter hours could be considerably less. To argue that shorter hours

would not be a solution because the average part-time worker is employed for fifteen hours does not support her claim.

The Wallace Commission has a slightly different reason for supporting more part-time work. Having asked respondents how many additional hours per month they would prefer to work for the same employer, the Commission found that in 73 percent of the part-time jobs, additional hours were not preferred. From this, they concluded that "underemployment could not be substantiated for the majority of part-time job holders" (Labour Canada, 1983b:22). Leaving aside the issue of whether or not underemployment relates solely to preferred hours of work, the argument is flawed because the question of the conditions under which more hours would be desired is never raised. In other words, it assumes free choice and does not explore the factors involved in this preference. More than a quarter of the women aged twenty-five to fifty-four said they worked part-time because of family responsibilities; another 15 percent said they could only find part-time work (Labour Canada, 1983b:199). It cannot be assumed that the preferences of these women were not predetermined by structural constraints. Furthermore, many of the women who said they did not want full-time work may not want the work because the conditions of their jobs make the prospect of full-time work undesirable. With this kind of evidence, it is difficult to establish the absence of underemployment. It should also be noted that the Wallace Commission's argument is weakened by the fact that full-time workers were not asked if they would like shorter or even fifteen-hour weeks. It may be the case that the majority of all workers in these kinds of jobs would like to spend very few hours at their paid work.

Whether or not women prefer more part-time work, given their current circumstances, it is clear that they will get it. However, the evidence collected in Chapter Four suggests that their share of even this work may decrease, as more men compete for the part-time work that is available. Indeed, requirements for better wages and benefits in part-time work may reduce the number of such jobs available and make them more attractive to men, in the process reversing the intent of providing improved part-time jobs for women. If the recommendations of these two studies are implemented, the women doing the part-time work would at least face better conditions. But as long as there is part-time work and as long as that work is primarily female, there will be large inequalities among workers and between women and men.

NOTES

[1] Taken from unpublished Employment and Immigration Canada statistics.

[2] *Ibid.*

[3] Calculated from unpublished Statistics Canada Labour Force data.

[4] Data on union membership can be found in the *Corporations and Labour Unions Returns Act* (Ottawa: Statistics Canada, 1983:44).

[5] Calculated from Statistics Canada, *An Overview of Volunteer Workers in Canada. February 1980* (Ottawa: Supply and Services Canada, 1981: Table 19).

[6] *Ibid.*

CHAPTER SEVEN

MICROELECTRONICS IN THE WORKPLACE

As THE ECONOMIC COUNCIL of Canada (1983:15) points out in a recent report on productivity and future growth, "Technical change includes new processes, technniques, products, and ways of organizing productive activities and it is pervasive across all industries." It is also a never-ending process integral to capital accumulation. Technical change, both in equipment and in the organization of work, was largely responsible for the steady growth in productivity and the long boom following the war. And to a large extent, it is the cause, effect and solution to the current economic crisis.

Technological change has contributed to the increasing competitiveness of foreign manufacturers as well as to the declining sales and jobs of some domestic industries. By increasing productivity in the printing industry for instance, technical change has eliminated jobs while retaining profits. By making possible the international division of labour in such areas as clothing manufacturing and the production of the microchip, it has exported other jobs to foreign countries. At the same time, it is largely responsible for the growth of profits and jobs in such sectors as business services. Technical change has thus been, and continues to be, a major factor in the combined and uneven development of industries and occupations discussed in previous chapters.

Central to the latest technical change is the microchip – a tiny, cheap, relatively sturdy piece of silicon that contains complete electronic circuits

and that can do what a large, fragile, expensive and therefore limited mainframe computer did in the past. As Margaret Lowe Benston (1983:46) points out in an article on the development of microtechnology, "The introduction of electronic data processing equipment has been continuous since the first commercial computers appeared in the early 1950's." What leads researchers like Heather Menzies (1982:viii) to claim that "We are living through a second industrial revolution, propelled and shaped by the computer," however, is not that the chip can do so much more than the computer – itself a sophisticated version of the adding machine – but that the chip allows the dispersion and application of computer processes to an incredible range of tasks, at a price and in a form that many can afford and understand. Stephen Peitchinis, an economist who has examined many aspects of the new technology (1980:02), explains that "Unlike mechanical technology, which was not appropriate for the production of many services, electronic technology has widespread application." Moreover, the dispersion and transformation of this technology is happening at a rate unknown in history.

Although there is little agreement on what the precise consequences of this new technology are and will be for women's and men's work, there is little disagreement about the enormous impact on the processes, techniques, products and ways of organizing productive activities in the labour force. This chapter explores these consequences for women's and men's paid work.

In his book on the human / technology relationship, *Architect or Bee?*, development engineer Mike Cooley (1980:10) outlines a common view of microtechnology's future:

> There is still a widespread belief that automation, computerization and the use of robotic devices will free human beings from soul destroying, routine, backbreaking tasks and leave them free to engage in more creative work. It is further suggested that this is automatically going to lead to a shorter working week, longer holidays and more leisure time – that in an all round way it is going to result in 'an improvement in the quality of life.' It is usually added, as a sort of occupational bonus, that the masses of data that we will have available to us from computers will make our decisions so much more creative, scientific and logical, and that as a result we will have a more rational form of society.

Cooley goes on to challenge these assumptions about the consequences of this new technology and his scepticism is shared by a growing number of people. Indeed, when the Labour Canada Task Force on Microelectronics and Employment solicited the opinions of various Canadian organizations on this

issue, it found a clear polarity in views. According to the Task Force's report, *In the Chips: Opportunities, People, Partnerships:*

> Almost exclusively, the employer groups – Employers' Council of British Columbia, British Columbia Telephone, Canadian Manufacturers' Association (CMA), Bell Canada, Canadian Pacific and the Canadian Bankers' Association – considered that "while there are undoubtedly some ill side-effects of the revolution, it must be realized that some short-term ill effects are more than offset by long-term benefits." More specifically the prevailing view was along the lines that "we would rather examine the ways and means of making Canadian industry more competitive, instead of dealing with ghosts and shadows of alleged problems that might exist at some future time." Their presentations usually concluded that to this point there have been no massive disruptions in the existing labour force caused by the introduction of micro-electronic technology.
>
> On the other hand, union spokespersons – Communications Workers' of Canada, CUPE, National Union of Provincial Government Employees, Alberta Federation of Labour and United Steel Workers of America in particular – returned constantly to the general theme that "if we do not provide our members with an awareness and tools needed to deal with this challenge effectively, we will surely be beaten by this looming threat to our employment, income and way of life." Targeted jobs, particularly in communications were stressed, and lists and tables of employment effects, both potential and already happening, were noted frequently (Labour Canada, 1982:36).

These opposing views are not surprising, given the interests of both groups. Nor are they inconsistent with the same outcome. The drive to accumulate pushes employers to raise productivity and to lower costs, particularly labour costs, to increase control over the labour process and thus over workers. Microtechnology enhances their ability to do all these things. It also, as the employees' unions maintain, results in job loss and reduced control for workers. As the scenario outlined by Cooley suggests, the new technology does open up a wide range of possibilities. And as the employers suggest, many of these possibilities remain unknown. There are choices to be made, as the employees point out. The technology is not independent or determining. But neither is it neutral, as the Task Force seems to argue (Labour Canada, 1982:5).

Technology must be understood as a social process, one that is shaped by the political economy. The choices, the problems, the applications, the very commitment to and definition of science and technology, are made within the context of a capitalist society and reflect the larger social forces in that

society. "As we design technological systems, we are in fact designing sets of social relationships" (Cooley, 1980:100), relationships, it should be added, that are divided by sex as well as by class. The particular technologies that have been developed were primarily shaped by the interests of capital, and their future development and application are likely to continue to reflect these interests.

Behind the new processes, techniques, products and ways of organizing productive activities is the drive to accumulate. The purpose is not exclusively technical efficiency. As Braverman (1974), Edwards (1979) and Marglin (1976) all demonstrate, the new technology is also designed to control the labour process and the worker. It allows the extension of scientific management techniques to the office, where work has been growing but productivity has not, where mental rather than manual work has been a large component of the labour done and where skills as well as the difficulty of measuring tasks have given the workers some degree of control over their work. It allows the separation of much of the work into repeatable, easy-to-learn tasks that take decisions and skills out of workers' hands. It also allows the quantification of work, so that performance can be easily measured, and enables the employer rather than the employee to control the speed of the work. In his article on microelectronics, Mike Duncan (1981:194) includes a quote by the joint managing director of Olivetti that clearly outlines management's interests in developing this technology.

> The problems which are usually associated with office automation make up the final chapter of a story which began with the industrial revolution, that is, with the supreme assertion of capitalist production over all preceding types of production and over all those that still exist today.... Information technology is basically a technology of co-ordination and control of the labour force, the white collar workers, which Taylorian organization does not cover.

In the words of a General Motors pyschologist, "The computer may be to middle management what the assembly line is to the hourly worker" (quoted in Cooley, 1981:51). The application of the computer is not limited to office work, however. According to Peitchinis (1980:16), "There prevails a general view in industry that within the next decade manufacturing processes will become as computerized as are information processes today." It is unlikely that the scenario outlined by Cooley will prevail under these conditions. The long-term benefits are likely to be increasing profits for employers, the short-term ill effects likely to be unemployment and loss of control for workers.

MICROELECTRONICS IN THE WORKPLACE

But the consequences of the new technology or even its development are not solely determined by the interests of capital. The new technology was developed in response not only to the growth in paperwork and workers, to the falling profits linked with these areas and to the developing recession but also to the increasing strength of unions and the demands of the women's movement. The process is dialectical, with the interests of these groups clashing and with contradictory results for each growing out of their pursuit of their interests. Technology helps create and solve the crisis. The organization of women helps create and deal with the new technology. The interests of capital usually prevail and, for this reason, it is possible to predict many of the consequences of this new technology for the work of women and men. But there are still choices to be made. Therefore, it is important to examine the likely outcome of the application of this new technology.

In Canada, there appears to be a growing commitment to the development, production and implementation of the new technology. The 1983 federal budget of Finance Minister Marc Lalonde gave priority to the funding of research and development specifically in the microelectronic fields. "The application of new technology in Canadian industry can improve international competitiveness and productivity and thus can increase growth prospects and employment opportunities" (Lalonde, 1983:1). But, as the Economic Council of Canada (1983:5) points out,

> Any increase in productivity means, by definition, that less work is needed to produce the same output. If total output does not rise, some people are thrown out of work.

And most research studies indicate that the demand for services will not increase at a rate sufficient to offset the increase in productivity (see Zeman, 1979). Yet the Economic Council (1983:35) remains firmly convinced that technical change is significant "both in explaining the recent slowdown in total factor productivity and in discovering remedies for that slowdown" and thus, like the government, recommends even greater commitment to technological development. In both statements, increased productivity rather than employment is the major goal. In fact, the Council's (1983:81) emphasis on increasing productivity in the service sector, particularly in the state part of these industries, would almost inevitably lead to reduced employment opportunities and altered working conditions for those who remain. In a published dissent on the report, Mr. Kaplansky (Economic

Council of Canada, 1983:113) expressed his concern that insufficient attention had been given

> to the human element, to problems of industrial relations, to meaningful consultation and to the need for effective programs now to ease the burden of change in particular individuals or groups.

As he goes on to point out, the new technology could lead to "a loss of employment and income perhaps for fairly extensive periods and for fairly large groups." When priority is given to productivity, when employment is assumed to take care of itself, when employee response is severely constrained by legislation limiting strike activity and enforcing wage controls and by the pressure from the reserve army of unemployed, when the labour force is highly segregated – it is possible to predict the future employment of women and men with a fairly high degree of confidence.

It would be easier to make these predictions, however, if we had a more accurate and complete picture of the current uses and impact of microtechnology. A number of factors combine to obscure the consequences of the new technology for women and men's employment during the crisis. Since, as the Canadian Union of Public Employees' (1982:4) submission to the Labour Canada Task Force points out, "employers are not required to maintain public records on the composition and changing characteristics of their workforce," it is not easy to monitor the employment trends related to the new technology. In addition, Statistics Canada's failure to collect data on turnover rates makes it difficult to determine any alterations in patterns when microtechnology is introduced, and it leaves silent firing – the non-replacement of employees who leave – unrecorded as a method of dealing with redundancy resulting from technical change. Peitchinis discovered in his research that, even when employers are asked direct questions about technological change, they often leave out those related to computer technology.

> The computer has become so commonplace that it is no longer regarded as a technological change. And industries which introduced computer technology some time ago, do not regard modifications in it as technological change, regardless how significant their effects might be. This is particularly the case with service industries, and service activities in goods producing industries (Peitchinis, 1982:14).

Such problems in data collection also make it difficult to determine how much of the increase in part-time jobs is a result of technological change. Since a high proportion of the workers in these industries and of all part-time

MICROELECTRONICS IN THE WORKPLACE

workers are women and since a variety of factors combine to give women higher turnover rates than men, it is the consequences for women that remain particularly difficult to tap.

But the problem in monitoring the ongoing consequences of technological change is not simply one of recording unemployment following the introduction of new equipment. The nature of the process itself camouflages and delays unemployment or underemployment. When the new technology is being introduced, the old staff is still required to perform their functions until machines and trained staff are in place. Additional people are needed to introduce and work in the new system so employment may even increase. But at the end of the initial overlap phase, many of the former employees as well as those introducing the equipment will no longer be required.

In addition, it takes time to educate the clientele and to accustom them to the new technology, especially to the self-service variety. Automatic tellers, for example, have only recently been installed in many banks across Canada and few customers have switched to the machines. At least one bank sends personally addressed (computer-typed) letters to clients who fail to use their new bank cards, providing further instructions on how to use the machines, indicating the nearest location of the new equipment, offering personal assistance for those unfamiliar with the technology or new code numbers for those who have forgotten theirs, and extolling the virtues of the new technology that means "no more waiting in teller line-ups, last minute dashes to the bank or running short of cash over the long weekend." Some banks have gone beyond positive encouragement to negatively sanction those who persist in dealing with a real teller, charging extra for such transactions if they can be done by the machine and increasing the length of time customers wait in line. During the transition stage of customer reeducation, the bank still requires most of the tellers it has been employing as well as additional people to introduce and publicize the machines. But once the transition is complete, many tellers and public relations personnel will no longer be required.

The technology itself has different levels of sophistication, each requiring different kinds and numbers of workers. Heather Menzies (1982:22) suggests that, in the office,

> The spread of computer technology seems to involve three phases: the automation phase, where individual functions and procedures are automated; an integration phase, where the automated functions are woven into a computer communications network called an automated information system or a management information system; and an innovation stage, in which these

integrated systems are applied as computer aids toward the creation of new economic activity and possibly new employment opportunities as well.

While the initial wave involves adding some new machines to the old office, the second wave creates a very different office, one which employs fewer and different workers. Until this second wave takes place, employment changes are unlikely to show up in the data, however they are collected.

Furthermore, since the new technology is designed to increase productivity, one consequence of its use is often jobless, or nearly jobless, growth. Profits and output increase but jobs do not, or at least not at the same pace. However, the small increase in the number of workers that accompanies this growth may hide the actual elimination of jobs that is taking place. Young people and new entrants to the labour force are increasingly denied paid employment because rising productivity resulting from the new technology reduces the need for additional workers. Thus, much of the unemployment among youth and new entrants, most of whom are women, may be the result of technology rather than some more broadly defined economic crisis.

The unemployment created by the new technology may be both a cause of unemployment during the crisis and hidden by the crisis it has helped to create. Without an accurate picture of the current consequences of the new technology, it is easy to attribute job loss to the general economic conditions. And the crisis certainly provides both a justification of and incentive for technological change. The Economic Council of Canada's (1983) report on technological change is just one example of this process. In addition, worker resistance to the introduction of new technology is considerably reduced during an economic crisis, as the employer proposals seem the only way out of the crisis and the only possibility for a few to retain their employment in the face of a huge reserve army of labour. Alternatively, workers' success in gaining clauses covering technological change may help delay, and thus camouflage, the employment impact of the new equipment. "Firemen" clauses, for example, which ensure that a particular worker will keep her or his job even if that job is done by new equipment, may artificially maintain employment levels for a short period of time.

Job Loss

Even the most optimistic researchers agree that there will be at least a short-term loss of jobs resulting from the introduction of the new technology, especially in offices and the service industries, where productivity is low and

MICROELECTRONICS IN THE WORKPLACE

where much of the new technology has its most obvious application. And, while frequently hesitant to make predictions in other areas, most investigations of the impact of the new technology agree that women will lose more. At the international level, the Commission des Communautés Européenes (1982, Vol II:112) conclude, on the basis of their research in this area, that

> Les femmes seront affectées de manière beaucoup plus importante que les hommes par l'introduction des NTI. Cela est dû à la fois aux mécanismes traditionnels de ségrégation dans le marché du travail et aux facteurs sociaux et d'organisation qui font en sorte que les femmes (en raison du système de formation professionnelle et de leur niveau de qualification) seront moins capables de profiter des nouvelles opportunités d'emploi liées aux NTI que les hommes.

Closer to home, the Labour Canada Task Force (1982:15) makes it clear that

> Although women make up more than forty percent (40%) of the labour force, two-thirds (2/3) of women workers in Canada are concentrated in those positions which are currently prime targets for efficiency and productivity improvements via the introduction of microelectronic technology.

When the segregation outlined in the previous chapter is linked to the sectors and occupations where the new technology is being introduced, the reasons for these predictions become clear.

As noted in an earlier chapter, employment growth since World War Two has been concentrated in tertiary industries, where the growth of output per worker-hour has been much slower than in the primary and secondary sectors. According to the *Fifteenth Annual Review of the Economic Council of Canada* (1978:78), in the service sector "the annual rate of increase in capital per worker has been less than half that in the goods-producing sector." More work meant more workers, primarily female workers. As Shirely Serafini and Michael Andrieu (1981:13) point out in their study of the "information revolution," the majority of the new jobs involved information-related activities, and "the bulk of Canadian information workers are information processors (about 63 percent in 1971), that is workers engaged in activities which essentially involve collecting and compiling information, such as clerical workers." In 1982, more than three-quarters of the clerical workers were women and more than one in three employed women did clerical work (Table 4.15). It is this information processing work, this clerical work, this "women's work," that is most readily and easily transformed by microtechnology.

The computer made possible the electronic processing of data. The simplest, most widespread and therefore in most firms the earliest application of this technology has been in the automation of such accounting functions as payroll, accounts receivable and accounts payable (Globerman, 1981:2). The cost, size and structure of this early equipment meant that large organizations were the first to replace workers in these areas with machines since they had the volume to justify the expenditure on the technology, the space and the skills required. It also meant that the diffusion rate was relatively slow. For example, although the technology had been available for a number of years, by 1974 only about 19 percent of Canadian hospitals were using data processing for either clinical or adminstrative purposes (Globerman, 1981:21). However, the microchip made electronic data processing simpler and cheaper, the machines smaller and less fragile, the applications incredible. The new equipment, within reach of most organizations with more than a few workers, can store and retrieve information, correct and change texts, set margins and letters, record telephone messages and send mail electronically. It can even correct spelling errors, alphabetize material and remember birthdays. It cannot only process numbers but words, designs, photographs, speech. It can copy material and produce it in written form or on a visual display terminal. The newest machines can talk to each other. And they can record the errors and speed of the operator. As Digital's advertisements for their latest processor point out, the machines can do all this, if not with a smile, at least without protest.

> It's all things to all people.
> Well, almost. There are some things Digital's new DEC mate can't do.
> Though its minor deficiencies are more than offset by the fact that
> it never gets headaches, never takes holidays, never feels "blue".
> Beyond that, DEC mate is just about all things to all people. Consider:
> It files instantly and retrieves just as fast.
> It lets you amend data with instant ease.
> It never forgets.
> It types 540 wpm, with faultless precision.
> It can deliver you mail, *sans* postman.
> It can stand alone as a computer or "talk" to other computers.
> It can do math, and because it can write, it could even do your payroll.
> It is very discreet.
> It can plot marketing strategies.
> It can help solve all sorts of engineering problems.
> It can track inventories, payables, receivables and job applicants.
> It can ... well, you get the point.
> *(The Financial Post,* July 31, 1983:14)

An advertisement placed by AES Data Inc. in *The Financial Post Magazine* (September 1, 1983:45) outlines the steps involved in introducing such equipment:

> Most businesses begin their office evolution through the introduction of a word processor. Simple to operate, it's the first basic step in office automation. Word processors reduce tedious, time-consuming clerical chores like correcting and retyping, substantially improving the accuracy and speed of a typist. This frees the typist for more productive and beneficial duties.
>
> One word processor is just a start. Several word processors linked together represent the beginning of an information network whose capacity for productivity is only limited by the imagination.

With this new technology, more secretarial work means more (and more powerful) machines, not more workers. Heather Menzies (1982:25) reports that a 1981 study of automation in Ontario municipal government offices found that "word processing operators were able to average ten pages an hour, while regular typists, juggling typing with other responsibilities, averaged only two pages." A British study reports that one company was able to get three times as much work done with the same staff (reported in Huws, 1982:25). Of course, less office work means that even more workers are laid off than would be the case with the older equipment. While, as the advertisement suggests, some typists may be free to do more meaningful work, many more are likely to be free to join the unemployed. Menzies (1982:29) found that between 1972 and 1980, the head office of one large corporation reduced employment in the information services department by 10 percent as they began to automate the office. There is no evidence to indicate that the process of automation, and therefore layoffs, is complete. There is a great deal of evidence to indicate that most of those losing these jobs are women.

With the price of equipment falling and the applications expanding, offices are now being automated more rapidly. For example, by 1978, 30 percent of hospitals had computerized at least some part of their operations (Globerman, 1981:201). The steady rise in unemployment among female clerical workers is probably largely attributable to this process. But it must be remembered that two-thirds of these hospitals have not yet introduced the computer. Most of them are likely to do so and most of those replaced or refused future work because of the machines will be women. *The Financial Post* (March 5, 1983:sl) reports that an estimated "48% of The Financial Post's top 500 companies are planning integrated office projects in 1983."

Because it takes two or three years to plan and implement these projects however, the integrated offices are unlikely to be in place for a few years. As another article in *The Financial Post* (July 31, 1983:12) puts it,

> The automated office has been defined as a means of handling business documents and person-to-person communications through electronic office equipment, connected to a communications network to form an integrated system capable of many functions. In its broadest sense, it is also intended to connect with an external network for outside communications.

Such offices will not require many of the female clerical employees that work in them today.

Clerical workers and the new equipment are not located exclusively in offices, however. Both are found, in large numbers, in the branches of banks and trust companies. Canada's major banks and trust companies started as early as the 1950s to use computers for centralized banking services. With large mainframe computers, tellers carried out the transactions with customers and then passed the information on to other clerical workers who keyed the data into the computer. During this period, clerical work grew, especially for women (Table 4.2 and Table 4.4). Later, on-line systems allowed terminals to be moved to tellers' counters, where transactions could be instantly recorded. Clerical jobs disappeared in the process but the growth in banking services and in bank branches (Menzies, 1982:42) prevented a drop in the overall numbers employed (CSE Microelectronics Group, 1980:102). Banks have continued to expand rapidly the applications of the microtechnology. The newest systems can read the codes on cheques and electronically transfer funds. With the automatic tellers now being introduced across Canada, machines and customers can do most of the teller work. Once customers have been trained to use this self-service equipment and once the automated banks are in full service, fewer branches and a much smaller clerical workforce will be required to offer the same number or even expanded services.

Work in the Finance, Insurance and Real Estate sector is increasingly women's work (Table 4.2). In spite of the continuing profit growth in many of the finance industries, however, the proportion of women doing this work is not increasing. Jobless growth, or nearly jobless growth, has already begun to show up in the data and a growing proportion of unemployed women last held a job in the finance sector (Table 5.10). Banking services are still expanding. An advertisement in a recent issue of *The Financial Post*

MICROELECTRONICS IN THE WORKPLACE

Magazine (September 1, 1983:15) offers an example of new developments in the finance industry:

> For many companies, payroll preparation qualifies as a major headache. It can be costly, complicated and time consuming. Yet it needn't be. Because the Commerce can do it all.
> Backed by a national network of data centres and branch offices, we can provide a totally integrated payroll system, eliminating internal payroll preparation.
> With the fast, accurate information the Commerce generates, you can improve your cost control. And Commerce payroll services offer convenience for you and your employees with direct deposit into their bank accounts.

This payroll service is unlikely to increase the number of banking jobs beyond the few primarily male professionals needed to introduce the system. On the other hand, the largely female clerical staff now preparing payrolls in other offices will lose their jobs if the banks take over this function. In their book on *The Collapse of Work*, Clive Jenkins and Barrie Sherman (1979:122) predict that, with the "development of automatic banking and insurance, the increasing concentration of other financial markets and the use of satellite communications," the number of British people employed in this sector will drop from 1136 thousand in 1978 to 650 thousand in the next twenty years. Similar patterns are likely in Canada and most of those losing these jobs will be women.

Telephone operators are also classified as clerical workers and most such operators are women. Technological developments have been steadily changing these jobs for years. According to Elaine Bernard (1982:108), the author of a study on British Columbia telecommunications workers, automatic switching technology was patented as early as 1881 but massive dial conversion did not begin until the late 1940s and continued well into the 1950s. The workforce doubled during these years, as employees were needed to run parallel automatic and manual systems, as services expanded and as record-keeping tasks grew. Eventually, many of the telephone operators were phased out, the record keepers, the bill-makers, the long distance operators as well as the service assistance operators kept their jobs. However, with the introduction of microelectronics, microprocessors replaced electromechanical equipment. Computerized long distance dialing and automatic billing became possible. Menzies (1982:58) reports that as a result of this new technology, the number of telephone operators in Vancouver was cut almost in half and that the operator staff requirements in Toronto were reduced by 40

percent. But this is not the end of the process. "More jobs are threatened with the automation of both directory assistance and operator intercept, anticipated during the 1980s" (Menzies, 1982:59). In addition, customers are now being trained to dial their own overseas, collect and person-to-person calls. Once training is complete, more of these female operators will be redundant.

Technological change clauses won by unions have protected some workers from immediate layoffs, but frequently they protect people rather than jobs. When these workers leave or retire, new workers will not replace them. Furthermore, technological change agreements such as those in the British Columbia telephone workers' contract (Bernard, 1982:166), may guarantee work only for a specified period of time, delaying but not eliminating the reduction of jobs. As a consequence, the figures that are available hide the actual number of people who have been replaced by microelectronic equipment. Furthermore, layoffs may be blamed on the economic crisis, rather than technology, and thus fall outside the technology clauses. This was the experience of the telecommunications workers in British Columbia. "The onus was on the union to prove that layoffs were caused by technological change and not economics" (Bernard, 1982:167). Most of the clerical workers threatened by this new equipment, most of those just waiting for their jobs to end and most of the clerical workers who have their dismissal blamed on the economic crisis are women.

As well as telephone operators, secretaries, file clerks, receptionists and bank tellers, the clerical category includes many postal workers, a high proportion of whom are women. It is difficult to be unaware of the new technology in the post office, because strikes centred around it disrupt mail service and because Canadians must struggle to remember postal codes. The codes make it possible to sort mail electronically and to eliminate many of the jobs related to this task. Once again, customers are in the process of being trained to do the jobs. When the population has finally been conditioned to use the postal codes, fewer sorters will be necessary.

Mail carriers are classified under reception, information, mail and message distribution, itself a subcategory of the clerical occupation group. This is one of the few areas where a high proportion of the clerical workers are male (Table 4.21). Mail carriers are still almost all mailmen. Work here has not yet been reduced by microtechnology but this is unlikely to be the case for long. Electronic mail may dramatically decrease the amount of information

transferred by hand in printed form. As an advertisement for Canon FAX explains, the new equipment

> is a remarkable invention that transforms hard copy, via electronic signals over the telephone, onto a hard copy at the other end. And as you know, nothing is more accurate than the printed word...
> Unlike mail couriers, a Canon FAX has the advantage of lightning speed. And unlike Telex, you can send charts and diagrams as easily as the printed word *(Financial Post Magazine,* September 1, 1983:23).

With such equipment, many fewer people will be required to send, sort and deliver the mail. Those now processing this information are primarily female, although those delivering it are largely male. Both kinds of jobs are threatened by the new technology.

Although close to 80 percent of all clerical workers are women, mailmen are not the only male clerical workers. Over one-third of the men doing clerical work fall into the material recording, scheduling and distributing category (Table 4.21). Most of the men in these occupations are in stockrooms and warehouses, where microelectronics could do much of the work. Many administrative functions, such as inventory accounting and control, ordering, identification of damaged material, the processing of claims and the identification of location transfers, can be relatively easily and cheaply computerized. However, fully automated warehouses, which "encompass computerized batch picking, along with automated storage and retrieval vehicles (which are supplanting traditional fork-lift trucks) and automated sortations systems" (Globerman, 1981:28), cost anywhere from $2.5 million to $4 million and are mainly useful for large numbers of uniform products. Given the cost and use of this technology, computerized planning and automated warehouses are unlikely to be within the reach of any but the biggest firms with large volumes of similarly shaped goods (Globerman, 1981:28). Therefore, although such male clerical work is not immune to microelectronic takeover, many of these jobs are not immediately threatened by the new technology.

Exactly how many clerical workers have been and will be made redundant by this new technology is difficult to determine. *Maclean's* (McQuaig, 1983:32) has cited a secret government analysis predicting that up to 25 percent of business and financial jobs could disappear by 1991. The Public Service Alliance of Canada has estimated that, in the Federal Civil Service, "for each position created by the new technology in the Adminstrative Support

field, more than two positions have been eliminated" (quoted in White, 1983:14). Another Canadian study found that four new word processors made it possible to do more work, to do this work at a faster pace and to decrease the typing pool from fourteen to eleven women (reported in Warskett, 1982:139). Menzies (1981) calculated that in the best possible scenario, 200,000 female clerical workers will be unemployed by 1990; in the direst circumstances, 750,000 will be without jobs. Even her gloomiest prediction may underestimate the problem, however. The supply of female clerical workers was already higher than the highest estimate she used for 1980. Thus there were many more women in a position to be put out of work by the new machines than she anticipated. Whatever the precise impact, full-time clerical work has already begun to decline (Table 5.15) and that is only the beginning of a dramatic drop in clerical jobs, especially for women.

Sales

Sales jobs are also threatened by the new technology. In many sales outlets, customers have already been trained to do most of the work, although an employee is still required to operate the cash register. However, according to industry experts, "computerization probably represents the most significant opportunity, to date, to improve productivity in this sector" (Globerman, 1981:36). The new electronic point-of-sales systems centre around the computerized cash register and the coded magnetic strip on the product label, otherwise known as the bar code. The new registers can capture information on the colour, size, model, quantity, stock number and cost of the item sold, on the customer's method of payment, on the speed and errors of the cashier, and can even make out new orders. The information can be keyed in by the cashier or read by a wand passed over the bar code. Some stores have long counters that automatically read the information from the articles placed on them. Once the information has been captured, it can be easily transmitted to other computers. Since the bar codes are now placed on most of the products by the manufacturer and since the price of the computerized registers is no longer prohibitive, retail stores are rapidly converting to the new machines. The more sophisticated and expensive wanding equipment, however, has been moving into the market slowly. In Globermen's (1981:36) 1979 survey of department stores, for example, only 11 percent of the firms were wanding. Full-time sales jobs have already begun to disappear, especially full-time female jobs (Table 4.20). When the wanding devices are in place across the country, many more sales jobs are likely to be eliminated.

MICROELECTRONICS IN THE WORKPLACE

The new technology makes it possible to hand even more work over to the customer. With wanding devices and credit cards, customers could check themselves out of the grocery store, eliminating entirely the need for the primarily female cashiers. Several pilot projects are now being conducted in the United States to initiate customers into the process of ordering directly from home, through their computer. Funds can be electronically and instantly transferred to pay for the goods. Wholesale workers, who now at least are mostly men, are still required under this system. And so are delivery "men." While some male jobs packing groceries, filling shelves and taking stock will disappear, the majority of those losing their jobs will be female cashiers.

But the new technology has not only eliminated female sales jobs. It has also been a factor in increasing female employment in one sales area – service station attendants. In 1971, only 4.3 percent of service station attendants were women. By 1981, 13.5 percent of the workers here were female (Armstrong and Armstrong, 1984:Table 7). During this period, customers were trained to serve themselves in many gas stations. The job of service station attendant was changed from one involving serving gas, checking oil, cleaning windows and billing customers to straight cashier work. In the process, more women were hired at lower wages than their predecessors.

Manufacturing

Although most clerical workers and a high proportion of sales clerks and cashiers are women, most factory workers are male. Moreover, while only 12 percent of all women workers are employed in manufacturing industries, almost 23 percent of the men have jobs in these sectors (Table 4.5). Therefore, when new technology increases productivity in the manufacturing sector, it is primarily male jobs that are at stake. However, women are unlikely to escape the impact of technology here either. More than one in ten women still find work in these sectors, and many are concentrated in the firms and jobs that are particularly vulnerable to automation. Moreover, many women work in the least productive, most labour-intensive industries where new technology is likely to have the greatest impact on employment (Table 6.1).

Machines that look like typewriters with a television screen attached or like a more streamlined version of the old cash register do not appear to be particularly threatening or revolutionary, but robots do. The word conjures up visions of science fiction figures heralding a brave new world. Although the robots of today bear little physical resemblance to their science fiction counterparts, their possibilities are as broad and as revolutionary as any Isaac

Asimov could envisage. As the Science Council of Canada's report, *Planning Now for an Information Society*, explains,

> Today's robot is basically a multifunction manipulator designed to move materials, parts, tools or specialized devices through programmed motions to complete a variety of tasks. It is a machine that moves, manipulates, joins or processes components in the same way as a human hand or arm. However, the essential characteristic of a robot is that it can be programmed and reprogrammed, which means that it can be taught new tasks (Science Council of Canada, 1982:34).

In addition to repeating endlessly the same series of pre-set motions, the newest robots can respond to information received through sensory devices and adjust their work accordingly. Such machines obviously have a wide range of applications in the manufacturing industries where much of the work has already been broken down into simplified, repetitive tasks. In that classic example of the assembly line, the automobile factory, robots already paint, weld, load machine tools, assemble and transfer parts. By 1990, General Motors alone plans to have 14,000 robots performing such tasks in their factories (Science Council of Canada, 1982:35). There can be little doubt that many male jobs will disappear in the process. However, the transportation equipment industry is already highly productive and capital intensive (Table 7.1) and thus the impact here is likely to be less dramatic than it will be in more labour-intensive industries. In the food and beverage industries, for example, where productivity is lower and the proportion of women considerably higher (Table 6.1), especially in assembly work (Table 4.21), the new technology is likely to have an even greater effect on employment. Here robots can decorate, select, sort, grade, arrange, pack and label – in other words, do many of the jobs women do now.

The applications of the new technology to manufacturing industries extend far beyond the introduction of robots, however. Computer technology has for a number of years been used in the continuous process industries such as chemicals and steel, in the industries where many men still find jobs. As Ursula Huws (1982:47) explains in her study of microtechnology's employment impact, "The difference made by the microprocessor is to make this type of operation many times cheaper and thus open its possibilities for a number of smaller scale processes in other industries." This difference means that many of the smaller industries that employ a higher proportion of women (Armstrong and Armstrong, 1983b:Table 14) can introduce an automatic control process and reduce their labour costs.

In those factories less readily adapted to continuous process technology, other kinds of microelectronic equipment are transforming the work. In the clothing and knitting industries, for example, where productivity is also low and the proportion of female employees high (Table 6.1), new technology could have a profound impact. Programmable sewing machines and electronic cutters are being introduced. As their costs fall, more of the small firms common in this sector will adopt them in order to reduce the skills and workers required. Women are the overwhelming majority of sewing machine operators (Armstrong and Armstrong, forthcoming:Table 7), so it is their jobs that are at risk. However, a high proportion of the cutters are men. As was the case in service stations, the more highly trained men may be replaced by fewer and lower-paid women who can be taught to operate the new equipment in a matter of weeks rather than years.

It should be noted that these are also the industries most threatened by imports from low-wage countries. While the countries currently offering the greatest competition to the clothing sector are faced with rising wages that will limit their advantage in this area, this does not mean, as Roy Matthews (1983) points out in *Canada and the Little Dragons,* that Canadian industries will be relieved from the pressure of low-wage imports. The competition will continue but it will come from other low-wage areas. Such predictions have encouraged the government to offer financial support for the technological transformation of industries in this field; a transformation, it should be noted, that will speed up the elimination of the mainly female jobs in these industries.

The jobs of monitoring and control, of both products and people, can also be done by microelectronic equipment. Women have been increasing their share of foremen's jobs and constitute more than 80 percent of the inspectors, testers, graders and samplers (Armstrong and Armstrong, 1984 Table 7). Such jobs are likely to be dramatically reduced in factories adopting the new equipment. In fact, women's increasing share of foremen's jobs may reflect more the reduction in responsibility that accompanies the introduction of new equipment than growing authority for women.

Microtechnology can also replace highly trained workers involved in the planning and development of systems, products and processes. Sophisticated equipment permits the automation of many of the drafting and engineering functions, functions that are now performed mainly by men. Indeed, the introduction of computer-aided design or CAD equipment may provide a partial explanation for the growing unemployment among engineers.

Computer-aided design and computer-aided manufacturing technology allow for the development of a completely automated factory. How soon we are likely to see such factories and how many workers will be required in them is difficult to predict. Based on his analysis of the situation in Britain, Peter Marsh (1981:114 and 115) contends that "it is very difficult to make automated factories work," and that they will not be set up for a long time, if ever, in some industries. The Science Council of Canada, on the other hand (1982), claims that "Robotics and CAD/CAM technology will characterize *all* manufacturing in the 1990's." Whether the process is slow or fast, complete or partial, it is clear that many jobs will disappear. More of these jobs will disappear for men than for women, since many more men now have jobs in the manufacturing sector. However, since women are concentrated in the sectors characterized by low productivity, in those targeted by the government for technological transformation and in those facing the greatest competition from abroad, many fewer women will find manufacturing jobs.

Education and Health

Although obviously vulnerable to government cutbacks, jobs in education and health appear to be protected from the redundancies created by the introduction of microelectronic equipment. And most of those with jobs in these sectors are women. However, it should be remembered that there are more than twice as many women with clerical jobs as there are with teaching and medical jobs combined. And even these jobs will not entirely escape the employment difficulties induced by the use of new technology.

Among the detailed descriptions of life on the jobs included in Barbara Garson's (1975) *All the Livelong Day* is one of the computer technology employed in laboratory technicians' work as early as 1970.

> Much of the actual testing work consists of loading and unloading the machines. With the new machinery, there is a much greater chance of error in the paper work than in the lab work. A great many women are employed in labelling the samples and checking the code numbers on IBM cards. Each test tube or slide is picked up several times along its route by a woman at a workbench or along a moving belt who scans its label and places it in an appropriate rack or slot (Garson, 1975:131).

Now electronic equipment can also do the scanning, checking and labelling. In addition, the huge computers required in this earlier period have been

largely replaced by smaller microprocessors, making them affordable by much smaller laboratories.

In hospitals, on-line systems can give hospital workers direct access to all kinds of information on treatment, personal records and staff schedules. Microelectronics can also make automatic diagnostic and treatment prescriptions possible. Patients can be monitored by some of the new machines, and lab reports can be rapidly transmitted and analyzed. According to Globerman (1981:19), "With the appearance of the microprocessor, automation is now possible in virtually any existing type of clinical equipment found in the hospital." Where automation is possible, so usually is a reduction in staff. Only the large hospitals have introduced much of this new equipment and the dispersion rate is much slower than in the profit-making sectors (Globerman, 1981:20). As costs for the equipment come down, as governments reduce their allocations and demand higher productivity, as the speed of adoption increases, jobs are likely to disappear rapidly. Since women form the majority of workers here, women are the ones most likely to be replaced by machines.

Fewer women are employed in educational institutions than in medical ones but these jobs seem somewhat better protected from technological redundancy than those in the medical fields. They are not, however, immune. Microelectronic equipment is already widely used in the teaching of languages, reducing the need for teachers in this area. Some teachers in large institutions have been using computer-graded examinations for a number of years but these have required access to a mainframe computer. Computer-aided learning is only now within the financial and technical reach of institutions of all sizes and will soon be available to many private households. As the Science Council of Canada (1982:36) explains,

> Computer aided learning (CAL) refers to direct interactions between a computer and a student in which the computer presents material for learning, asks questions, checks answers and varies its response on the basis of student answers.

The Science Council is convinced that such equipment will not replace a significant number of teachers but will instead enhance their ability to respond to and deal with the individual needs of students. Yet many school boards, faced with decreasing allocations and increasing teacher resistance, may be more than tempted to employ machines rather than people to do the teaching work. The Science Council acknowledges that such equipment may

take over much of the teaching in extension courses and that educational services could be expanded without significantly increasing the number of jobs. Such jobless growth and any job loss that does occur when the new equipment is in place will primarily affect women, who are the majority of workers in the teaching industries.

Primary Occupations

While offices and banks, hospitals and schools have, until very recently, been labour intensive, primary industries have become steadily more capital intensive since the turn of the century. Productivity has continued to increase and employment to decline. By 1982, only 9 percent of employed men and less than 4 percent of employed women worked in primary industries. And almost all these women and well over half of the men worked in the agriculture sector, an area less affected by microelectronics. Although many of the tasks have already been mechanized, microelectronics will continue to transform work and eliminate jobs in the resource industries.

Microprocessors can and are being used to monitor and control feeding and threshing operations in agriculture, to control the temperature in the barn and in farm machinery. This technology increases the quality and amount of output but it does not greatly reduce the number of jobs in the agriculture sector. Automatic feeding and milking machines have been in use for a number of years. Combine harvesting machines and threshers long ago reduced the need for labour in agriculture. The jobs that are left in the farm may be changed by the new technology but large numbers of them are unlikely to be eliminated. Moreover, while the prohibitive cost of the mechanized equipment may continue to put small farmers out of business and high interest rates force some into bankruptcy, the falling prices of the new microtechnology will place it within the financial reach of more and more small farmers, perhaps making them more efficient.

Microtechnology is also unlikely to reduce employment significantly in the male-dominated fishing industry. As Wallace Clement (1983:238) has pointed out on the basis of his research on resource industries, offshore fishing has already "been transformed into factory-like conditions with great capital investment, such as factory freezer trawlers costing $15-20 million, the application of science and an extensive division of labour." As is the case in manufacturing industries, microelectronic processes could further automate production in offshore fishing trawlers but the numbers employed on

these efficient vessels are already small. In addition, jobless growth in output could result from microelectronic-assisted techniques for locating fish. For inshore fishermen, work remains craftlike, "with low capitalization, little technology and a low division of labour" (Clement, 1983:238). It is difficult to see how these jobs could be immediately transformed or eliminated by microtechnology. Jenkins and Sherman (1979:116) predict that, "While some capital intensification is possible in fishing, it is unlikely that agriculture will shed more labour." Indeed they even suggest that agriculture could expand its workforce. Most men in agriculture and fishing, accounting for almost two-thirds of the men in all primary industries, are unlikely to lose their jobs to microelectronic equipment.

Mining is also a male-dominated and a capital-intensive industry. In the last thirty years, underground mining has been largely mechanized and surface plants have been automated (Clement, 1983:195 and Science Council of Canada, 1982:31). In the process the number of jobs has been steadily reduced. Jobless growth has also been common. For example, Clement (1982:201) reports that the "output of ore in the metal mining industry as a whole increased by 114 percent between 1964 and 1973 and its value increased by 114 percent, while the labour force grew by only 15 percent." Cutting control has remained manual, however, and the processing is largely electro-mechanically controlled. What microtechnology does is "make all these control functions potential candidates for microprocessor applications" (Science Council of Canada, 1982:31). In one coal mine in England for instance, three computers are at work. One controls coal preparation equipment, one stores and provides information for management and another controls the loading of trains (CSE Microelectronics Group, 1980:99). Such equipment can obviously reduce the need for labour but since the systems are already highly mechanized, the introduction of microelectronics will not have as dramatic an effect on these primarily male jobs as it will in more labour-intensive female-dominated sectors. The new technology is already built into much of the petroleum industry and is unlikely to further reduce employment there in the near future.

Like the mining industry, the forestry industry is largely male-dominated and capital intensive. In her article on the British Columbia forestry industry, Patricia Marchak (1979:10) explains that simple materials are produced

> through a highly sophisticated imported technology. Logging has become increasingly mechanized. Sawmills were mechanized throughout the 1950's and 1960's, and newer mills are now partially '17' automated. Pulpmills have

been automated for most of the post-war period, each few years allowing for extension of that process.

This does not mean that microelectronics will have no effect on employment in the industry. Microprocessing equipment can automatically assess a log, select an appropriate cutting pattern and cut according to the plan. Menzies (1982:71) reports that such equipment allowed one sawmill in British Columbia to get 10 percent more out of each log at the same time as the mill workforce was reduced by 40 percent. At the Abitibi Price mill in Iroquois Falls, Ontario, the government helped the company purchase a new machine that incoporates microtechnology and is capable of rolling out 180,000 tons of newsprint a year. "The new machine ... employs 155 fewer employees than the four [machines] it replaced" *(The Financial Post,* 1983:17). While some reduction in male employment will continue as microelectronics are applied to the forestry industry, there is unlikely to be a sudden and large drop in jobs resulting from the new technology, since much of the work is already highly mechanized.

There can be little doubt that the introduction of microelectronics into the primary industries will make some jobs redundant. Since most workers here are male, most of the jobs will be lost to men. However, in those areas such as mining where women have recently made some progress in acquiring "non-traditional" jobs, union seniority lists will ensure that women are the first to go. In addition, job loss will be limited in the agriculture and fishing industries, where most of the men now employed in primary industries work. In other primary industries, the highly mechanized nature of the work means that the gains in productivity following the introduction of microelectronics are also likely to be relatively small.

The Overall Impact

Microtechnology will eliminate jobs for women and men, in most occupations, in all industries. However, the greatest job loss will be in the female clerical and sales occupations, where 44 percent of all employed women now work. In the manufacturing industries, more men than women will see their jobs disappear, since the majority of factory workers are men. Nevertheless, because women are concentrated in the jobs and firms characterized by low productivity and by tasks that can be easily performed by the new machines, women's relative job loss may be greater. In the male-dominated primary industries, job loss will be less dramatic and will involve mostly men. But

the few women who have recently moved into these traditionally male jobs will be the first to go.

While most researchers agree that the new technology will increase productivity and eliminate jobs, many argue that new and better jobs will emerge to replace the old. But a brief look at these new jobs suggests that there will be fewer of them, that a smaller proportion will go to women in this country and that many of them will offer poorer conditions, rewards and opportunities, especially for women. Although worker resistance may alter some of these trends, predictions can be reliably made because the technology has been primarily designed by and for capitalists who are interested in reducing labour costs and increasing control over the labour process.

Employment Expansion

Benston (1983) suggests that there are five areas where computer technology may lead to employment expansion: jobs running the new automated equipment, jobs involved with the development, maintenance and use of computer programs and data bases, jobs repairing and maintaining the new equipment, jobs manufacturing the hardware, and jobs selling the new equipment as well as training and educating people to run it. Undoubtedly jobs have grown in the first area, especially for women. However, this job creation primarily means some women take over jobs previously done by other female workers and, in the process, there is an absolute reduction in jobs for women. For example, between 1975 and 1982, the number of people in the word processor operator category in the federal civil service "more than doubled from 782 to 1,931, while the number of typists and stenographers declined" (White, 1983:14). The result was a net decrease of 19 percent within the larger clerical category.

The jobs of even the word processor operators may have a very short future. The new computers can talk to each other and those with voice recognition capabilities can be talked to. Such machines can eliminate much of the work now linked to the keyboard and thus eliminate the need for many of these workers as well. They will go the way of the keypunch operators of ten years ago. Indeed the process has already begun. Menzies (1983:15) reports that in the spring of 1982, there were seven hundred unemployed word processor operators in the Peterborough area alone. In some areas, the introduction of the new equipment may switch the sex of the operator. It has already

been noted that in service stations and in clothing factories, the new lower-paid jobs often go to women. However, when jobs in other areas involve greater use of technology, the jobs may go to an increasing number of men. For example, Huws (1982) reports that the trend towards employing men in the higher levels of the nursing profession in Britain has been blamed on the increasing importance of machines in medical treatment.

In the second area of job creation, software production, jobs are both appearing and disappearing, and work is being transformed in the process. As Benston (1983) and others (Duncan, 1981; and CSE Microelectronics Group, 1980) have pointed out, software production itself is being automated. Structured programming systems permit software to be produced in a standardized way, requiring fewer skills of the more closely monitored workers. Various aspects of the work are being separated out for automation, easily understandable language has been adopted and computers that can develop programs have been introduced. Canned programs, which can be relatively easily modified for a range of tasks, also reduce the need for highly trained programmers. According to Benston (1983:52), "Those who are predicting the creation of thousands of jobs for software workers in the next short period in Canada and the United States clearly have not taken these new developments into account."

Even if a large number of such jobs were to be created, it is likely that the majority of them would go to men. A variety of factors – socialization, streaming in school, the cost of post-secondary education, early skills development, women's later start and discrimination – combine to ensure that few women acquire the necessary training for such jobs. As Mary Beth Dolin (1983:66) pointed out in her speech to the Conference on Women and Technology, only 8 percent of the Bachelor of Science and Engineering degrees went to women in 1980. Only 28 percent of those graduating in Mathematics and Physical Sciences were women. Only 4 percent of the students enrolled in computer technology at one Alberta community college were women. With very few women receiving the training necessary for these jobs, those which are created will go mainly to men, especially given that men are there first and only a relatively small number of good jobs will be created.

While some jobs are now being created in the third area, repair and maintenance, these are mostly going to men. These jobs are also likely to be limited in number and relatively short-lived. Maintenance and repair jobs have traditionally been filled by men, and few women have received the

training to do the work. Perhaps more importantly, microelectronic equipment is increasingly being built with component parts. Just as very few men work at repairing stereos and radios, few will be needed to insert the replaceable component parts. The newest machines can diagnose their own problems and outline the necessary repairs; some can even make the corrections themselves. Neither repair men nor repair women are likely to be needed in large numbers.

Women have a much better chance at the jobs involved in manufacturing the hardware, the fourth area of job creation. The majority of production workers in San Francisco's Silicon Valley are women. In his article on microtechnology, Mike Duncan (1981:178) describes the average production worker there:

> She is a woman whose second language is English because she is probably Chinese, Mexican or Puerto Rican. She is somewhere between 18 and 30 years old, has dependent children and has to pay for their care when they are not at school or when they are too young for schooling because she works a 40 hour week. She is most probably on some form of welfare because her pay, just over $5,000 a year, is either at or just above the legal maximum.

Few of these jobs will appear for such women in Canada, in part at least because more than half of the industries producing electronic products are foreign owned (Science Council of Canada, 1982:28), and they are likely to export many of these jobs to low-wage areas or countries. Moreover, those industries – electronics, telecommunications, office equipment and precision instruments – which are expected to have high growth potential are also, as the Science Council (1982:33) points out, "precisely the ones which will be using chips for product simplifications." As a result, their automated factories are unlikely to require large numbers of workers, male or female.

Men have a head start in the fifth area of job expansion outlined by Benston – selling the machines and teaching people how to use them. Few women have the necessary training and few are acquiring it. And considering these have traditionally been male jobs, they are unlikely to go to women when there are many men out of work. Moreover, the shift in educational institutions towards an increased emphasis on teaching computer skills may not only mean that more men get teaching jobs but also that jobs are reduced in the traditionally female teaching areas, especially at the higher levels.

New jobs then, are unlikely to compensate for those that are eliminated by microtechnology. This is not surprising given that the primary reason for their development was a saving in labour costs. Furthermore, the jobs that

do appear are more likely to go to men than to women, leaving many women permanently unemployed even if a recovery does occur. And finally, many of the jobs that do appear, especially for women, are likely to be deskilled, offering few rewards, few opportunities and little control over the work.

The Nature of the Work

The new technology has not been designed simply to increase productivity; it has also been designed to increase management's control. While the technology may be new, the process and the motivation are not. To achieve the real subordination of workers in industrialization — the transformation of craftspeople into factory operatives — tasks were separated, isolated and transformed into simple, repetitive, easily learned steps. Each step could be monitored, quantified, counted and the speed controlled by the employers. In the process, workers lost any control and independence they had gained from their knowledge, experience and the variety of tasks.

Computer technology allows an enormous range of mental and manual tasks to be broken down into simple yes/no decisions that can be made at an incredible speed by a machine, once it has been programmed with the necessary information. Microtechnology makes computer technology cheaper, faster, more reliable, less fragile and thus within reach not only of most public and private enterprises but also of many households. Like their earlier factory floor counterparts, this equipment allows management to separate and isolate tasks, to transform them into easily learned, repetitive steps and to monitor and control the speed of the operators as well as to record, and sometimes even to correct, the errors. In the process, these workers, like their nineteenth-century predecessors, have had their knowledge appropriated by management and built into the machines. They too have lost the independence and control that their knowledge, experience and the variety of tasks gave them.

Clerical work and cashier work — "women's work" — has been the most amenable to this process. Video display terminals and electronic cash registers record their operators' speed and errors. The skills required have been significantly reduced. Operators need little knowledge of the computer. They do not even have to know a special language, because the machines provide them with clearly written instructions in the language of their choice and the function keys are obviously labelled. As one observer put it, computer literacy is an idea whose time has passed. The skills now reside in the

machine, not the worker. A woman interviewed for *A Working Majority* (Armstrong and Armstrong, 1983b:159) explained, "Before, everyone was a typesetter. Now everyone works at a typesetting machine." Now the work has been divided up into simple, easily learned, repetitive tasks. In a survey undertaken by Abt Associates for the Women's Employment Division of Employment and Immigration Canada (1982a:60), 42 percent of the organizations surveyed reported that the word processor operator performed that function only. (An additional 12 percent did not offer an answer to this question.)

Although the new technology has made it possible to automate a wide range of clerical, sales and manufacturing jobs, in many areas it is difficult to increase productivity and control by breaking jobs down into easily learned and repetitive tasks that require little skill or knowledge. For a while at least, doctors, lawyers and dentists, for example, will be assisted by, but not replaced by, the microtechnological equipment. In addition to the difficulties involved in breaking down many jobs into simple tasks, there is often less motivation to do so. Many of the people in these occupations are self-employed and, while they are interested in increasing their efficiency and reducing their dependency on the labour of others, few are interested in decreasing their control over their work or in reducing the skill involved in it. Most of these professionals, and most self-employed workers, are men.

However, there is little guarantee that technical and professional jobs will be immune to monitoring and control through technology or that the people doing these jobs will retain a certain amount of independence as a result of their monopoly on some knowledge. Companies that employ technical and professional workers have devoted some effort to quantifying the labour involved in order to bring it more directly under management's control. In software production, for example, managements have been working to reduce the skill and independence of those writing and designing programs. Duncan (1981:187) quotes one senior manager who laid out the project clearly:

> As many functions as possible must be removed from the 'art' category of management. A measurement system is simply another tool which can be used by an alert management to increase productivity and quality, and to make the overall job of managing data processing easier.

As Benston (1983:51-52) points out, the development of "canned programmes and of structured programming is leading to an increasingly

refined division of labour in the software industry, one which allocates much of the work to lower level programmers." When women make it into the software industry, they are much more likely to get the jobs that are being deskilled.

Similar processes are taking place in other areas where large numbers of women hold professional jobs. On the basis of his research on work in the larger social service industries, Richard Williams (1983:13) concludes that

> new technologies combined with new management systems may have negative effects on social work as *work*, similar to what happened earlier in other fields of skilled work. The key concepts here are 'deskilling,' net reduction in good jobs – from the viewpoint of acceptable professional standards – and the generalized subordination of our professional goals of individual and social change to administrative preoccupations with 'efficiency' and 'productivity.'

In teaching and nursing jobs, computerized scheduling, as well as student or patient allocation, limits the choices available to these professionals, the majority of whom are women. And computerized grading and diagnosis reduce the skills required for these jobs.

Directly related to the increased use of the new technology to monitor and control workers is the change in promotion ladders. Fewer supervisors are needed when there are fewer workers and more of their work is monitored by the machines. Many of these supervisory jobs, especially in offices where many women work, have gone to women. The reduction in supervisory positions means that there are fewer routes for women up the career ladder. In addition, the distance between the women doing the new deskilled clerical work and those doing the remaining conceptual and managerial work may increase, making it very difficult for women to bridge the gap. In her case studies of chartered banks, supermarkets, an insurance company and a corporation head office, Menzies (1981) found that both the physical and skill gap between the female clerical workers and the largely male managerial and professional workers increased with the introduction of the new technology. Women's jobs became more dead-end. As the training involved decreased, so did the opportunities for advancement. Existing lower-level management jobs involving the transmission of information to people "down the line" or to other companies are also likely to be significantly reduced. More men than women now hold these jobs but women had recently begun to move up into these positions. They are therefore not only likely to be the first to go but they will also be deprived of yet another route to higher level jobs.

The new technology means that workers can be quickly trained and that work can be easily divided up into short, intense segments. Both these processes mean that part-time work increases and that part-time hours can be reduced. Most part-time workers and most part-time workers who get fewer hours of work — and pay — are women (Tables 4.6 and 4.13). At the same time, the investment in capital equipment grows, encouraging employers to make full use of the machines for as many hours as possible. Shift work may be introduced, making it difficult for women with family responsibilities to get or keep jobs. More common in offices is the intensification of the labour process, the lengthening of hours but not the pay of the workers. Between 1980 and 1982, the numbers of both women and men working extra hours grew but the increase for women was greater than that for men. In 1980, 23 percent of those working extra hours, but not necessarily getting overtime pay, were women. Just two years later, 29 percent of them were women.[1] It seems likely that many of these extra hours can be explained by the need to keep the new expensive machines at work.

The new technology also makes it possible for much of the work to be taken out of the offices and put in the home. In *The Seam Allowance,* Laura Johnson and Robert Johnson (1982:86) describe how homework in the garment industry forces women "into unhappy compromises in their roles as paid workers and as mothers and housewives." Such women are low paid, unprotected by unions and largely unprotected by labour legislation as well. Their hours are long, the tension is high. These high tension levels are created both by the conflict between their several jobs and by their isolation from other workers. Similar problems face the women who will work on the microelectronic equipment at home. The falling prices of the computers means that the employers can require word processor operators to purchase their own machines, just as the seamstresses do now. Thanks to the new technology, a whole new range of work can be quantified and monitored by the machines and thus done at home rather than under a supervisor's control. Piece work becomes possible. In addition to avoiding the expense of providing offices and equipment, and in addition to saving money on pay and benefits, employers also effectively prevent union resistance. At a Labour Canada conference on inequality in the workplace held in Toronto in the spring of 1982, a representative from a major employer of female clerical workers claimed that his company was now in a position to make half of its clerical jobs homework jobs. There is clearly enormous potential for increas-

ing the number of paid jobs done at home and most of those who will see their work transformed in this way are women.

All of these processes contribute directly to the increasing health and safety problems of those working with the new technology. At the 1983 Ottawa conference on women and technology, Gary Cwitco, a staff representative for the Communication Workers of Canada, showed that clerical work in the telephone office

> fits almost perfectly into Bertil Gardell's five key conditions of stressful work: 1) machine pacing and machine control; 2) monotonous, repetitious work; 3) lack of meaningful contact with other people; 4) piece rate payment systems; and 5) authoritarian control systems (Pelletier, 1983:88).

The very nature of the labour process and the way the technology is used creates increasingly high stress levels for the workers. Attention has focused more on the physical problems, such as the eye strain, backache and miscarriages associated with the lighting, ventilation and radiation factors connected to the use of video display terminals. These problems are also easier to solve since they involve changing some of the hardware, not the nature of the labour process itself. But as Russell Wilkins (1982:422) points out in his survey of research in this area:

> a consensus of opinion holds that only about *half* of the excess health problems experienced by VDT operators could potentially be corrected by attention to such things as better lighting, better workstation design and more frequent rest breaks – the areas of concern most amenable to direct regulation. The other half of abnormally high health problems frequently associated with VDT workplaces is not physical but psychosocial in nature. And this type of problem requires that questions of poor design and the dehumanization of work be confronted head-on.

The problem is machines that have been designed to increase the productivity of the workers and the control of the management, not to enhance the efficiency, skill and "job satisfaction" of the workers. Women are not only the majority of workers that will be put out of work by the machines but they will also be the majority of those forced to deal with some of the worst of the new equipment, and with the health problems generated by it.

Finally, the new technology makes it more difficult for workers to resist. Employees are more likely to be physically separated from each other when they are in the office and will certainly be separated form each other when

they work in the home. In addition, the job loss resulting from the new technology increases the size of the reserve army and thus the threat of unemployment. This in turn decreases workers' strength and their will to resist, especially when much of the loss is blamed on the crisis, not technology, and when technology is seen as the only way out of the crisis. Union membership may also decline both because there are fewer workers and because, as Jane Stinson (1980:12) of CUPE has pointed out, employers can create new positions which they try to exclude from the bargaining unit. Unions have not been very successful in dealing with the new technology. Some have been able to save people but few have been able to save jobs. More importantly, none has been able to halt the changes in the labour process and it is these changes that are the most crucial in terms of the jobs that remain. However, the new technology is also making work more homogeneous and this may lay the basis for greater worker strength. The capital-intensive nature of the work also means that it is more vulnerable to disruption through strikes and other means of worker resistance. And finally, capital is still stuck with the old contradiction. Without jobs, people cannot buy the products. Capital is creating its own problems with the new technology.

The new technology is both a cause of and a solution to the crisis. The employment impact of the technology is both hidden by the crisis and promoted by it. Resistance to the technology is broken down by the growth of the reserve army during the crisis and by the promise that the new technology will eventually create employment and improve competitiveness, thus ending the crisis. Whether or not a recovery takes place, it is clear that work will be transformed, that jobs will disappear and that the nature and conditions of work will change for both women and men.

As the new technology increases productivity and reduces the number of workers required, the least protected in all sectors are part-time employees, those most recently hired, those not yet hired and those without union protection. The overwhelming majority of part-time workers are women. Since it is women's labour force participation rate that has been rising in recent years, women are likely to be the majority of those most recently hired. And fewer women than men belong to unions. In addition, since more women than men are forced to abandon their paid work in order to follow their spouse's job, to care for aging relatives and to look after young or ailing children, women are more likely to be subject to silent firings, to the elimination of the position when the worker leaves. Most of the jobs immediately threatened by the new technology are currently performed by women. While

some of the new jobs will go to women, men are more likely to get the highly skilled computer-related jobs while women have a better chance at the deskilled, closely monitored, dangerous work. The new technology will affect us all but women will be the first and hardest hit.

Women's Future Strength

The future does not look bright for women. The economic crisis is increasing their unemployment and halting the growth in their participation rates. Job creation programs offer women little assistance and government restraint programs will throw many women onto the unemployment lines and deny women some of their best jobs. Part-time work will continue to increase, although here women will face growing competition from men. Union membership will probably decline as jobs disappear in those areas where women have collective agreements. The new technology will affect women first and most, eliminating many female jobs, reducing skills in others and widening the gap between those operating the machines and those directing the work. Contradictory pressures work to unite and divide women; similar processes both separate them from and bring them together with men.

The possibility that government restraint programs will limit women's union membership has already been discussed. What has received little consideration are the factors that divide female from male workers and women from women, the factors that reduce the strength of the working class and of women. These are not easy to set out because there are contradictory processes creating both division and unity. And they are not easy to examine empirically, because there is little information available on what is currently happening within households. But, given the preceding analysis, it is possible to outline the pressures and speculate on their effects.

With more women making it into the seats of power and into the traditionally male technical and professional jobs but with even more women segregated into low paying, dead-end jobs, the differences between women in the labour force will increase. And with this trend, the tendency to blame the women rather than the structure of the market for the inequality will also increase. As unemployment rises for women and jobs become more difficult to get and keep, the gap will grow between those with and those without paid employment. As part-time work increases, so will the separation between those with a whole job and those with part of one. As women's union membership ceases to grow, the differences between those with and

without union protection will at least be maintained. The differences may increase if governments introduce more user pay services and cut back on social support programs, since unions may negotiate these benefits into their contracts. As "homework" expands, the separation between those who go out to work for pay and those who work for pay at home will grow and so will the differences between those who get paid for working at home and those who do not.

Unpaid household work will expand, primarily for women, but it will not be uniformly distributed among women. The workload will increase the most for women married to unemployed men, and for unmarried women not living with an employed adult, as they are forced to compensate for the reduction in state services and in income as well as deal with the increase in tension. The pressure on these women to get and keep paid jobs will also grow but the jobs they get will be low paid and short term. The women least likely to increase their domestic workload are those who are employed in high-level jobs and who are married to or living with men in similar occupations. Such women can afford to pay for services and are more likely to have full benefit coverage even when the state cuts back. The women who do homework or who have no paid work will have little relief from their unpaid domestic labour. The gap between those with and without children will also grow, as the state provides less and less support for childrearing.

On the other hand, there are processes that may bring women together. More jobs are becoming routinized and deskilled. More and more women employees are facing unemployment and few jobs are secure. More and more women will find the household income inadequate and will seek paid work. Fewer and fewer will be able to compensate by intensifying their domestic labour. The reaction against legal abortions, the reduction of recreational and afterschool activities for children, the cancelling of human rights commissions and the downgrading of medical services will give women common concerns. So will the continuing strength of a patriarchal ideology.

There are also pressures that divide and unite women and men. Scarcity of jobs increases competition between the sexes for the work that remains. But increasing male unemployment or falling real wages and declining state services may also mean that men want and need their wives to work for pay. Unemployed men are more likely to be able to rely on unemployment insurance while women are more likely to have to rely on others or on welfare programs. Although this difference may create a gap in their consciousness, it may also unite those who are denied wage labour. The gap between the

good and bad jobs will probably increase with the new technology; many more men than women will be in the better jobs and their interests will continue to diverge. On the other hand, more male jobs will also be deskilled and as men move into traditional female jobs such as elementary school teaching, their interests will converge with those of women. But women will continue to have the babies and to bear the primary responsibility for their care, and this process will continue to offer a basis for segregation and for shared female concerns. As more women find themselves unemployed or doing "homework" more of the domestic labour is likely to fall to them, separating their interests from those of men. Patriarchal ideology may be strengthened rather than challenged, uniting men against women. Sweeping government restraint programs may encourage women and men to work together, as they did in British Columbia's Solidarity Coalition. However, men still have more power.

The pressures are contradictory and the outcome difficult to determine. The factors uniting women remain stronger than those uniting them with men, although the increasing similarity of many jobs in the market, the growth in women's labour force participation and the reduction in state service and support may bring women and men together. The working class still has two sexes and this limits its strength. The new processes underway during the crisis may also limit the strength of women, dividing them further from each other. The application of the new technology, however, may bring women together in a fight against the elimination and transformation of their labour force jobs and may also encourage them to work with men.

The future is not predetermined. Women will be active in making their futures. But, given the forces now at work, they are likely to lose more than men.

NOTES

[1] Calculated from unpublished Statistics Canada Labour Force data.

CHAPTER EIGHT
CONCLUSION

CAPITALISM DEVELOPS BY LEAPS and jerks. Crises are inevitable. Technological change is an integral part of this process, causing and resolving such crises, reflecting and promoting a restructuring of the political economy. The state actively intervenes in an effort to smooth out the worst bumps, to encourage profit-making, to sustain the growth of a healthy and educated workforce and to limit the harshest effects of economic hard times. While those with the economic power and the state set the stage, their interests do not always prevail, both because people resist and because the results of the efforts of the powerful are often contradictory. The consequences are also different for women and men, because the labour in the formal economy and in the household is highly segregated.

This book sets out to demonstrate that the new technology, as well as state programs and policies, must be included in any analysis of the crisis; that the uneven development of capitalism in crisis has a different impact on the interpenetrating – but not uniformly progressing or functionally related – formal economy and household; that the effects are different for women and men; and that, as the crisis continues, women will likely lose more than men.

The analysis of the data shows that segregation has continued, and has even increased in some areas. While women seem to have made some significant gains in managerial work, the data may primarily reflect the reclassification, as a result of the new technology, of many formerly clerical

jobs as executive work. A few women have made it into senior management positions but this movement is probably over. Gillian Barnes, one of the four women vice-presidents of a Canadian bank, explains that "putting women into a decision-making position is considered risky and, in hard times, banks are not generally willing to take that risk. They want to play it "safe" (reported in *The Montreal Gazette,* September 10, 1983:G-1). Women continue to dominate the health and education fields, but they have made little progress in capturing the top jobs there. A recent study of Ontario's Peel Board of Education secondary schools revealed that only 7.7 percent of the principals and 6.5 percent of the vice-principals are women (reported in the *Globe and Mail,* June 24, 1983). Service work is more and more women's work and women have had very limited success in gaining entry to traditional male jobs in the primary industries, in construction and manufacturing.

Following the established pattern, the crisis has hit first and most obviously many of the primary and secondary sectors, the areas where men work. Men experience the sudden and visible loss of full-time jobs. Their unemployment is concentrated in a limited range of industries, occupations, even cities. However, when and if a recovery takes place, many of these jobs are likely to reappear and, since these sectors are already capital-intensive, the impact of the new technology will be more limited than it is in other more labour-intensive areas where women work. Moreover, state job creation programs are primarily directed towards those industries and occupations where men are employed and unemployed. State cutbacks, on the other hand, should not have a major effect on men's employment, since male employment is not concentrated in those areas supported directly or indirectly by the government and since many of the men who are there were there first.

The service industries, where the majority of workers are women, are only now suffering from economic hard times and many have profited during the crisis. Women's unemployment has been more scattered and less visible, both because it has not meant massive layoffs for large numbers of women at the same time, and because it has frequently involved the transformation of full-time jobs into part-time ones and the reduction of hours for those already in part-time work. However, women's unemployment rates are higher than men's in all areas where enough women work to make the statistics reliable, and the decades-old steady growth in women's labour force participation has abruptly halted. The number of women not looking for work

CONCLUSION

for "labour market-related" reasons, and therefore not counted as unemployed, has soared. And, where women directly compete with men for jobs, the women usually lose. Recovery is once again beginning in the service sectors but this is likely to mean rising profits without growing employment, since the new technology that helps make recovery possible will replace many of the largely female workers who are employed in the labour-intensive industries. State job creation, directed at areas where few women work, will do little to increase jobs for women, and state cutbacks directed towards areas where women are concentrated, will eliminate many of women's best jobs. Indeed, it is state employment that has primarily protected women during the early years of the crisis and kept their overall unemployment rates lower than those of men. With the signs of a weak recovery, men's unemployment rates are dropping but women's are not.

The household has felt the impact of, and been responding to, the crisis. As the state reduces support for social programs and as household incomes decline, women's work increases. Both women and men face deteriorating conditions at work and this increases the tension and violence at home, altering the nature and conditions of work there. It is primarily women who are responsible for handling the tension. It is mainly women who are the subjects of the violence. It is mostly women who intensify their labour to make up for falling or disappearing wages. It is almost exclusively women who look after the old, the sick, the young and the not-so-young children when the state no longer provides care for them outside the home. It is women's household work that increases the most as the crisis continues. And it is usually women who bear the greater burden of the work and the loss in income if the marriage breaks up in these hard times.

There are, however, real limits to these developments. The relationship is not one-way, not functional. Women find it increasingly difficult to compensate for lost wages by working harder at home. Women are not always willing or able to give up their access to even the low wages they can command. The pressure on women to seek paid work increases while their jobs decline. Falling consumption also interferes with recovery. Workers are also consumers, and employers can go only so far in cutting wages and reducing employment. The state can cut back only so much before consumption and the state's ability to legitimate the cutbacks drop too far for the system to bear.

Ideology is also changing. Keynesian economics have been abandoned; inflation, not lack of jobs, is seen to be the problem. Research studies argue

that babies need their mothers. Women's right to control their bodies is under attack. Human rights commissions that have offered some redress for women in the past are in danger of being restricted or eliminated. Equal pay for work of equal value is being removed from the agenda. Governments address their programs to the unemployed "prime-age males" and lump women with the young, the old, the handicapped, disabled and Native Canadians as groups requiring some special but limited treatment.

Women have not passively accepted their deteriorating position at home or in the labour force. Their responses have had varying degrees of success. Action, or threat of action, has managed to alter somewhat state employment policies in Quebec and British Columbia, to raise concern over the issue of pornography, to encourage special studies on part-time work and the impact of technology. Women's ability to act collectively may be more restricted in the future, however. As Don McGillvray has pointed out in his *Montreal Gazette* column (November 4, 1983), "More and more, unions are confined to the shrinking industrial sector and shut out of the expanding service sector." Men work in the industrial sector, women in the service sector. In addition, the most highly unionized women are those who work directly or indirectly for the state and state cutbacks will lower the number of women union members. The jobs that are growing are in non-unionized areas. Indeed, some movement of women into management may reflect a reclassification designed to remove them from the bargaining unit. As technology and unemployment push more women back into the home, they will be more isolated and less able to resist.

While women in general are losing ground, the impact of the crisis has not been the same for all women and men. Differences may increase between those women who have jobs and those who do not; those who have full-time and those who have only part-time work; between those who work, with or without pay in the home and those who go out every day to work; between those who must intensify their domestic labour and those who do not; between those who have employed spouses and those who have unemployed ones or none at all. The crisis may also put men and women in more direct competition for jobs, increasing the distance between them. The increasing economic pressures on the family may, on the other hand, mean that men, too, have an interest in women working for pay. Increasing pressure resulting from declining incomes will serve to bring some families together to struggle against the system and it will tear others apart.

CONCLUSION

The impact of the crisis is not uniform across industries and occupations, for the household and the formal economy or for women and men. Although there will be differences among women as well as differences between women and men, it is clear that most women will experience similar consequences, and ones that will differ from those experienced by most men. It is also likely that, as the crisis develops, women's position will deteriorate, and more than that of men. Unless, of course, we get together to do something about it.

APPENDIX

METHODOLOGY

LIKE MOST RESEARCH IN CANADA attempting to analyze the national scope of a particular issue, this book relies mainly on Statistics Canada sources. And like most research, it must therefore depend on the issues, questions, response alternatives, sample, categories, time periods and in many cases, the tabulations selected by the federal data collection agency. Any investigation of women's work also faces some specific problems. The data are often sex-blind. While many of the data are or can be tabulated by sex, the segregation that creates very different situations and problems for women and men in the labour force is seldom taken into account in developing the data collection techniques. In addition, that other half of particularly women's work – domestic labour – is seldom included in national sample survey or Census data.

Moreover, there are particular problems related to the examination of current situations. There is always some time lag in the data, making it difficult to analyze a crisis in progress. Changes over a few years are small and more difficult to interpret than long-term trends. It would be easier to wait for the crisis to pass and then analyze the impact. But that would also mean that the research could play no part in influencing or averting the consequences of the crisis. These and other limitations on the data are considered here as part of a discussion on data sources and their use.

APPENDIX: METHODOLOGY

The Census

Theoretically at least, all Canadians are counted in the Census every ten years. In the most recent Censuses, a sample (1/5 in 1981, 1/3 in 1971 and 1/5 in 1961) of the population fifteen years of age and over, excluding inmates, was asked about their work. For the purposes of the Census, and for the monthly Labour Force Survey as well, work was defined in the following way:

> It includes working for wages, salary, tips or commission, working in their own business, farm or professional practice, or working without pay in a family business or farm owned or operated by a relative in the same household. "Work" excludes housework or other work around the house, and volunteer work (Statistics Canada, 1982:17).

Although not limited to paid employment, the focus is on work that results directly in profit or exchange, work that brings individuals money income. Similarly, for the Labour Force Survey,

> The concepts of employment and unemployment are derived from the concept of the supply of labour as a factor of production measured over a short interval of time. The production referred to is in turn defined as those goods and services included in the National Accounts (Statistics Canada, 1979:15).

A wealth of data about this work is collected, including hours, amounts and sources of income, occupations, industries, places of work, and weeks worked in the previous year. Data on the personal characteristics of workers are gathered as well. Information on households – their composition, structure, income, payments and facilities – is also generated, although some of it was requested for the first time in the 1981 Census.

The Census provides the most comprehensive data available at regular intervals on this kind of work. Because the sample is so large, it also offers detailed information on a wide range of labour force activity and household facilities. It is thus the best primary source for an historical examination of the labour force and of some trends in household composition and facilities. In Chapter Three, Census data are the basis for the analysis of the restructuring, since the Second World War, of the labour force, including the alterations in the sex composition of that labour force, and for the analysis of some aspects of household labour.

There are problems, however, in using Census data to examine the impact of the crisis on sex-specific work in the household and in the formal economy.

The most obvious difficulty results from the definition of work. Statistics Canada does not count all the ways people spend their days or expend their energy, how they survive on a daily basis, how food gets to their tables or even how they improve their standard of living. The work most women do in their households as well as the important volunteer work they do in hospitals, schools, playgrounds and a variety of other institutions disappears. While research[1] indicates that women do most of the domestic work, men do cut lawns and wood, fix faucets and repair cars, and this work is also invisible. Such work, which falls outside the definition used by Statistics Canada, is likely to be of increasing importance in tough economic times, as women and men try to compensate for falling incomes by intensifying their labour in the household and as the state cuts back on many services.

Even the data on labour force work have severe limitations for the purposes of this study. Most importantly, the data provide only snapshots of some details of employment and unemployment taken every ten years. What appear as long-term trends may be concentrated in the shorter periods. Indeed, trends may have slowed or reversed in recent years but there is no way of telling from the Census data. The data may even reflect a temporary upturn in what is otherwise a declining employment picture. For an assessment of the impact of the crisis, the recent years are critical and changes during this period cannot be examined with Census data. Similar problems arise in using the available Census data on household composition and facilities.

The Census data permit an examination of overall trends in the structure of the labour force, but changing definitions and changing jobs make detailed historical analysis difficult (see Armstrong and Armstrong, 1978:Chapter 2). And, since little information is collected on the nature and conditions of work, there is no way of determining whether or not growing numbers in occupational categories reflect actual alterations in people's daily working lives. The increasing number of women in some jobs may be more an indication of changing job content than of improving conditions for women. Such processes are not confined to clerical, sales and factory work. The growing number of female lawyers, for instance, may be a consequence of and may contribute to the increasing stratification and narrowing tasks in this occupation.

Thus, Census data may be used to develop a picture of patterns over time in the structure and composition of the labour force but there are considerable limits placed on any analysis relying solely on this source. Therefore,

APPENDIX: METHODOLOGY

Chapter 3 also examines a range of research studies and some other – particularly government – data sources to supplement and extend the analysis.

The Labour Force Survey

Statistics Canada conducts a Labour Force Survey each month. Approximately 55,000 households across Canada are included in every survey. Each dwelling is kept in the sample for six months, with one-sixth of the households retired and replaced for each survey. Using the same definition of work as they do in the Census, Statistics Canada interviewers ask questions about the labour force activity of all household members over the age of fifteen, excluding those residing in the Yukon and the Northwest Territories, residents of Indian reserves, full-time members of the armed forces and inmates of institutions. Thus, although the definition of work is the same as that used in the Census, the populations are not strictly comparable.

The data collected in the Labour Force Survey refer to a particular week in the month, normally the week containing the fifteenth day. Changes in the reference week can produce considerable monthly variations in the data but these tend to be smoothed out if annual averages, rather than monthly statistics, are used. Although more limited in some areas than the Census, the interviews include questions on the number of people with or without work (as defined by Statistics Canada), their occupation and industry, the hours worked, their job search methods, some work history, and the reasons for hours lost, hours worked, absence from work and job loss. Some information is collected on household composition and on the educational activity and achievements of household members as well.

Because it provides monthly and yearly statistics, because it covers many aspects of labour force work as well as a few on household composition, and because it is the most regular and reliable information available, the primary data from the Labour Force Survey provide the basis for much of the analysis in this book, particularly for the examination of recent occupation and industry trends undertaken in Chapter 4. It is possible, from these data, to follow the broad outlines of the combined and uneven development in different industries and occupations, and, consequently, for women and men. Both published and unpublished data are used here to monitor changes by sex in employment, unemployment and hours of work as well. The unpublished data that cross-tabulate industries and occupations permit some examination of the kinds of work women and men do within the broad

industrial categories used by Statistics Canada. Data available by three-digit categories allow the analysis of segregation by fifty-one industry divisions and eighty occupational groups.

But even with these breakdowns, a major problem with the data remains the lack of detail. Given the sample size, unemployment rates cannot be reliably calculated for the three-digit groups, making it difficult to tell whether or not women and men are directly competing with each other for jobs. Moreover, the three-digit employment figures are not available for earlier years. As a result, there is a problem in determining the impact of the crisis on the specific jobs of women and men. Although three-digit figures do permit a much more extensive investigation of segregation and competition between the sexes than do data organized by nine or even twenty-one groups, they do not provide enough information to determine whether or not women, for instance, are losing jobs as cleaners or as supervisors in the knitting mills and whether or not they are losing either of these jobs to men, to workers in foreign countries or to machines. Census data, however, can offer some clues by providing information on the segregation that existed in 1981.

In addition to the lack of detail and to the more general problem shared with the Census, of the definition of work, the Labour Force Survey uses some categories and definitions that make it difficult to monitor the impact of the economic crisis on women and men's work. The way occupations are grouped often camouflages major inequalities or shifts within categories. The Managerial, Technical and Professional category, for instance, includes lawyers and library technicians, physicists and lab technicians, social workers and safety inspectors, board members of major banks and their executive secretaries. Even within the more detailed occupation categories, large differences and major changes may be hidden. Executive secretaries, for example, are classified as other managers and administrators. Their numbers may increase as a result of office reorganization following the introduction of new technology, or of the intensification or rationalization of the labour process or simply as a result of alterations in titles. In any case, the power, pay and duties of the secretary, usually a woman, may remain much the same. This is particularly a problem with Labour Force Survey data. As Statistics Canada (1982:37) points out in the *1981 Census Dictionary*,

> Since no question is asked on the most important activities or duties in the job held, as in the census, the Labour Force Survey may classify more persons to the

APPENDIX: METHODOLOGY

"Managerial" group on the basis of job titles than would be the case in the census.

What appears as a movement of women into management may merely indicate that some women have had their job titles changed. Growth in the teaching category may also falsely suggest that women are increasingly moving into what are traditionally thought of as teaching jobs. The occupations lumped together under University Teaching and Related Occupations include jobs, not elsewhere classified, that are concerned with university teaching and related activities, such as lab technician and teaching assistant. Similarly, the "Other Teaching and Related Occupations" category covers education technologists and technicians as well as persons providing on-the-job training, who are considered to be distinct from foremen. In both these groups, the pay, job security and unionization are significantly lower than in teaching jobs and this work may be the first to go in times of restraint.

Industry categories also make it difficult to examine and predict employment patterns for men and women in a crisis economy. State sectors, for example, cannot be separated out from other industries, although they respond to different kinds of pressures. The broad Community, Business and Personal Service category includes universities and hairdressing salons, social work agencies and security companies, drycleaning establishments and hospitals, companies providing computer services and restaurants offering gourmet food. Each may respond to the crisis in very different ways, creating quite varying consequences for the employment of women and men.

Even when the more detailed categories are used, unequal development is frequently camouflaged. The most obvious example is the Retail Trade sector, where small dress boutiques may go bankrupt while large department stores take over their business, releasing the largely female staff in one and perhaps maintaining male staff in the other. Less obvious is the Insurance Agency and Real Estate category. Insurance companies may be suffering little from the crisis; new technology may be making their business more profitable, while real estate agencies are facing hard times.

The variations in profits, and in male or female employment, may be enormous and have different features. Data cross-tabulated by industry and occupation do overcome some of these problems. But only more detailed industrial and occupational data could provide the basis for a full view of the impact of the crisis on the sexual division of labour.

More generally, there are problems in both the Labour Force Survey and the Census with the definitions of employment, unemployment and parttime work. Employed people are those who did any work at all during the reference week or who had a job but were not at work because they were sick, on vacation, on strike or were prevented by bad weather or by personal or family responsibilities from going to work. Since work is defined as "any work for pay or profit. That is paid work in the context of an employer-employee relationship, or self-employment" and unpaid work is included if it "is defined as unpaid work which contributes directly to the operation of a farm, business or professional practice owned or operated by a related member of the household" (Statistics Canada, July 1979:16), women who do full-time unpaid housework or volunteer work generally are not counted as employed but if they do unpaid work on their husband's farm, they become part of the employed labour force. Moreover, tax changes in 1980, which for the first time permitted the deduction of spouse's wages as expenses, may switch the status of some women from unpaid to paid workers or even get them counted as employed for the first time, although the work they do on a daily basis may not change at all. This artificial inflation of those recorded as employed is pushed higher by the fact that any work for pay, no matter how brief, puts people into the category of the employed (labour force).

On the other hand, questions on overtime hours may fail to reveal the fact that those who have full-time jobs now work longer hours, since people usually report overtime only if they are paid for it and if it means the extension of work beyond what are defined as the usual hours. Indeed, Statistics Canada is searching here for unusual hours. Regular hours may be lengthened during the crisis as a means of cutting wage costs, but the categories used by the Labour Force Survey for hours of work are unlikely to expose many of these changes. Therefore, the figures on employment may hide the increasing underemployment for some and the intensification of labour for others, while entirely failing to record what is happening to most unpaid work in and out of the household.

Some data on unpaid workers are available and are used in this study. Generally, however, it is necessary to use the employed as the basis for analysis, since these figures are the most reliable, as well as the most commonly tabulated and readily available. Data on hours are also analyzed but they provide only an indication of general trends.

APPENDIX: METHODOLOGY

The 1975 revisions to the Labour Force Survey extended (from two to four) the number of weeks during which job search activity would count towards being classified as unemployed, and in the process significantly increased the number of women counted as unemployed. People who had not looked for work in the last four weeks because they were on lay-off for twenty-six weeks or less from a job they expected to return to and who were available for work are also counted as unemployed. So are those people who quit looking for a job because they have found one that will start in four weeks or less although they must also be available now for work. For the purposes of the Labour Force Survey, included in the available category are full-time students seeking part-time but not full-time jobs and any person who reported "that there was no reason why they could not take a job in the reference week, or, if they could not take a job, it was because of 'own illness', 'personal or family responsibility' or 'already had a job.'" Unemployed are allocated to occupations and industries according to the most recent jobs they held in the last five years.

There can be little doubt that this way of defining unemployment does not accurately reflect the number of people who want and need some or more paid work. Some people who have been laid off during times of crisis but who think they have a job to return to are recorded as unemployed even though they consider their situation temporary. Many more men than women are in this position. However, the definition of unemployment used by Statistics Canada mainly underestimates rather than overestimates those without a paid job or the promise of one. Because women have another job in the household, because many of them have been out of the labour force for some time and therefore are discouraged from searching for a job, women's unemployment is more likely than men's to go unrecorded. Early in the crisis, Robert Stirling and Denise Kouri (1979:194) estimated that the unemployment rate would increase by more than eighteen percentage points over the official rate if conditions at home and in the labour market were altered to improve pay, working conditions, child-care facilities and other forms of assistance and that 87 percent of these potential workers were women.

More recently, Statistics Canada has developed a number of supplementary measures of unemployment that clearly indicate how the way unemployment is counted and defined alters significantly the number officially recorded as searching for work. If, for example, "the definition of unemployment is expanded to include persons not in the labour force who have sought work in the past six months, but are not currently looking for 'labour market

related reasons'" (Webber, 1983:10) – such as the belief no work is available, waiting for replies from job applications, or waiting for recall from a former job – the unemployment rate for 1982 increases from the official rate of 11.0 to 12.7 (1983:Table 1). If the unemployment rate for the full-time labour force is calculated by showing unemployed people seeking full-time jobs plus one-half of involuntary part-time workers as a percentage of the full-time labour force, the same effect is achieved, as the unemployment rate again becomes 12.7 (Webber, 1983:Table 1). A similar calculation has been made for part-time workers and this too produces a higher unemployment rate.

Even more startling is the estimation of underemployment in terms of hours. To calculate the unutilized hours, Webber (1983:11) included "a) hours lost through unemployment, b) hours lost by part-time workers unable to find full-time work, and c) hours lost due to working short time (e.g. work sharing)." This underutilization rate based on hours worked and hours "offered" raises the unemployment ratio to a whopping 15.3 (1983:Table 1).

When the full-time unemployment rate is calculated by sex, women's unemployment rates are significantly higher (14.3 versus 11.7 in 1982) than those of men (Statistics Canada, July 1983:95). More women than men are also likely not to be in the labour force for labour-related reasons. This figure too is likely to be significantly higher for women than the official rate would suggest.

There is also a problem with the distinction made between part-time and full-time work. According to Statistics Canada, people are employed full-time if they usually work thirty hours or more per week or if they usually work less than thirty hours but consider themselves to be employed full-time. As a result, many people who are considered by their employers to be part-time and thus receive the same limited benefits, pay, job security and right to join the union as part-time employees, are classified as full-time workers. Since the overwhelming majority of part-time workers are women, it seems likely that a large proportion of these part-time workers who disappear into the full-time category are women. The data on hours do not allow them to be sorted out easily from those who receive full-time rights and benefits.

In spite of these and other difficulties with the Labour Force Survey, it does provide regular, reliable, current data that are readily available. For

APPENDIX: METHODOLOGY

these reasons it forms the basis for the analysis of women and men's employment trends during the crisis. However, because of the limitations in the Labour Force Survey, it is necessary to use other sources to supplement the data, and, when none are available, to speculate on the basis of known past trends.

Other Sources

Statistics Canada itself provides some of the most important alternative information on the regular Labour Force Survey. Indeed, some of the most useful data collection is done as a supplement to that survey. Both the primary data and the analytical material from surveys, such as the one done in 1983 on the job search activities and the desire for employment by persons not in the labour force (Statistics Canada March, 1983), are used in various parts of the book to extend the analysis. So are articles, such as that on family characteristics and labour force activity (Statistics Canada, May, 1982), which offer analysis of previously unpublished data collected in the Labour Force Survey. Special surveys, such as the one investigating child-care arrangements and that examining volunteer work, and those regularly carried out on a wide range of economic indicators, also provide useful additions to the information gathered through the regular monthly surveys. A major problem with many of these surveys, however, is their infrequent and irregular publication.

Government departments and agencies other than Statistics Canada generate data that are employed here to extend the analysis beyond that possible using Statistics Canada data alone. In addition to the kinds of problems discussed in relation to Labour Force Survey and Census data, these sources often use definitions, categories and time frames that do not match those of Statistics Canada. Moreover, many are much more outdated by the time they are published than Statistics Canada data, making it difficult to monitor a crisis in progress. Some are difficult to obtain, in spite of new freedom of information policies. However, once again they are the only sources available and while they do not often provide information neatly organized for an examination of crisis-induced consequences for women and men's work, they do offer some indication of current trends, particularly in the areas of household consumption patterns, child-care arrangements and unionization.

Government sources of any description provide little information that is of use in analyzing the division of labour in the household, changes in the

nature and conditions of domestic and wage labour or in monitoring the impact of the new microelectronic equipment. Such data are difficult to generate through national survey techniques[3] and expensive to gather. Therefore, the chapters on future employment trends and on household labour rely heavily, but not exclusively, on other research studies that have explored these issues. While depending primarily on the researchers' analysis of their data, in some cases these data are reinterpreted for the purposes of this analysis. Once again, the problem is one of categories and definitions that are inconsistent, of questions asked and not asked, which limit the ability to examine the impact of the crisis on men and women's work.

Nevertheless, there is enough information available from this range of sources to investigate the broad trends, to indicate what the impact of the crisis is likely to be on the work of women and men and to suggest where further information is required if the consequences of the crisis are to be influenced by public policy makers and by the actions of male and female workers.

The Use of Sources

This range of sources can be used in a variety of ways. It is therefore important to clarify the concepts employed and the manipulations made to the data.

The concept of the economic crisis can have a variety of meanings. As Michael Lebowitz (1982:5) points out in an article on Marx's theory of crisis, "We see crisis all about us – in falling rates of profit, capital strikes, capital flights, unemployment, raw material shortages and falling real wages."

With even *The Financial Post Magazine* (March 1, 1983) featuring Marx on the cover and suggesting in its lead article that perhaps Marx might just be right, with a warning that, if this is the case, "senior corporate executives had better begin to thumb through the pages of *Das Kapital* (Weiner, 1983:22), it seems only appropriate to use a marxist definition of crisis. Gamble and Walton (1976:2), in their book on *Capitalism in Crisis*, explain:

> Marx used the term in the main to refer to economic and commercial crises which were interruptions to production and the process of capital accumulation, and took the form of (i) goods piling up because they could not be sold profitably, (ii) widespread bankruptcies, (iii) financial panics, (iv) cutbacks in production, and (v) mounting unemployment.

APPENDIX: METHODOLOGY

They go on to explain that "such crises are not merely economic but political and social as well." This marxist definition points to some concrete economic measures of crisis, while at the same time suggesting that political and social developments be considered. It differs from other definitions in that it extends the problem beyond a strictly defined economic sphere. What this definition fails to do is extend the concept of crisis to include the household. The counterpart of these processes happening in the formal economy is falling household incomes, rising stress and marital disruption, intensification of labour and personal bankruptcies. These too will be included in the definition of crisis used here.

Difficult to separate completely, the concepts of household and formal economy are also often difficult to define. Moreover, households and families are not always either practically or theoretically distinct, although the terms frequently have different meanings. As L.J. Jordonova (1981:44), in her article on the history of the family, explains:

> Demographers have tended to study households, that is, those living under one roof. Although this solves many of the practical difficulties which might otherwise stand in the way of quantitative analysis, it does not express the full complexity of the term 'family.' Family is also, of course, a normative notion and carries with it connotations of ideal, stable social units.

Chaya Piotrkowski (1978:8) expands on this distinction:

> Whereas the concept of the family refers to patterns of kinship and the relations among relatives, households are social systems that organize material resources and labor for the social and physical maintenance and reproduction of people.

Following Piotrkowski's definition of the term, this book examines households, not families. This definition facilitates the use of available statistics and more closely coincides with a perspective that views domestic arrangements as primarily but not solely economic units (thus avoiding the problem of dealing only with those groups which are defined or define themselves as a family).

The formal economy is defined, as it is by Statistics Canada, to include the product and labour markets. For the most part, the other definitions used here are those of Statistics Canada as well, since these data form the basis of the analysis. The focus of concern is the jobs available or not available and the number of people without paid work. Therefore, most tables refer to the employed, the unemployed and part-time workers.

The term labour force is used in tables when overall trends in participation are considered, but because it includes both the officially employed and the officially unemployed, it often creates a false impression of job growth and therefore is only occasionally used elsewhere in this study. The employment/ population ratio indicates the percentage of the population fifteen years of age and over who are officially employed. It thus provides a more accurate picture than the labour force participation rates of the proportion of the working age population who actually found jobs. However, many of those who found jobs had only a few hours of work. In order to obtain an indication of those of working age who found full-time jobs, we developed a measure called the full-time employment / population ratio (Armstrong and Armstrong, 1982a), and this figure is used in Chapter Three to indicate the relative success of men and women in finding full-time jobs in the labour market.

In our previous work (Armstrong and Armstrong, 1978), we also introduced two measures of segregation that are used here to explore the changes over time in the allocation of jobs to women and men. The degree of sex-typing is measured by calculating the percentage of all workers in an industry or occupation who are female. In other words, this figure indicates what proportion of jobs go to women. The degree of concentration is measured by calculating the percentage of all female workers who are employed in an industry or occupation. This figure indicates whether or not the proportion of women working in a particular occupation or industry has changed over the years. Percentages, rather than actual numbers, are used in most cases because they indicate the proportionate, that is, the relative change. And the relative changes between women and men and those during the crisis are what is of interest here. Because percentages are used, the changes in numbers often appear quite small. However, it must be remembered that these small percentage changes may represent large numbers of workers. If, for example, the proportion of women working in private households increased from 2.7 to 2.9 between 1980 and 1982, this means that more than 8,000 additional women worked in these jobs.

As well as changes in employment and unemployment, sex-typing and concentration, the book also examines the creation and elimination of jobs in occupations and industries, for women and men, for full-time and part-time work. These figures are calculated by subtracting the 1980 numbers from those for 1982, separating the job creation from job loss and then organizing them according to their relative contribution on each individual table. In

APPENDIX: METHODOLOGY

order to indicate how important each occupation or industry was in terms of the creation or elimination of jobs, the percentage of all jobs that were created or destroyed in that occupation or industry is calculated. A second column shows the percentage of jobs gained or lost in each occupation or industry which were full-time or part-time, thus indicating the relative importance of full-time or part-time job creation or loss within the occupation or industry. Other percentage calculations are made to indicate how important this job creation or loss was for women workers and to determine how much of the job gain or loss in each category was a loss or gain for women. From these calculations, it is possible to analyze the uneven development of jobs in different occupations and industries, and to calculate the impact of this uneven development on full-time and part-time employment for each sex.

The table on hypothetical employment is also calculated to indicate the relative development in different sectors, for each sex. By estimating the overall employment patterns for women, if the distribution of jobs remained relatively the same, and comparing these to the actual patterns, it is possible to see where uneven development has taken place.

For most of these tables, annual averages, rather than monthly Labour Force Survey data, are used because they are a better indication of trends over time, because they smooth out some of the variations created by alterations in the day the interviews are conducted and because the data are easier to manipulate. On most tables, the data are calculated for the years 1975, 1980 and 1982. The year 1975 is used because the signs of recession were just beginning to appear and because the Labour Force Survey was revised at that time, making it difficult to generate many strictly comparable data for earlier years. The 1975 data thus provide something of a base from which other comparisons can be drawn. In 1980 and 1982, the crisis was acknowledged to exist and to deepen. By comparing data from these two years, it is possible to explore the impact of the crisis within a short period, to compare these employment trends with earlier years and to develop some predictions about the future.

Other years are referred to in some tables, for different reasons. Census data for 1951, 1961, 1971 and 1981 indicate the overall trends in labour force restructuring since the Second World War. The comparable data that are available for the Labour Force Survey provide an indication of yearly variations in participation and unemployment for the more recent period.

Additional Difficulties with the Data

There are limitations to all data, as many researchers have pointed out[4] and there are extra problems for researchers forced to use data not explicitly collected for their own purposes. But in addition to these frequently discussed difficulties, there are, as indicated at the beginning of the chapter, three that deserve particular consideration here.

The first, and perhaps the most important in terms of this book is the sex-blindness of the data. As we have argued elsewhere (Armstrong and Armstrong, 1982b) Statistics Canada methodologies, like all methodologies, reflect a perspective, one that tends to serve more the interests of men and the formal economy than those of women and the household. The way data are collected and tabulated, the way questions are asked and not asked, the way government programs and policies are structured, the way history is considered, all influence the data and in the process often leave out and sometimes misrepresent the position of women. It is not enough to tabulate all data by sex or to change "head of household" to "person one." A sex-conscious collection of data – one that would allow a thorough examination of the different work of women and men – would begin with the recognition that workers come in two sexes and that the labour force is segregated. To permit a full examination of these differences, and of the impact of the crisis, Statistics Canada would also have to generate data on the labour process, on health and safety, hiring and promotion, wages and benefits, job security – to mention only some of the issues – as they differentially affect women and men.

Directly related to these problems in the labour force data is the absence of regular Statistics Canada data either on work done in the household or on volunteer work. The collection of this information is not only important for the recognition of women's other job; it is also central to an understanding of the impact of the crisis. In times of crisis, people reduce expenditures and in part substitute extra labour in the household. If responses to the crisis are to be predicted, alternative resources need to be assessed. For example, unemployed men in Sudbury may not seek work in other communities because they already own their own home and cannot sell it now. They can, however, supplement the food budget with fish they catch in the winter and moose they shoot in the fall, and can further reduce their need for money income by planting a garden, gathering wood and doing their own repairs. Their wives

APPENDIX: METHODOLOGY

may take on part-time or even full-time work. On the other hand, the unemployed men in Toronto likely have no place to plant a garden, no place to gather wood, no place to hunt or fish and fewer skills to use in repairing the car. In addition, they may have a large mortgage and their wives may already be fully employed, with earnings that are totally inadequate for their money needs.

Volunteer work is also an important supplement to service agencies who have had their grants cut by the government and to unemployed workers who have little to occupy their time or maintain their skills. In times of crisis, this work is growing but there is little help, from Statistics Canada at least, in monitoring this growth on a regular basis.

The invisible economy includes more than unpaid housework and volunteer work, however. It also includes all those jobs that are done for pay in the home, primarily by women, but often go unrecorded in the official data. Statistics Canada does try to gather information on the women who sew clothes, babysit, type, clean and do telephone surveys at home, but is frequently unsuccessful. This lack of success is more related to government regulations in such areas as taxation, unemployment insurance and welfare than to Statistics Canada methodologies, however. Yet this area too is likely to grow during crisis when people need additional income. As technology makes homework more and more possible and as the drive to accumulate makes it more and more desirable in many industries and occupations, homework is likely to grow even if a recovery takes place. But the available data make it difficult, if not impossible, to monitor this growth.

Finally, there is the problem of analyzing a crisis in progress. Hindsight usually makes analysis much easier and this is particularly the case when dealing with such volatile material as employment patterns for women and men. Even monthly data may be out of date by the time they are published and such data are often difficult to use to predict longer-term trends since the changes are so small and the factors involved so complicated. In this case, there is little choice but to proceed, as carefully as possible, on the basis of the data that are available and with the benefit of knowledge from historical patterns. Although there are limitations in the data, there is enough information available to make a scientific analysis of the sex-specific consequences of this current economic crisis. And there can be little doubt that such an analysis is necessary if we are to influence the future rather than simply examine the past.

NOTES

[1] For research on domestic labour and women's contribution to that work, see, for example, Clark and Harvey (1976), Kome (1982), Luxton (1980 and 1983) and Meissner *et al.* (1975).

[2] For a discussion of the problems encountered in developing comparable historical data, see Armstrong and Armstrong (1978: Chapter 2).

[3] For a more complete discussion of these problems in Statistics Canada data collection, see Armstrong and Armstrong (1982b).

[4] As early as 1959, C. Wright Mills was critically examining the growing faith in numbers as proof. More recently, Irvine, Miles and Evans (1979) have explored the links between methods and theory. The articles brought together by Roberts (1981) in *Doing Feminist Research* explore the implications of a feminist perspective for empirical work.

TABLES

Table 3.1

The Concentration of Labour Force[1] by Occupation, Canada, 1951, 1961, 1971 and 1981

Occupation[2]	1951	1961	1971	1981
Managerial	8.1	8.6	8.7	7.1[3]
Professional and Technical	7.4	10.0	13.8	15.8
Clerical	11.1	13.2	16.2	19.2
Sales	6.5	6.5	6.7	10.1
White Collar Sub Totals	32.0	38.3	45.4	52.2
Service & Recreation	9.9	12.6	12.8	12.5
Transport & Communications	6.3	6.2	5.5	4.0
Farmers & Farm Workers	15.8	10.3	6.4	4.5
Loggers and Related	1.9	1.3	0.7	0.7
Fisherman, Trappers & Hunters	1.0	0.5	0.4	0.4
Miners, Quarrymen & Related	1.2	1.0	0.8	0.7
Craftsmen, Production Process & Related	25.0	24.3	23.3	23.0
Labourers	6.7	5.5	4.8	2.1
Blue Collar Sub Totals	68.0	61.7	54.6	47.9
Totals	100.0	100.0	100.0	100.0

Notes:
1. The 1951 and 1961 data exclude persons looking for work who never worked before. For 1971 and 1971, figures exclude persons looking for work who last worked prior to January 1 in 1970 or 1980, respectively. Not including occupations unspecified or undefined.
2. Occupations are not precisely comparable due to definition changes each Census.
3. The managerial category was more strictly defined in the 1971 Census. The 1981 data used here are based on 1971 definitions. 1981 Census definitions change the numbers of people in the managerial category from 814, 035 (1971 definition) to 1,060,015 (1981 definition). Many of these people were shifted by this definition from management to sales.

Sources: For 1951, 1961 and 1971, taken from Armstrong (1979: Table 3). For 1981, calculated from Statistics Canada, unpublished Census data.

Table 3.2

The Concentration of Female and Male Labour Force[1]
by Occupation, Canada, 1951, 1961, 1971 and 1981

(percentages)

Occupation[2]	Females 1951	1961	1971	1981	Males 1951	1961	1971	1981
Managerial	3.3	3.3	2.3	4.4	9.4	10.5	6.2	9.0
Professional & Technical	14.5	15.8	20.1	19.9	5.4	7.8	11.1	12.9
Clerical	28.1	29.6	35.9	36.7	6.3	7.1	8.5	7.2
Sales	8.7	8.6	9.5	10.1	4.6	5.8	11.1	10.0
White Collar Sub Totals	54.6	57.3	67.8	71.1	25.7	31.2	36.9	39.1
Service & Recreation	21.4	23.0	17.1	16.1	6.6	8.7	10.2	10.1
Transport & Communications	2.9	2.2	0.3	0.6	7.3	7.7	6.5	6.3
Farmers & Farm Workers	2.8	4.4	4.1	2.3	19.5	12.5	7.9	5.9
Loggers & Related	0.0	0.0	0.1	0.1	2.5	1.7	1.3	1.1
Fisherman, Trappers & Hunters	0.0	0.0	0.0	0.1	1.3	0.7	0.5	0.6
Miners, Quarrymen & Related	0.0	0.0	0.0	0.0	1.6	1.4	1.2	1.1
Craftsmen, Production	16.5	11.9	9.2	8.6	27.4	28.9	32.3	32.9

Process and Related Labourers	1.8	1.2	1.5	1.2	8.1	7.1	3.2	2.8
Blue Collar Sub Totals	45.4	42.7	32.3	29.0	74.3	68.7	63.1	60.8

Notes:
1. The 1951 and 1961 data exclude persons looking for work who never worked before. For 1971 and 1981, figures exclude persons looking for work who last worked prior to January 1 in 1970 or 1980 respectively. Not including occupations unspecified or undefined.
2. Occupations are not precisely comparable due to definition changes each Census. For 1971 and 1981, materials handling and related occupations, n.e.c. is used for the labourers category. Included in craftsmen, production process and related are processing occupations, machining and related occupations, product fabricating, assembling and repairing occupations as well as other crafts and equipment operating occupations. Occupations not elsewhere classified have been subtracted for the calculations.

Sources: For 1951 and 1961, calculated from Dominion Bureau of Statistics Labour Force Occupation and Industry Trends 1961 Census of Canada (Cat. No. 94-551) Ottawa, Minister of Trade and Commerce, 1966. For 1971, calculated from Statistics Canada, Economic Characteristics Occupation by Industry 1971 Census of Canada (Cat. No. 94-792 (SE-1)) Ottawa Minister of Industry, Trade and Commerce Ottawa, 1976. For 1981, calculated from unpublished Statistics Canada 1981 Census data.

Table 3.3

The Concentration of Labour Force[1] by Industry Division, Canada, 1951, 1961, 1971 and 1981

(percentages)

Industries	1951	1961	1971	1981
Agriculture	15.6	9.8	5.6	4.0
Forestry	2.5	1.7	0.9	0.8
Fishing & Trapping	1.0	0.6	0.3	0.3
Mines (including drilling, quarries & oil wells	1.9	1.8	1.6	1.7
Manufacturing Industries	24.5	21.6	19.8	18.5
Construction Industry	6.1	6.8	6.2	6.3
Transportation, Communication & other utilities	9.9	9.4	7.8	7.8
Trade	14.3	15.4	14.7	16.3
Finance, Insurance & Real Estate	2.7	3.5	4.2	5.2
Community, Business & Personal Service	15.1	19.6	23.7	28.3
Public Administration	5.3	7.4	7.4	7.4
Industries unspecified & undefined	1.3	2.5	7.9	3.4
All Industries	100.0	100.0	100.0	100.0

Notes: 1. The 1951 and 1961 figures exclude persons looking for work who had never worked before. The 1971 and 1981 figures refers to the population 15 years of age and over, excluding inmates, who were either employed or unemployed during the week prior to enumeration (June 3, 1981). This is a derived variable.

Sources: For 1951 and 1961, calculated from Statistics Canada, Economic Characteristics - Industry Trends, 1951-197. Special Bulletin 1971 Census of Canada (Cat. No. 94-793 (SE-2)). Ottawa: Industry, Trade and Commerce. For 1971 and 1981, calculations taken from Statistics Canada, unpublished 1981 Census data.

Table 3.4

The Concentration of Females and Males by Industry, Canada, 1951, 1961, 1971 and 1981

(percentages)

Industry[4]	Females 1951[1]	1961[1]	1971[2]	1981[3]	Males 1951[1]	1961[1]	1971[2]	1981[3]
Agriculture	3.0	4.6	4.2	2.5	19.4	12.3	7.0	5.3
Forestry	0.2	0.1	0.1	0.2	3.1	2.3	1.3	1.3
Fishing & Trapping	0.0	0.0	0.0	0.1	1.2	0.7	0.5	0.5
Mines, Quarries & Oil Wells	0.2	0.3	0.4	0.6	2.5	2.5	2.5	2.6
Manufacturing	23.5	17.5	15.2	13.3	25.4	24.1	24.7	23.1
Construction	0.5	0.6	1.0	1.5	7.7	9.2	9.7	9.9
Transportation, Communications and other utilities	5.2	4.8	4.3	4.7	10.8	11.3	10.7	10.4
Trade	18.3	17.5	17.5	18.2	13.2	15.1	15.2	16.0
Finance, Insurance & Real Estate	5.6	6.1	6.9	8.1	2.0	2.7	3.3	3.5
Community, Business & Personal Service	39.3	43.4	44.2	43.8	8.4	11.2	16.4	19.5
Public Administration & Defense	4.2	5.0	6.1	7.0	6.2	8.6	8.9	8.1
All Industries	100.0%	100.0%	100.0%	100.0%	100.0%	100.0%	100.0%	100.0%

Notes:
1. The 1951 and 1961 figures exclude persons looking for work who had never worked before.
2. The 1971 figures exclude persons looking for work who last worked prior to January 1, 1970 or who never worked.
3. The 1981 figures exclude persons looking for work who never worked or who had worked only prior to January 1, 1980.
4. Not including industry unspecified or undefined.

1981 figures are based on 1971 labour force concepts.

Sources: For 1951 and 1961, taken from Armstrong and Armstrong (1978: Tables 2 and 12). For 1971, calculated from Statistics Canada, Economic Characteristics, Industry Trends 1951-1971, 1971 Census of Canada. (Cat. no. 94-793 (SE-2)), Ottawa 1978. For 1981, calculated from Statistics Canada, unpublished Census data.

Table 3.5

Labour Force Participation, Employment and Unemployment, Canada, 1966-82

Year	Participation rate Women	Participation rate Men	Women as % of employed	Unemployment rate Women	Unemployment rate Men	Women as % of unemployed
1966	35.4	79.8	31.3	3.4	3.3	31.8
1967	36.5	79.3	32.1	3.7	3.9	31.4
1968	37.1	78.6	32.7	4.4	4.6	31.8
1969	38.0	78.3	33.2	4.7	4.3	35.1
1970	38.3	77.8	33.6	5.8	5.6	34.7
1971	39.4	77.3	34.2	6.6	6.0	36.8
1972	40.2	77.5	34.5	7.0	5.8	39.1
1973	41.8	78.2	35.1	6.7	4.9	42.6
1974	42.9	78.7	35.6	6.4	4.8	42.6
1975	44.2	78.4	36.3	8.1	6.2	43.2
1976	45.0	77.7	36.9	8.4	6.4	44.2
1977	45.9	77.7	37.3	9.5	7.3	44.1
1978	47.8	77.9	38.3	9.6	7.6	44.8
1979	48.9	78.4	38.3	8.8	6.6	46.1
1980	50.3	78.3	39.7	8.4	6.9	44.8
1981	51.6	78.3	40.7	8.3	7.1	44.7
1982	51.6	76.9	41.2	10.8	11.1	40.6

Sources: For 1966-77, calculated from Statistics Canada, <u>Historical Labour Force Statistics: Actual Data, Seasonal Factors, Seasonally Adjusted Data</u> (Cat. no. 71-201) Ottawa, 1978. For 1978, calculated from Statistics Canada, <u>Labour Force Annual Averages, 1975-1978</u> (Cat. no. 71-529) Ottawa, 1979. For 1979-82, calculated from <u>The Labour Force</u> (Cat. no. 71-001), various issues.

Table 3.6

Full-time and Part-time Employment, Canada, 1966-82

Year	Employment/population ratio Women	Men	Full-time employment/ population ratio Women	Men	% employed part-time Women	Men
1966	34.2	77.1	28.6	74.6	17.0	3.4
1967	35.1	76.3	29.3	73.4	17.4	3.7
1968	35.5	75.1	29.1	72.0	18.6	4.1
1969	35.2	74.9	29.4	71.4	19.1	4.4
1970	36.1	73.4	29.2	69.8	19.6	4.9
1971	36.8	72.7	29.7	69.2	19.7	5.0
1972	37.4	73.0	30.2	69.5	19.6	4.9
1973	39.1	74.3	31.7	70.9	19.4	4.7
1974	40.2	74.9	32.4	71.3	19.9	4.9
1975	40.8	73.5	32.6	69.8	20.3	5.1
1976	41.4	72.7	32.0	69.0	21.1	5.1
1977	41.7	72.0	32.5	68.0	22.1	5.5
1978	43.2	72.1	33.4	68.1	22.6	5.6
1979	44.6	73.2	34.2	69.0	23.3	5.8
1980	46.0	72.9	35.1	68.6	23.8	5.9
1981	47.3	72.7	35.9	68.1	24.1	6.3
1982	46.0	68.3	34.4	63.6	25.1	6.9

Note: The pre-1975 data have been recalculated on the basis of the revised Labour Force Survey, excluding 14 year olds and using population estimates derived from the 1976 Census.

Sources: Calculated from Statistics Canada, Historical Labour Force Statistics: Actual Data, Seasonal Factors, Seasonally Adjusted Data (Cat. no. 71-201), Ottawa, 1980; and from Statistics Canada, The Labour Force (Cat. no. 71-001), various issues.

Table 4.1
Actual and Hypothetical Distribution of Labour Force, by Occupation and Sex, Canada, 1980 and 1982

Industry	(thousands) Total 1980 Employment	Total 1982 Employment	Female 1980 Employment
All Industries	10655	10574	4225
Agriculture	477	465	126
Forestry	70	61	5
Fishing	34	33	*
Mining	192	167	23
Non-durable Manufacturing	1062	1004	390
Durable Manufacturing	1044	922	176
Construction	619	590	54
Transportation	550	508	80
Communications	227	247	88
Utilities	123	120	19
Wholesale Trade	476	480	126
Retail Trade	1355	1359	664
Finance	608	601	357
Education	681	710	377
Hospitals	666	723	524
Doctor's Offices	127	146	87
Religion	62	59	33
Recreation	118	128	49
Business Services	404	440	165
Personal Services	695	690	424
Private Households	125	134	116
Miscellaneous Services	201	225	87
Federal Government	263	272	99
Provincial Government	251	256	100
Local Government	224	231	52

Source: Calculated from Statistics Canada, unpublished Labour Force data.

Female 1982 Employment	Hypothetical 1982 Total Employment	Hypothetical 1982 Female Employment
4354		
129	473	131
4	69	5
*	38	*
22	191	25
361	1053	379
161	1035	181
56	614	58
79	546	85
99	225	90
20	122	20
122	472	120
666	1344	659
364	603	365
399	676	380
570	661	521
104	126	90
29	62	31
54	117	49
186	401	170
421	689	420
128	124	118
94	199	83
108	261	104
115	249	112
58	222	56

Table 4.2

Employed by Industry and Sex, Canada, 1975, 1980 and 1982

Industry	Women as % of All Female Workers 1975	1980	1982	Men as % of All Male Workers 1975	1980	1982	Women as % of Occupation 1975	1980	1982
Agriculture	3.2	3.0	3.0	6.4	5.5	5.4	22.3	26.4	27.7
Forestry	0.1	0.1	0.1	1.0	1.0	0.9	5.1	7.1	6.6
Fishing	—	—	—	0.3	0.5	0.5	—	—	—
Mining	0.3	0.5	0.5	2.2	2.6	2.3	8.2	12.0	13.2
Non-Durable Manu-facturing	9.7	9.2	8.3	10.9	10.5	10.3	33.8	36.7	36.0
Durable Manufacturing	3.9	4.2	3.7	13.0	13.5	12.2	14.6	16.9	17.5
Construction	1.2	1.3	1.3	9.6	8.8	8.6	6.6	8.7	9.5
Transportation	1.6	1.9	1.8	7.6	7.3	6.9	10.9	14.5	15.6
Communications	2.5	2.0	2.3	2.1	2.2	2.4	39.8	38.8	40.1
Utilities	0.4	0.5	0.5	1.6	1.6	1.6	12.2	15.5	16.7
Wholesale Trade	3.0	3.0	2.8	5.7	5.4	5.8	22.9	26.5	25.4
Retail Trade	16.1	15.7	15.3	11.1	10.7	11.2	45.4	49.0	49.0
Finance	8.0	8.4	8.4	3.4	3.9	3.8	57.3	58.7	60.6
Education	10.6	8.9	9.2	5.0	4.7	5.0	55.0	55.4	56.2

Hospitals	13.5	12.4	13.1	2.2	2.2	2.5	77.7	78.7	78.8
Doctor's Offices	2.0	2.1	2.4	0.6	0.6	0.7	64.1	68.5	71.2
Religion	0.7	0.8	0.7	0.5	0.5	0.5	43.1	53.2	49.2
Recreation	0.9	1.2	1.2	1.0	1.1	1.2	32.6	41.5	42.2
Business Services	3.2	3.9	4.3	2.8	3.7	4.1	39.2	40.8	42.3
Personal Services	8.6	10.0	9.7	3.6	4.2	4.3	57.6	61.0	61.0
Private Households	2.5	2.7	2.9	0.1	0.1	0.0	93.2	92.8	95.5
Miscellaneous Services	1.9	2.1	2.2	1.6	1.8	2.1	40.2	43.3	41.8
Federal Government	2.7	2.3	2.5	2.8	2.6	2.6	36.2	37.6	39.7
Provincial Government	1.9	2.4	2.6	2.2	2.3	2.3	37.1	39.8	44.9
Local Government	1.2	1.2	1.3	2.7	2.7	2.8	19.8	23.2	25.1
All Industries	100.0	100.0	100.0	100.0	100.0	100.0	36.4	39.7	41.2

Note: A dash in this and subsequent tables indicates the numbers involved were too small to be statistically reliable.

Source: Calculated from Statistics Canada, unpublished Labour Force data.

Table 4.3

Industrial Concentration by Sex and Occupation, Canada, 1982

Occupation	Sex	All Industries	Agriculture	Other Primary	Manufacturing	Construction	Utilities	Trade	Finance	Services	Public Admin.
All Occupations	M	100.0	100.0	100.0	100.0	100.0	100.0	100.0	100.0	100.0	100.0
	F	100.0	100.0	100.0	100.0	100.0	100.0	100.0	100.0	100.0	100.0
Managerial etc.	M	23.7	—	16.4	18.3	9.7	16.2	8.4	39.2	50.0	42.0
	F	26.0	—	27.6	11.7	12.5	14.7	5.8	18.4	41.5	30.5
Clerical	M	6.4	—	2.6	6.1	0.9	14.6	6.9	8.0	4.6	10.2
	F	34.0	8.5	48.3	29.4	73.2	68.0	40.2	63.5	20.7	59.2
Sales	M	10.8	—	—	4.4	0.7	1.5	46.3	36.3	1.7	—
	F	10.2	—	—	3.3	—	—	45.1	12.1	1.0	—
Service	M	10.7	—	1.7	2.6	—	2.9	2.3	13.5	32.7	27.6
	F	18.2	—	—	2.1	—	5.1	2.9	6.0	35.2	8.9
Primary	M	8.0	96.7	52.2	0.5	2.4	—	—	—	1.3	2.5
	F	2.8	86.0	13.8	—	—	—	—	—	—	—
Processing	M	19.8	—	13.8	53.3	8.1	12.4	22.7	—	4.8	4.2
	F	6.4	—	—	44.7	—	—	2.9	—	0.9	—
Construction	M	9.3	—	3.9	2.1	74.0	12.4	1.0	—	1.3	5.8
	F	0.2	—	—	—	8.9	—	—	—	—	—
Transportation	M	6.0	—	4.7	2.6	2.2	32.2	4.9	—	1.9	4.2
	F	0.6	—	—	—	—	8.1	—	—	0.2	—
Materials	M	5.1	—	4.3	9.9	0.9	7.4	7.1	—	1.7	3.1
Handling	F	1.8	—	—	8.4	—	—	2.5	—	0.4	—

Source: Calculated from Statistics Canada, unpublished Labour Force data.

Table 4.4

Female Sex-Typing by Industry, by Occupation, Canada, 1982

Occupation	All Industries	Agriculture	Other Primary	Manufacturing	Construction	Utilities	Trade	Finance	Services	Public Admin.
All occupations	41.2	27.7	11.1	27.2	9.5	22.5	42.8	60.6	61.0	37.1
Managerial etc.	43.4	—	17.4	19.2	11.9	20.9	34.3	42.1	56.5	30.0
Clerical	78.8	91.7	66.7	64.2	89.1	57.5	81.2	92.4	87.6	77.3
Sales	39.7	—	—	21.5	—	—	42.2	33.6	46.3	—
Service	54.3	—	—	22.9	—	33.3	48.9	41.5	62.7	15.9
Primary	19.6	25.4	3.2	—	—	—	—	—	—	—
Processing	18.4	—	—	23.8	—	—	8.8	—	22.8	—
Construction	1.4	—	—	—	1.3	—	—	—	—	—
Transportation	6.0	—	—	—	—	6.8	—	—	14.3	—
Materials Handling	19.5	—	—	24.0	—	—	20.8	—	26.7	—

Source: Calculated from Statistics Canada, unpublished Labour Force data.

Table 4.5

Employment by Detailed Industry by Sex, Canada, 1982

Industry[1]	Concentration Male	Concentration Female (percentages)	Female Sex-typing	Concentration within major groups Male	Concentration within major groups Female
Agriculture	5.4	3.0	27.7	100.0	100.0
Primary	3.7	0.7	11.1	100.0	100.0
Forestry	0.9	0.1	6.6	24.6	13.8
Fishing	0.5	—	—	12.9	—
Metal Mines	0.9	0.1	6.9	23.3	13.8
Mineral Fuels	0.7	0.3	23.1	17.7	41.4
Non-Metal Mines	0.2	—	—	6.0	—
Quarries and Sand Pits	0.1	—	—	2.6	—
Services Incidental to Mining	0.5	0.1	14.3	12.9	17.2
Manufacturing	22.6	12.0	27.2	100.0	100.0
Non-durable	10.3	8.3	36.0	45.8	100.0 69.0 100.0
Food and Beverage	2.8	1.9	32.4	26.5	25.2
Tobacco Products	0.1	—	—	0.9	—
Rubber and Plastic Products	0.8	0.4	26.9	7.5	5.5
Leather	0.2	0.3	51.9	2.0	4.3

Textile	0.6	0.6	41.9	5.5	7.9
Knitting Mills	0.1	0.2	66.7	0.6	2.4
Clothing	0.4	1.8	76.2	3.8	24.3
Wood	1.5	0.2	9.4	14.7	3.0
Furniture and Fixtures	0.8	0.4	25.8	7.5	5.2
Paper and Allied Products	1.8	0.5	14.9	17.5	6.1
Printing, Publishing & Allied	1.4	1.2	37.6	13.5	16.1
Durable	12.2	3.7	17.5	54.2 100.0	31.0 100.0
Primary Metals	1.8	0.3	8.7	15.3	5.8
Metal Fabricating	2.0	0.6	16.3	16.4	12.6
Machinery	1.4	0.6	20.9	12.0	12.6
Transportation Equipment	2.3	0.6	14.1	19.4	12.6
Electrical Products	1.5	1.0	31.2	12.6	22.6
Non-Metallic Mineral Products	0.7	0.2	14.8	6.1	4.2
Petroleum and Coal Products	0.3	0.1	20.0	2.7	2.6
Chemical & Chemical Products	1.2	0.6	25.3	9.9	13.2
Miscellaneous Manufacturing	0.7	0.6	38.2	5.6	13.7
Construction	8.6	1.3	9.5	100.0	100.0
General Contractors	3.5	0.5	8.8	40.6	37.5
Special Trade	5.1	0.8	9.9	59.4	62.5

Table 4.5 continued

Employment by Detailed Industry by Sex, Canada, 1982

Industry[1]	Concentration Male	Concentration Female	Female Sex-typing	Concentration within major groups Male	Concentration within major groups Female
Transportation, Communication & Other Utilities	10.9	4.5	22.5	100.0	100.0
Transportation	6.7	1.8	15.6	61.6	39.1
Storage	0.2	—	—	1.8	—
Communications	2.4	2.3	40.1	21.8	50.3
Electric Power, Gas, Water Utilities	1.6	0.5	16.7	14.8	10.2
Trade	16.9	18.1	42.8	100.0	100.0
Wholesale Trade	5.8	2.8	25.4	34.0	15.5
Retail Trade	11.2	15.3	49.0	66.0	84.6
Finance, Insurance & Real Estate	3.8	8.4	60.6	100.0	100.0
Finance	1.4	4.8	70.4	36.9	56.9
Insurance Carriers	0.8	1.6	58.7	21.2	19.5
Insurance Agencies & Real Estate	1.6	2.0	46.2	42.0	23.6

Community, Business & Personal Service	20.4	45.6	61.0	100.0	100.0
Education & Related Services	5.0	9.2	56.2	24.5	20.1
Health & Welfare Services	3.1	15.5	77.6	15.4	34.0
Religious Organizations	0.5	0.7	49.2	2.4	1.5
Amusement & Recreation Service	1.2	1.2	42.2	5.8	2.7
Service to Business Management	4.1	4.3	42.3	20.1	9.4
Personal Services	0.7	5.0	83.4	3.4	10.9
Accommodation & Food Services	3.7	7.6	58.9	18.2	16.8
Miscellaneous Services	2.1	2.2	41.8	10.3	4.7
Public Administration	7.7	6.5	37.1		
Federal Administration	2.6	2.5	39.7	34.2	38.4
Provincial Administration	2.3	2.6	44.9	29.7	40.9
Local Administration	2.8	1.3	25.1	36.1	20.6

Note: 1. There is some discrepancy between the figures on concentration given here and those calculated from Table 1. This discrepancy is due to the small differences in numbers between detailed and more aggregate data. In the more detailed unpublished data, some numbers are too small to be reliable and are therefore not included.

Source: Calculated from Statistics Canada, unpublished Labour Force data.

Table 4.6

Part-time Employment by Industry by Sex,
Canada, 1975, 1980 and 1982

Industry[1]	Part-time % of employment						Female % of part-time employment		
	Men			Women					
	1975	1980	1982	1975	1980	1982	1975	1980	1982
Agriculture	8.5	10.3	10.1	33.6	39.7	37.2	53.3	58.1	58.5
Non-Durable Manufacturing	1.9	2.2	2.8	6.1	7.9	8.9	61.4	67.4	64.0
Durable Manufacturing	1.1	1.3	1.3	5.9	5.7	6.8	47.1	47.6	52.4
Construction	2.2	3.0	4.3	22.9	33.3	30.4	42.1	51.4	42.5
Transportation	2.3	2.8	3.7	13.9	18.8	19.0	42.3	53.6	48.4
Communications	—	—	2.7	12.6	14.8	11.1	75.7	76.5	68.8
Wholesale Trade	3.0	3.4	3.9	14.4	15.9	16.4	58.7	62.5	60.6
Retail Trade	14.4	15.2	16.9	36.8	39.5	42.3	68.1	71.2	70.7
Finance	3.3	4.0	5.1	10.2	11.5	12.1	80.5	78.9	77.2
Education	5.9	5.6	7.1	18.9	22.0	23.1	79.8	82.2	80.7
Hospitals	5.8	7.7	9.2	17.0	23.9	24.6	91.0	92.6	90.9
Doctors Offices	—	—	—	24.3	27.6	29.8	91.9	88.9	91.2

Religion	8.9	—	31.1	33.0	37.9	72.5	78.6	78.6	
Recreation	24.3	23.2	25.7	40.9	44.9	42.6	44.9	57.9	54.8
Business Services	3.6	4.6	5.9	14.4	17.6	19.9	72.4	72.5	72.6
Personal Services	16.9	22.1	23.8	29.3	32.6	34.4	70.2	69.7	69.4
Private Households	—	75.0	80.0	43.4	51.7	53.1	92.8	90.9	94.4
Miscellaneous Services	8.8	11.4	15.4	26.7	31.0	34.0	67.2	67.5	61.5
Federal Government	—	3.0	3.0	4.9	6.1	5.6	55.0	54.6	54.6
Provincial Government	—	—	—	6.3	7.0	7.0	76.1	87.5	80.0
Local Government	3.7	4.1	4.6	19.5	23.1	22.4	56.8	63.2	61.9
All Industries	5.1	5.9	6.9	20.3	23.8	25.1	69.5	72.5	71.7

Note: 1. Only those industries with at least 4,000 part-time workers are included.

Source: Calculated from Statistics Canada, unpublished Labour Force data. These figures differ slightly from the published figures for 1982.

Table 4.7
Full-time Job Creation by Industry and Sex, Canada, 1980-82

Industry[1]	Both Sexes % of all new full-time jobs	Both Sexes Full-time % of new jobs	Women % of all new full-time jobs	Women Female % of new full-time jobs
Hospitals	25.0	66.7	19.7	79.0
Business Services	16.5	69.4	8.6	52.0
Communications	13.8	105.0	7.2	52.4
Education	9.9	51.7	8.6	86.7
Doctors	7.9	63.2	6.6	83.3
Miscellaneous Services	7.9	50.0	2.0	25.0
Federal Government	5.9	100.0	5.9	100.0
Recreation	4.0	60.0	2.6	66.7
Municipal Government	3.3	71.4	3.3	100.0
Provincial Government[2]	2.6	80.0	7.9	300.0
Private Households	2.0	33.3	2.6	133.3
Wholesale Trade[3]	1.3	50.0		
Total	100.0		75.0	

Notes: 1. Includes only those industries in which full-time jobs were created for both sexes taken together. Women also gained some full-time jobs in agriculture, construction, utilities and finance industries.
2. There was a loss of full-time male jobs in provincial governments.
3. There was a loss of full-time female jobs in wholesale trade.

Source: Calculated from Statistics Canada, unpublished Labour Force data.

Table 4.8

Full-time Job Loss by Industry and Sex, Canada, 1980-82

Industry[1]	Both Sexes % of all full-time jobs lost	Full-time % of jobs lost	Women % of all full-time jobs lost	Female % of full-time jobs lost
Durable Manufacturing	33.1	100.0	4.3	13.1
Non-Durable Manufacturing	16.8	106.9	8.1	48.4
Transportation	12.2	107.1	0.3	2.2
Construction[3]	9.5	120.7		
Retail Trade[2]	7.3		4.9	66.7
Mining	6.8	100.0	0.3	4.0
Personal Services	4.1	300.0	2.7	66.7
Finance[3]	3.3	171.4		
Forestry	2.4	100.0	0	0
Agriculture[3]	2.2	66.7		
Utilities[3]	1.1	133.3		
Religion	0.8	100.0	1.1	133.3
Fishing	0.5	200.0	—	—
Total	100.0		21.7	

Notes: 1. Includes only those industries in which full-time jobs were lost for both sexes.
2. There was an overall job increase in retail trade.
3. There was an increase in full-time female agriculture, construction, finance and utilities.

Source: Calculated from Statistics Canada, unpublished Labour Force data.

Table 4.9

Part-time Job Creation by Industry by Sex, Canada, 1980-82

Industry[1]	Both Sexes % of all new part-time jobs	Part-time % of new jobs	Women % of all new part-time jobs	Female % of new part-time jobs
Retail Trade	24.2	775.0	15.6	64.5
Hospitals	14.8	33.3	11.7	79.0
Education	10.2	44.8	7.0	69.2
Miscellaneous Services	9.4	50.0	3.9	41.7
Personal Services[2]	8.6		5.5	63.6
Business Services	8.6	30.6	6.3	72.7
Doctors	5.5	36.8	5.5	100.0
Private Households	4.7	66.7	6.3	133.3
Construction[2],[3]	3.9			

Finance[2]	3.9	2.3	60.0
Recreation	3.1	0.8	25.0
Non-Durable Manufacturing[2]	3.1	0.8	25.0
Totals	100.0	65.7	

Notes: 1. Includes only those industries in which part-time jobs were created and in which there were at least 4,000 part-time jobs, for both sexes taken together.

2. There was an overall job loss in non-durable manufacturing, construction, finance and personal services.

3. There was a loss of part-time female construction jobs.

Source: Calculated from Statistics Canada, unpublished Labour Force data.

Table 4.10

Unemployment Rates by Industry and Sex,
Canada, 1975, 1980 and 1982

Industry	1975 Women	1975 Men	1980 Women	1980 Men	1982 Women	1982 Men
Goods Producing Industries	9.9	7.3	9.9	8.4	14.3	14.2
Agriculture	4.8	2.3	5.5	3.7	7.7	5.9
Other Primary Industries	—	10.6	—	9.3	13.9	17.3
Forestry	—	19.3	—	17.7	—	29.0
Fishing & Trapping	—	—	—	11.0	—	10.5
Mines, Quarries & Oil Wells	—	5.6	—	5.2	—	13.1
Manufacturing	11.3	6.0	11.0	6.8	15.9	12.4
Construction	—	12.1	8.7	14.4	13.0	21.3
Service Producing Industries	6.0	4.3	7.0	5.3	8.9	8.1
Transportation, Communications & other utilities	5.4	4.7	5.9	4.8	7.5	7.5

Transportation & Communication	5.5	5.1	5.7	5.0	7.7	7.9
Electric Power, Gas & Water Utilities	—	—	—	3.3	—	5.1
Trade	6.8	4.8	7.9	5.9	9.9	9.3
Finance, Insurance & Real Estate	3.7	1.8	4.0	2.7	5.8	4.6
Community, Business & Personal Service	6.3	4.2	7.1	5.8	9.3	8.9
Public Administration	5.5	3.5	7.4	4.9	8.5	6.1
All Industries	8.1	6.2	8.4	6.9	10.8	

Sources: For 1975, Statistics Canada, Labour Force Annual Averages, 1975-1978 (Cat. no. 71-529), Ottawa. Supply and Services Canada, 1979. For 1980 and 1982, Statistics Canada The Labour Force (Cat. no. 71-001), Ottawa. Supply and Services Canada, various issues.

Table 4.11

Unemployment by Industry and Sex, Canada, 1975, 1980 and 1982

Industry[1]	Women as % of all Unemployed Women 1975	1980	1982	Men as % of all Unemployed Men 1975	1980	1982	Women as % of Unemployed 1975	1980	1982
Goods Producing Industries	27.8	24.8	25.7	57.4	54.5	55.7	25.2	25.5	23.0
Agriculture	2.0	2.0	2.3	2.6	3.1	2.8	35.7	33.3	34.4
Other Primary	—	—	1.1	6.9	5.9	6.3	—	—	9.4
Forestry	—	—	—	4.0	3.1	3.1	—	—	—
Fishing & Trapping	—	—	—	—	0.9	0.5	—	—	—
Mines, Quarries & Oil Wells	—	—	—	2.3	2.0	3.0	—	—	—
Manufacturing	24.1	20.4	20.7	25.7	24.6	26.9	39.6	38.5	33.2
Construction	—	1.5	1.7	22.3	20.9	19.4	—	5.0	5.2
Service Producing Industries	72.3	75.2	74.3	42.6	45.5	44.3	54.3	55.5	51.9
Transportation, Communication and other Utilities	3.7	3.5	3.4	9.4	7.9	7.4	21.4	25.0	22.5

Transportation & Communications	3.3	2.9	3.1	8.6	7.0	6.7	21.1	23.8	23.1
Electric Power, Gas & Water	—	—	—	—	0.9	0.7	—	—	—
Trade	19.2	19.8	18.0	14.3	14.3	14.4	49.0	51.5	44.3
Finance, Insurance & Real Estate	4.5	4.4	4.6	1.1	1.5	1.5	78.6	68.2	64.7
Community, Business & Personal Service	40.4	41.7	42.9	13.1	16.3	16.7	68.3	65.6	62.5
Public Administration	4.9	5.8	5.4	4.9	5.5	4.2	41.4	44.4	45.6
All Occupations	100.0	100.0	100.0	100.0	100.0	100.0	43.3	44.8	40.6

Note: 1. The unemployed falling into the unclassified category have been subtracted from the totals before this table was calculated.

Sources: For 1975, calculated from Statistics Canada, Labour Force Annual Averages, 1975-1978 (Cat. no. 71-529), Ottawa: Supply and Services Canada, 1979.
For 1980 and 1982, calculated from Statistics Canada, The Labour Force (Cat. no. 71-001), Ottawa: Supply and Services Canada, various issues.

Table 4.12

Concentration of Unemployment Within Occupations, by Sex and Industry, Canada, 1982

Occupation	Sex	Agriculture	Other Primary	Manufacturing	Construction	Utilities	Trade	Finance	Service	Public Administration
Managerial, etc.	M	—	4.1	5.5	3.5	3.6	3.7	27.3	24.2	22.6
	F	—	20.0	5.1	0.0	6.3	3.5	8.7	23.5	23.1
Clerical	M	—	2.0	5.0	0.5	9.1	9.4	9.1	4.8	12.9
	F	9.1	40.0	18.4	55.6	68.8	43.0	69.6	21.1	57.7
Sales	M	—	—	2.0	0.0	1.8	33.7	36.4	2.4	—
	F	—	—	2.0	—	—	44.2	13.0	2.0	—
Service	M	—	2.0	2.5	—	5.5	4.7	18.2	50.8	32.3
	F	—	—	2.0	—	12.5	3.5	4.4	52.0	11.5
Primary	M	95.0	67.4	1.5	3.5	—	—	—	4.0	12.9
Occupations	F	81.8	40.0	—	—	—	—	—	—	—
Processing	M	—	12.3	66.0	6.9	10.9	27.1	—	5.7	3.2
	F	—	—	61.2	—	—	2.3	—	0.5	—
Construction	M	—	4.1	3.0	78.5	12.7	2.8	—	3.2	12.9
	F	—	—	—	11.1	—	—	—	—	—
Transport	M	—	6.1	3.0	4.2	41.8	8.4	—	3.2	6.5
	F	—	—	—	—	12.5	—	—	0.5	—
Materials	M	—	2.0	11.5	2.1	16.4	12.2	—	2.4	3.2
Handling	F	—	—	10.2	—	—	3.5	—	0.5	—
Total	M	100.0	100.0	100.0	100.0	100.0	100.0	100.0	100.0	100.0
Total	F	100.0	100.0	100.0	100.0	100.0	100.0	100.0	100.0	100.0

Note: Lines may not add up to 100% because of rounding error and because of elimination, on reliability grounds, of cases in which employment, and thus unemployment, was small. Data on unemployment was obtained by subtracting the employed from the labour force. Each column for each sex indicates the proportion of each sex that is seeking work in the occupation within the industry given across the top of the table.

Source: Calculated from Statistics Canada, unpublished Labour Force data.

Table 4.13

Employed Persons by Usual Hours Worked at Main Job[1], by Industry and Sex, Canada, 1975 and 1982

Industry	Sex	% 1-9 hours 1975	1982	% 10-19 hours 1975	1982	% 20-29 hours 1975	1982	% 30-34 hours 1975	1982	% 35 & over hours 1975	1982
Agriculture	M	1.9	3.3	4.3	5.4	4.8	5.4	4.3	5.7	85.1	80.1
	F	9.4	12.3	17.0	16.9	14.2	15.4	12.3	11.5	47.6	43.9
Other Primary	M	—	—	—	—	—	—	—	1.7	99.0	96.6
	F	—	—	—	—	—	—	—	—	80.0	79.3
Manufacturing	M	0.5	0.6	0.6	0.7	0.6	0.9	0.7	1.6	97.6	96.2
	F	1.5	1.7	2.0	2.9	3.5	4.6	3.0	4.2	90.0	86.6
Construction	M	0.7	1.1	0.7	1.7	1.1	2.3	1.6	3.8	95.9	91.4
	F	—	11.5	12.5	13.5	10.0	13.5	—	9.6	57.5	51.9
Transportation & Storage	M	—	—	1.6	1.9	2.0	2.8	2.0	2.8	94.0	91.8
	F	—	—	9.1	12.3	9.1	12.7	—	6.3	67.3	59.5
Communications	M	—	—	—	—	—	2.7	—	—	91.1	92.6
	F	—	—	6.2	—	7.4	8.1	6.2	—	77.8	81.8
Utilities	M	—	—	—	—	—	—	—	—	94.7	92.0
	F	—	—	—	—	—	—	—	—	92.3	90.0
Trade	M	2.5	3.8	5.2	5.4	3.2	3.9	1.5	2.6	87.5	84.3
	F	6.2	7.6	16.3	17.0	13.5	15.9	6.1	7.8	57.9	51.7
Finance	M	—	1.7	2.0	2.1	2.0	2.5	3.5	2.9	92.1	90.4
	F	2.6	2.2	4.8	5.2	5.1	6.0	5.5	4.1	82.1	82.4
Community Service	M	2.9	3.3	3.6	4.6	3.8	4.6	5.2	5.4	84.5	82.1
	F	5.0	5.9	9.0	10.9	9.1	12.4	6.4	7.6	70.5	63.2
Business & Personal Service	M	2.8	3.8	5.9	7.2	3.9	5.9	3.4	4.5	84.0	78.8
	F	8.3	9.8	12.4	12.8	11.2	13.9	8.5	9.7	59.6	53.9
Miscellaneous Services	M	—	5.3	4.2	6.1	4.2	6.1	4.2	4.6	85.4	77.9
	F	8.2	10.2	13.1	13.6	14.8	15.9	11.5	12.5	52.5	47.7
Public Administration	M	0.9	1.1	1.1	1.3	0.9	1.1	6.4	4.0	90.8	92.7
	F	2.9	2.9	4.4	4.3	3.4	3.6	10.2	5.4	79.1	83.9

Note: 1. The percentage working less than 30 hours/week is normally higher than the part-time percentage both because other jobs are excluded and because some of those working less than 30 hours/week consider themselves to work full-time.

Source: Calculated from Statistics Canada, unpublished Labour Force data.

Table 4.14

Union Membership, Canada, 1981

Industry Group	% Distribution of Paid Workers Unionized	% Women Members of Industry Membership	% Women Members of Total Women Membership
Fishing and Trapping	37.5	4.8	—
Forestry	56.2	1.7	—
Mines, Quarries and Oil Wells	35.5	2.7	0.2
Manufacturing	44.4	19.3	17.2
Construction	54.0	0.6	0.2
Transportation, Communication and Other Utilities	53.2	20.5	9.4
Trade	8.9	36.1	5.6
Finance	2.8	61.9	1.0
Service Industries	25.6	63.8	48.1
Public Administration	69.1	34.6	17.9

SOURCES: Taken from Statistics Canada, Corporations and Labour Unions Returns Act Report for 1981 Part II - Labour Unions (Cat. no. 71-202).

Ottawa: Supply and Services Canada, 1983. Pages 61 and 62.

Table 4.15

Employed by Occupation and Sex, Canada, 1975, 1980 and 1982

Occupation	Women as % of All Female Workers 1975	1980	1982	Men as % of All Male Workers 1975	1980	1982	Women as % of Occupation 1975	1980	1982
Managerial	3.4	4.9	6.0	8.4	9.5	10.2	18.7	25.2	29.7
Natural Science	0.8	1.3	1.3	4.8	5.2	5.2	9.1	14.0	14.7
Social Science	1.4	1.8	1.9	1.1	1.3	1.4	43.5	47.8	47.7
Religion	—	0.1	0.1	0.4	0.4	0.4	—	14.8	14.8
Teaching	7.2	5.8	6.2	3.0	2.9	3.0	58.2	57.2	59.2
Medicine	9.5	8.6	9.2	1.8	1.7	1.9	75.6	76.9	76.9
Artistic	1.1	1.4	1.4	1.3	1.4	1.6	33.3	38.4	39.0
Clerical	36.1	34.6	34.0	6.9	6.3	6.4	75.0	78.2	78.8
Sales	10.4	10.4	10.2	11.5	10.4	10.8	34.0	39.6	39.7
Service	16.6	18.1	18.2	9.7	10.1	10.7	49.6	54.0	54.3
Farming	3.0	2.8	2.7	6.8	6.2	5.9	20.4	23.1	24.2
Fishing	—	—	—	0.3	0.5	0.5	—	—	—
Forestry	—	—	—	0.8	0.8	0.8	—	—	—
Mining	—	—	—	0.9	1.0	0.9	—	—	—
Processing	1.8	1.8	1.7	5.0	5.1	4.7	17.2	19.2	19.8
Machining	0.4	0.3	0.3	4.0	3.9	3.6	5.2	4.9	5.5
Fabrication	5.9	5.4	4.4	11.2	11.6	11.5	23.2	23.4	21.1
Construction	0.1	0.2	0.2	10.9	10.0	9.3	0.7	1.2	1.4
Transport	0.4	0.6	0.6	6.3	6.4	6.0	3.1	5.7	6.0
Materials Handling	1.3	1.3	1.2	3.3	3.5	3.3	18.4	19.1	20.7
Other Crafts	0.5	0.6	0.6	1.9	1.8	1.8	12.9	17.0	17.3
All Occupations	100.0	100.0	100.0	100.0	100.0	100.0	36.4	39.7	41.2

Note: A dash in this and subsequent tables indicates that the number involved was too small to be statistically reliable.

Sources: Calculated from Statistics Canada, The Labour Force (Cat. no. 71-001), Ottawa, various issues.

Table 4.16

Occupational Concentration by Sex and Industry, Canada, 1982

Occupation		All Industries	Agriculture	Other Primary	Manufacturing	Construction	Utilities	Trade	Finance	Services	Public Admin.
All Occupations	M	100.0	5.4	3.7	22.6	8.6	10.9	16.9	3.8	20.4	7.7
	F	100.0	3.0	0.7	12.0	1.3	4.5	18.1	8.4	45.6	6.5
Managerial, etc.	M	100.0	—	2.6	17.4	3.5	7.4	6.0	6.3	43.0	13.6
	F	100.0	—	0.7	5.4	0.6	2.6	4.1	5.9	72.9	7.6
Clerical	M	100.0	0.7	1.5	21.7	1.3	24.9	18.4	4.8	14.6	12.3
	F	100.0	—	0.9	10.4	2.8	9.1	21.4	15.6	27.8	11.3
Sales	M	100.0	—	—	9.2	0.6	1.5	72.5	12.8	3.1	—
	F	100.0	—	—	3.8	—	—	80.3	10.0	4.3	—
Service	M	100.0	—	0.6	5.5	—	3.0	3.6	4.8	62.1	19.8
	F	100.0	—	—	1.4	—	1.3	2.9	2.8	88.2	3.1
Primary	M	100.0	65.0	24.2	1.4	2.6	—	—	—	3.2	2.4
	F	100.0	91.0	3.3	—	—	—	—	—	—	—
Processing	M	100.0	—	2.6	60.8	3.5	6.8	19.4	—	5.0	1.6
	F	100.0	—	—	84.5	—	—	8.3	—	6.5	—
Construction	M	100.0	—	1.6	5.2	68.2	14.5	1.9	—	2.8	4.8
	F	100.0	—	—	—	62.5	—	—	—	—	—
Transport	M	100.0	—	2.9	9.6	3.2	58.1	13.9	—	6.4	5.3
	F	100.0	—	—	—	—	66.7	—	—	16.7	—
Materials Handling	M	100.0	—	3.1	43.6	1.6	15.7	23.5	—	6.9	4.7
	F	100.0	—	—	57.1	—	—	26.0	—	10.4	—

Source: Calculated from Statistics Canada, unpublished data.

Table 4.17
Concentration of Male and Female Unemployment,
by Industry and Occupation, Canada, 1982

Occupation	Sex	Agriculture	Other Primary	Manufacturing	Construction	Utilities	Trade	Finance	Service	Public Admin.	All Industries
Managerial, etc.	M	—	0.3	1.5	0.7	0.3	0.5	0.4	4.0	0.9	8.5
	F	—	0.2	1.0	0.0	0.2	0.6	0.4	10.0	1.3	14.0
Clerical	M	—	0.1	1.4	0.1	0.7	1.4	0.1	0.8	0.5	5.1
	F	—	0.4	3.8	1.1	2.3	7.7	3.3	9.0	3.1	30.8
Sales	M	—	—	0.5	0.0	0.1	4.9	0.5	0.4	—	6.5
	F	—	—	0.4	—	—	8.0	0.6	0.9	—	9.6
Service	M	—	0.1	0.7	—	0.4	0.7	0.3	8.5	1.4	12.4
	F	—	—	0.4	—	0.4	0.6	0.2	22.2	0.6	24.9
Primary Occupations	M	2.6	4.5	0.4	0.7	—	—	—	0.7	0.5	9.4
	F	1.9	0.4	—	—	—	—	—	—	—	2.5
Processing	M	—	0.8	17.8	1.4	0.8	3.9	—	0.9	0.1	25.5
	F	—	—	12.6	—	—	0.4	—	0.2	—	13.6
Construction	M	—	0.3	0.8	15.2	0.9	0.4	—	0.5	0.5	18.4
	F	—	—	—	0.2	—	—	—	—	—	0.4
Transport	M	—	0.4	0.8	0.8	3.1	1.2	—	0.5	0.3	7.2
	F	—	—	—	—	0.4	—	—	0.2	—	0.6
Materials Handling	M	—	0.1	3.1	0.4	1.2	1.8	—	0.4	0.1	7.0
	F	—	—	2.1	—	—	0.6	—	0.2	—	3.1
All Occupations	M	2.7	6.6	27.0	19.4	7.4	14.4	1.5	16.7	4.2	100.0
	F	2.3	1.0	20.5	1.9	3.3	18.0	4.8	42.7	5.4	100.0

Note: Totals may not add up because of rounding error and because of the elimination, on reliability grounds, of cases in which employment, and thus unemployment, was small. Unemployment that was unclassified by industry and occupation is excluded.

Source: Calculated from Statistics Canada, unpublished data.

Table 4.18

Concentration of Unemployment within Industries, by Sex and Occupation, Canada, 1982

Occupation	Sex	Agriculture	Other Primary	Manufacturing	Construction	Utilities	Trade	Finance	Service	Public Administration
Managerial, etc.	M	—	3.2	17.5	7.9	3.2	6.4	4.8	47.6	11.1
	F	—	1.5	7.5	0.0	1.5	4.5	3.0	71.6	9.0
Clerical	M	—	2.6	26.3	2.6	13.2	26.3	2.6	15.8	10.5
	F	0.7	1.4	12.3	3.4	7.5	25.2	10.9	29.3	10.2
Sales	M	—	—	8.3	0.0	2.1	75.0	8.3	6.3	—
	F	—	—	4.4	—	—	82.6	6.5	8.7	—
Service	M	—	1.1	5.4	—	3.3	5.4	2.2	68.5	10.9
	F	—	—	1.7	—	1.6	2.5	0.8	89.1	2.5
Primary Occupations	M	27.1	47.1	4.3	7.1	—	—	—	7.1	5.7
	F	75.0	16.7	—	—	—	—	—	—	—
Processing	M	—	3.1	69.1	5.2	3.1	15.2	—	3.7	0.5
	F	—	—	92.3	—	—	3.1	—	1.5	—
Construction	M	—	1.5	4.4	83.1	5.2	2.2	—	2.9	2.9
	F	—	—	—	50.0	—	—	—	—	—
Transport	M	—	5.7	11.3	11.3	43.4	17.0	—	7.6	3.8
	F	—	—	—	—	66.7	—	—	33.3	—
Materials Handling	M	—	1.9	44.2	5.8	17.3	25.0	—	5.8	1.9
	F	—	—	66.7	—	—	20.0	—	6.7	—

Note: Lines may not add up to 100% because of rounding error and because of the elimination, on reliability grounds, of cases in which employment, and thus unemployment, was small. Unemployment that was unclassified by industry and occupation is excluded.

Source: Calculated from Statistics Canada, unpublished data.

Table 4.19

Full-time Job Creation by Occupation and Sex, Canada, 1980-82

Occupation[1]	Both sexes % of all new full-time jobs[1]	Both sexes Full-time % of new jobs	Women % of all new full-time jobs[1]	Women Female % of new full-time jobs
Managerial	48.4	90.2	33.3	68.9
Medicine	22.2	72.3	15.7	70.6
Service	11.1	35.4	8.5	76.5
Social Science	7.8	80.0	2.6	33.3
Teaching[2]	7.2	52.4	7.8	109.1
Artistic	3.3	62.5	1.3	40.0

Notes: 1. Includes only those occupations in which full-time jobs were created for both sexes taken together.

2. There was a loss of full-time male jobs in teaching.

Source: Calculated from Statistics Canada, unpublished data.

Table 4.20

Full-time Job Loss by Occupation and Sex, Canada, 1980-82

Full-time Job Loss by Occupation and Sex, Canada, 1980-82

Occupation[1]	Both Sexes % of all full-time jobs lost[1]	Full-time % of jobs lost	Women % of all full-time jobs lost	Female % of full-time jobs lost
Construction	18.9	111.1	0.0	0.0
Fabricating	17.3	100.0	9.5	54.7
Processing	13.0	109.1	2.2	16.7
Transport	10.8	105.3	0.3	2.5
Farming[2]	8.1	83.3	—	—
Machining	8.1	100.0	0.3	3.3
Materials Handling	7.3	128.6	0.7	7.4
Clerical[3]	6.5	—	2.7	41.7
Sales[3]	3.0	—	1.9	63.3
Natural Science[2]	2.2	160.0	—	—
Mining	2.2	114.3	—	—
Forestry	1.6	85.7	—	—
Other Crafts	1.1	200.0	0.5	50.0

Notes: 1. Includes only those occupations in which full-time jobs were lost for both sexes taken together.
2. Women gained full-time jobs in this occupation.
3. There was an overall increase in jobs in this occupation.

Source: Calculated from Statistics Canada, unpublished data.

Table 4.21

Employment by Detailed Occupation by Sex, Canada, 1982

Occupation	Concentration[3] Male	Concentration[3] Female	Female Sex-typing[4]	Concentration within major groups Male	Concentration within major groups Female
	(percentages)				
Managerial, Administrative & Related	10.2	6.0	29.1	100.0	100.0
Officials & admin. unique to gov't	1.0	0.5	25.3	9.8	8.1
Other managers & admin.	6.3	2.9	24.1	61.8	47.9
Occupations related to management	2.9	2.6	38.5	28.5	44.1
Natural Science, Engineering &					
Mathematics	5.2	1.3	14.9	100.0	100.0
Physical Sciences	0.6	0.3	25.5	10.8	21.1
Life Sciences	0.4	0.2	24.1	6.8	12.3
Architects and Engineers	2.0	0.2	6.7	38.5	15.8
Other occup. in architecture & engineering	1.4	0.2	10.0	27.7	17.5
Mathematics, Statistics & Systems Analysis	0.9	0.4	26.4	16.3	33.3
Social Science & Related	1.4	1.9	48.3	100.0	100.0
Social Science	0.3	0.2	36.0	17.8	10.8
Social Work & Related	0.4	0.9	61.9	26.7	47.0
Law	0.6	0.3	23.9	40.0	13.3
Library, Museum & Archival Sciences	0.1	0.4	75.0	6.7	21.7
Other Social Science & Related	0.1	0.1	42.9	8.9	7.2

Table 4.21 continued

Employment by Detailed Occupation by Sex, Canada, 1982

Occupation	Concentration Male	Concentration Female	Female Sex-typing	Concentration within major groups Male	Concentration within major groups Female
	(percentages)				
Religion	0.4	0.1	14.6	100.0	100.0
Teaching & Related[1]	3.0	6.1	58.9	100.0	100.0
University Teaching & Related	0.8	0.5	31.9	26.6	8.6
Elementary & Secondary School Teaching	1.6	4.4	65.5	53.8	71.2
Other Teaching & Related	0.6	1.2	59.3	19.6	20.2
Occupations in Medicine & Health	1.9	9.2	76.9	100.0	100.0
Health Diagnosing & Treating	0.8	0.3	18.8	43.3	3.0
Nursing, Therapy & Related	0.6	7.2	89.0	32.5	79.0
Other Occup. in Medicine & Health	0.5	1.7	71.3	24.2	18.1
Artistic, Literary, Recreation & Related	1.6	1.4	39.0	100.0	100.0
Fine & Commercial Art, Photogr.	0.5	0.5	40.0	34.4	35.5
Performing & Audio-visual Arts	0.4	0.3	28.9	28.1	17.7
Writing	0.3	0.4	47.2	18.8	27.4
Sport & Recreation	0.3	0.3	40.0	18.8	19.4
Clerical & Related Occupations	6.4	34.0	78.9	100.0	100.0
Stenographic & Typing	0.1	10.4	98.7	1.5	30.5

Bookkeeping, Account Recording & Related	1.2	11.4	86.9	18.9	33.6
Office Machine, Electr. Data Processing	0.3	1.8	79.6	5.1	5.3
Material Recording, Scheduling & Distributing	2.2	1.1	25.4	34.3	3.1
Library, File & Correspondence clerks	0.1	0.7	81.6	1.8	2.1
Reception, Information, Mail & Message Distribution	1.2	3.7	68.2	18.7	10.9
Other Clerical & Related	1.3	4.9	73.4	19.7	14.5
Sales[1]	10.8	10.1	39.6	100.0	100.0
Sales Commodities	8.7	8.8	41.5	80.2	86.9
Sales Service	1.6	1.1	32.5	15.2	11.1
Other Sales	0.5	0.2	22.5	4.6	2.0
Service	10.7	18.2	54.3	100.0	100.0
Protective Service	2.6	0.5	11.0	24.1	2.5
Food & Beverage Preparation	2.6	7.2	66.2	24.0	39.3
Lodging & Other Accommodation	0.5	1.4	65.6	4.9	7.9
Personal Service	0.5	5.6	87.4	5.1	30.5
Apparel & Furnishing Service	0.2	0.7	72.1	1.8	3.9
Other Service	4.3	2.9	32.0	40.1	15.9
Farming, Horticultural & Animal Husbandry	5.9	2.7	24.2	100.0	100.0
Farmers	3.5	0.6	10.0	58.7	20.5
Farm Management	0.1	—	—	1.6	—
Other Farming, Horticultural & Animal Husbandry	2.3	2.1	39.1	39.6	79.5

Table 4.21 continued

Employment by Detailed Occupation by Sex, Canada, 1982

Occupation	Concentration Male	Concentration Female	Female Sex-typing	Concentration within major groups Male	Concentration within major groups Female
	(percentages)				
Fishing, Hunting, Trapping & Related	0.5	—	—	—	—
Forestry & Logging	0.8	—	—	—	—
Mining & Quarrying Incl. Oil & Gas	0.9	—	—	—	—
Processing[1]	4.6	1.4	16.9	100.0	100.0
Mineral Ore Treating	0.8	—	—	17.1	—
Metal Processing	0.2	—	—	4.5	—
Clay, Glass & Stone Processing					
Chemicals, Petrol, Rubber, Plastic & Related	0.4	0.1	12.5	9.4	6.6
Food, Beverage & Related Process	1.6	1.1	32.2	33.8	75.4
Wood Process. Occup. (Except Pulp & Paper making)	0.5	—	—	11.9	—
Pulp & Paper making	0.7	—	—	16.0	—
Textile Processing	0.3	0.3	39.3	5.9	18.0
Other Processing	0.1	—	—	1.4	—
Machining & Related[1,2]	3.6	0.1	2.5	100.0	100.0
Metal Machining	1.1	—	—	31.6	—
Metal Shaping & Forming	2.1	0.1	4.4	58.2	46.2

Wood Machining	0.1	—	—	3.6	—
Clay, Glass & Stone Machining	0.1	—	—	2.7	—
Other Machining	0.1	—	—	4.0	—
Product Fabricating, Assembling & Repairing	11.5	4.4	21.1	100.0	100.0
Fabricating & Assembling Metal Prod., N.E.C.	1.2	0.3	13.8	10.5	6.3
Fab. Ass. Install & Repair Electrical & Electron.	2.0	0.6	18.0	17.2	14.1
Wood Products Fab. Ass. & Repair	0.6	0.1	10.0	4.9	2.1
Textiles Fur & Leather – Fab. Ass. & Repair	0.6	2.6	73.7	5.6	58.3
Rubber, Plastic & Rel. Prod – Fab. Ass. & Repair	0.4	0.2	25.7	3.6	4.7
Mechanics & Repairmen Except Electric	5.8	0.1	1.4	50.7	2.6
Other Products Fab. Ass. & Repair	0.9	0.5	29.9	7.5	12.0
Construction Trades[2]	9.3	0.2	0.9	100.0	100.0
Excavating, Grading, Paving	1.3	—	—	4.0	—
Electr. Power, Light & Wire Comm. Install & Repair	1.7	0.1	1.3	18.5	—
Other Construction Trades	6.3	0.1	1.3	67.8	62.5
Transport Equipment Operating[2]	6.0	0.6	5.3	100.0	100.0
Air Transport Operating	0.2	—	—	4.0	—
Railway Transport Operating	0.4	—	—	6.9	—
Water Transport Operating	0.3	—	—	4.5	—
Motor Transport Operating	5.0	0.5	6.4	82.1	91.3
Other Transport & Related	0.1	—	—	2.4	—

Table 4.21 continued

Employment by Detailed Occupation by Sex, Canada, 1982

Occupation	Concentration Male	Concentration Female	Female Sex-typing	Concentration within major groups Male	Female
	(percentages)				
Materials Handling & Related	3.3	1.2	20.7	100.0	100.0
Other Crafts & Equipment Operating	1.8	0.4	13.7	100.0	100.0
Printing & Related	0.9	0.4	26.0	47.0	
Stationary Engine & Util. Equip. Operating	0.8	—	—	44.4	—
Electronic & Rel. Comm. Equip. Operating	0.1	—	—	5.2	—
Other Crafts & Equip. Operating	0.1	—	—	3.5	—

Notes: 1. There is some discrepancy between the figures on concentration given here and those calculated for Table 1. This discrepancy is due to the small differences in numbers between detailed and more aggregate data. In the more detailed unpublished data some numbers are too small to be reliable and are therefore not included.

2. Calculations are based on overall differences between male totals and totals for both sexes since the numbers for women are too small to be reliable. The calculations should therefore be used with caution.

3. Concentration indicates the proportion of all employed women or men who work in each occupation.

4. Female sex-typing indicates the proportion of employed workers in each occupation who are female.

Source: Calculated from Statistics Canada, unpublished data.

Table 4.22

Part-time Employment by Occupation by Sex,
Canada, 1975, 1980 and 1982

| Occupation[1] | Part-time % of employment[2] ||||||| Female % of part-time employment |||
|---|---|---|---|---|---|---|---|---|---|
| | Men ||| Women |||| | | |
| | 1975 | 1980 | 1982 | 1975 | 1980 | 1982 | 1975 | 1980 | 1982 |
| Managerial | 1.1 | 0.8 | 1.1 | 5.7 | 6.8 | 7.3 | 58.3 | 73.7 | 73.1 |
| Natural Science | — | — | 1.5 | — | — | 8.9 | — | — | 55.6 |
| Social Science | — | — | 4.4 | 14.9 | 16.0 | 18.3 | 63.6 | 80.0 | 83.3 |
| Teaching | 5.8 | 5.4 | 6.5 | 16.8 | 20.6 | 22.0 | 80.4 | 82.3 | 83.1 |
| Medicine | — | 5.6 | 5.8 | 18.0 | 25.1 | 25.6 | 95.1 | 94.8 | 93.6 |
| Artistic | 11.2 | 13.0 | 15.5 | 26.9 | 29.3 | 30.6 | 52.6 | 56.7 | 57.6 |
| Clerical | 5.5 | 7.4 | 8.1 | 16.5 | 19.7 | 21.4 | 90.2 | 90.6 | 90.8 |
| Sales | 9.1 | 9.9 | 11.0 | 35.1 | 36.1 | 38.0 | 66.2 | 70.9 | 69.4 |
| Service | 13.2 | 16.9 | 18.4 | 31.4 | 37.0 | 37.9 | 70.1 | 71.9 | 71.0 |
| Farming | 8.5 | 10.8 | 11.2 | 33.9 | 37.5 | 35.0 | 50.8 | 51.1 | 50.0 |

Processing	1.5	2.1	3.1	6.6	7.7	9.7	50.0	50.0	43.8
Fabricating	1.7	2.3	2.4	4.7	5.7	6.8	42.9	43.3	43.3
Construction	1.9	2.3	3.6	—	—	—	—	—	—
Transport	3.7	3.9	5.1	33.3	40.0	33.3	22.2	38.5	29.6
Materials Handling	13.6	13.3	17.2	13.9	13.2	17.0	18.2	18.9	20.5
Other Crafts	—	—	—	—	16.7	20.8	—	66.7	62.5
All Occupations	5.1	5.9	6.9	20.3	23.8	25.1	69.5	72.5	71.7

Note: 1. Only those occupations with at least 4,000 part-time workers are included.

2. Part-time jobs are those in which workers are employed for less than 30 hours a week, unless such workers consider themselves full-time.

Source: Calculated from Statistics Canada, unpublished data. These figures differ slightly from the published figures for 1982.

Table 4.23

Part-time Job Creation[4] by Occupation by Sex,
Canada, 1980-82

	Both sexes		Women	
Occupation[1]	% of all new part-time jobs[5]	Part-time % of new jobs[6]	% of all new part-time jobs	Female % of new part-time jobs
Clerical	22.2	500.0	20.7	93.3
Service	22.2	62.5	13.3	60.0
Sales	14.1	237.5	7.4	52.6
Medicine	9.6	27.7	8.1	84.6
Teaching	6.7	42.9	5.9	88.9
Managerial	5.2	8.5	3.7	71.4
Construction[2]	5.2			—
Materials Handling[2]	5.2		1.5	28.6
Processing[2]	3.0		0.7	25.0
Natural Science[2]	2.2			—
Social Science	2.2	20.0	2.2	100.0
Artistic	2.2	37.5	1.5	66.7
Other Crafts[2]	1.5		0.7	50.0
Transport[2,3]	0.7			

242

Notes: 1. Includes only those occupations in which part-time jobs were created, and in which there were at least 4,000 part-time jobs, for both sexes taken together.

2. There was an overall loss of jobs in this occupation.
3. There was a loss of part-time female jobs in transport.
4. Job creation was calculated by subtracting the 1980 figures in each occupation from those for 1982. It therefore indicates the net growth in jobs. Slightly more part-time jobs may have disappeared. There is no way of determining such precise figures on job creation from Statistics Canada.
5. Part-time jobs include all those in which workers were employed for less than 30 hours a week, unless the workers considered themselves full-time.
6. Indicates proportion of all additional jobs that are part-time.

Source: Calculated from Statistics Canada, unpublished data.

Table 4.24

Employed Persons by Usual Hours Worked at Main Job[1], by Occupation and Sex, Canada, 1975 and 1982

Employed Persons by Usual Hours Worked at Main Job[1], by Occupation and Sex, Canada, 1975 and 1982

Occupation[2]	Sex	% 1-9 hours 1975	% 1-9 hours 1982	% 10-19 hours 1975	% 10-19 hours 1982	% 20-29 hours 1975	% 20-29 hours 1982	% 30-34 hours 1975	% 30-34 hours 1982	% 35 & over hours 1975	% 35 & over hours 1982
Managerial	M	—	—	—	—	0.8	0.8	2.4	2.2	95.9	96.5
	F	—	1.9	3.5	2.7	3.5	4.6	5.3	3.8	84.2	87.7
Natural Science	M	—	—	—	—	—	—	3.6	2.5	95.4	96.0
	F	—	—	—	—	—	—	—	—	82.2	85.7
Social Science	M	—	4.9	—	7.3	—	8.5	6.5	5.6	87.1	89.0
	F	2.9	2.7	2.3	3.2	3.4	3.8	8.3	7.3	66.7	70.8
Teaching	M	2.9	2.7	2.3	3.2	3.4	3.8	6.9	7.0	83.9	83.3
	F	7.0	8.2	7.4	9.3	8.6	10.4	9.9	9.3	66.7	62.7
Medicine	M	—	—	—	—	—	3.3	3.9	5.0	92.1	88.4
	F	2.8	3.3	9.3	11.3	7.2	13.3	4.4	6.5	76.4	65.4
Artistic	M	5.3	6.2	5.3	6.2	9.2	8.2	7.9	7.2	73.7	72.7
	F	13.2	12.9	10.5	9.7	10.5	11.3	—	9.7	50.0	46.8
Clerical	M	1.5	2.0	2.5	3.5	2.0	3.0	4.4	2.8	89.4	88.7
	F	3.2	4.4	7.9	8.9	7.6	10.0	6.2	5.7	75.1	71.0

Sales	M	2.2	3.7	4.6	4.5	3.2	3.6	2.1	3.0	88.1	85.3
	F	7.4	8.4	17.1	17.0	14.0	14.7	6.3	8.4	55.6	51.4
Service	M	3.3	5.1	6.7	8.4	4.4	6.1	2.8	3.9	82.8	76.5
	F	9.4	11.1	13.5	15.0	13.4	15.2	8.0	10.1	55.5	48.8
Farming	M	2.0	4.1	4.3	5.5	4.8	5.5	4.0	5.7	84.8	79.3
	F	8.8	11.1	17.6	16.2	14.7	15.4	11.8	12.0	46.1	46.2
Processing	M	—	—	—	1.4	—	—	—	1.4	97.7	95.2
	F	—	—	—	—	—	5.6	—	5.6	85.2	81.9
Fabricating	M	—	0.6	0.8	0.8	0.8	1.3	0.8	1.8	97.2	95.5
	F	—	—	2.0	2.6	3.0	4.2	3.5	5.2	90.5	86.0
Construction	M	—	0.9	0.8	1.4	1.1	1.9	1.6	3.1	96.2	92.6
	F	—	—	—	—	—	—	—	—	—	—
Transport	M	—	1.1	2.1	2.7	2.7	3.5	2.4	3.5	92.2	89.4
	F	—	—	—	25.0	—	16.7	—	—	—	20.8
Materials	M	3.6	4.4	7.2	7.9	3.6	4.9	—	2.5	84.6	79.9
Handling	F	—	—	—	7.5	—	7.5	—	7.5	75.0	69.8

Notes: 1. The percentage working less than 30 hours/week is normally higher than the part-time percentage both because other jobs are excluded and because some of those working less than 30 hours/week consider themselves to work full-time.

2. Includes only those occupations in which at least 4,000 worked less than 30 hours/week.

Source: Calculated from Statistics Canada, unpublished data.

Table 4.25

Unemployment by Occupation and Sex,
Canada, 1975, 1980 and 1982

Occupation	Women as % of all unemployed women 1975	1980	1982	Men as % of all unemployed men 1975	1980	1982	Women as % of unemployed 1975	1980	1982
Managerial	1.7	2.3	2.6	2.3	2.3	2.6	38.5	45.0	41.2
Natural Science	—	—	1.3	1.8	1.9	2.6	—	—	23.1
Social Science	—	1.6	1.3	—	—	0.5	—	66.7	63.6
Religion	—	—	—	—	—	—	—	—	—
Teaching	3.7	2.6	2.6	1.0	0.8	0.7	73.3	71.4	70.0
Medicine	4.0	3.4	3.2	—	—	—	92.3	86.7	85.0
Artistic	—	1.3	1.3	1.0	1.7	1.3	—	38.5	38.9
Clerical	24.1	26.6	27.7	5.9	4.8	4.9	75.8	81.8	79.5
Sales	8.4	9.0	8.9	5.4	5.9	6.2	54.4	55.6	49.5
Service	17.7	22.7	22.5	9.5	12.5	11.7	58.9	59.6	56.4
Farming	2.0	2.1	1.9	3.6	4.8	3.9	31.6	25.8	25.0
Fishing	—	—	—	—	0.8	0.5	—	—	—
Forestry	—	—	—	3.1	2.9	2.8	—	—	—
Mining	—	—	—	1.3	1.3	1.7	—	—	—

Processing	4.3	3.4	3.6	6.4	5.6	6.7	34.2	31.7	26.8
Machining	—	—	0.8	4.1	4.6	5.7	—	—	8.5
Fabricating	8.7	8.5	7.9	10.0	11.7	12.3	40.0	37.1	30.7
Construction	—	—	—	19.7	19.8	17.7	—	—	—
Transport	—	—	—	6.4	6.7	6.8	—	—	—
Materials Handling	2.7	2.3	2.3	5.6	4.8	5.8	27.6	28.1	21.1
Other Crafts	—	—	—	—	0.8	1.0	—	—	—
Unclassified	17.7	11.6	9.8	10.5	4.8	4.1	56.4	66.2	61.9
All Occupations	100.0	100.0	100.0	100.0	100.0	100.0	43.3	44.8	40.6

Sources: For 1975, calculated from Statistics Canada, Historical Labour Force Statistics: Actual Data, Seasonal Factors, Seasonally Adjusted Data (Cat. no. 71-201), Ottawa: Supply and Services Canada, 1979. For 1980 and 1982, calculated from Statistics Canada, The Labour Force (Cat. no. 71-001), Ottawa: Supply and Services Canada, various issues.

Table 4.26

Unemployment Rates by Occupation and Sex, Canada, 1975, 1980 and 1982

Occupation[1]	Women 1975	Women 1980	Women 1982	Men 1975	Men 1980	Men 1982
Managerial	3.8	4.1	5.1	1.7	1.7	3.0
Natural Science	—	—	9.6	2.3	2.7	5.9
Social Science	—	7.1	8.0	—	—	4.6
Teaching	4.3	4.0	5.1	2.1	1.9	2.8
Medicine	3.5	3.4	4.2	—	—	—
Artistic	—	7.4	10.8	5.4	8.4	9.5
Clerical	5.6	6.6	9.0	5.3	5.3	8.8
Sales	6.6	7.4	9.6	3.0	4.0	6.7
Service	8.6	10.3	13.1	6.2	8.4	12.0
Farming	5.2	6.1	7.9	3.3	5.6	7.7
Fishing	—	—	—	—	11.5	10.7
Forestry	—	—	—	21.1	20.7	32.0
Mining	—	—	—	8.7	8.8	18.5
Processing	17.2	14.6	20.7	7.8	7.7	15.1
Machining	—	—	22.6	6.5	8.1	16.3

Fabricating	11.4	12.6	18.1	5.5	7.0	11.7
Construction	—	—	—	10.8	13.0	19.1
Transport	—	—	—	6.4	7.2	12.3
Materials Handling	14.6	14.3	18.9	10.1	9.5	18.0
Other Crafts	—	—	—	—	3.7	6.4
All Occupations	8.1	8.4	10.8	6.2	6.4	11.1

Note: 1. Includes all occupations except religion, an occupation in which fewer than 4,000 were unemployed.

Sources: For 1975, Statistics Canada, Labour Force Annual Averages, 1975-1978 (Cat. no. 71-529), Ottawa: Supply and Services Canada, 1979. For 1980 and 1982, Statistics Canada, The Labour Force (Cat. no. 71-001), Ottawa: Supply and Services Canada, various issues.

BIBLIOGRAPHY

Abt Associates of Canada.
: 1982a The Integrated Electronic Office and Women: Implications for Career Mobility. Project Report for Women's Employment Division, Employment and Immigration Canada. Ottawa: Mimeo.
: 1982b The Integrated Electronic Office and Women: Training Resources and Needs. Project Report for Women's Employment Division, Employment and Immigration. Ottawa: Mimeo.

Action Travail des Femmes.
: 1982 Micro Technologie Méga Chômage: A la recherche d'Alternatives. Montréal: Mimeo.

Ainsworth, Jackie, Ann Hutchinson, Susan Margaret, Michèle Pujol, Sheila Perret, Mary Jean Rands and Star Rosenthal.
: 1982 "Getting Organized ... in the Feminist Unions." Pp. 132-140 in Maureen FitzGerald, Connie Guberman and Margie Wolfe, eds., *Still Ain't Satisfied: Canadian Feminism Today*. Toronto: The Women's Press.

Anderson, Charles H.
: 1974 *The Political Economy of Social Class*. Englewood Cliffs, New Jersey: Prentice-Hall.

Archibald, Kathleen.
: 1970 *Sex and the Public Service*. Ottawa: Queen's Printer.

Armstrong, Hugh.
: 1974 The Patron State of Canada: An Exploratory Essay on the State and Job Creation in Canada Since World War Two. Masters Thesis, Carleton University.
: 1977 "The Labour Force and State Workers in Canada." Pp. 289-310 in Leo Panitch, ed., *The Canadian State: Political Economy and Political Power*. Toronto: University of Toronto Press.
: 1979 "Job Creation and Unemployment in Post-War Canada," Pp. 59-77 in Marvyn Novick, ed., *Full Employment: Social Questions for Public Policy*. Toronto: Social Planning Council of Metropolitan Toronto.

Armstrong, Hugh and Pat Armstrong.
: 1975 "The Segregated Participation of Women in the Canadian Labour Force, 1941-71." *Canadian Review of Sociology and Anthropology* 12:4 (1, November):370-384.

Armstrong, Pat.
: 1980 "Women and Unemployment." *Atlantis* 6(1, Fall):1-16.

Armstrong, Pat and Hugh Armstrong.
: 1978 *The Double Ghetto: Canadian Women and Their Segregated Work*. Toronto: McClelland and Stewart.

1982a "Job Creation and Unemployment for Canadian Women." Pp.129-152 in Anne Hoiberg, ed., *Women and the World of Work*. New York: Plenum.

1982b "Beyond Numbers: Problems with Quantitative Data." Pp. 307-335 in Mary Kinnear and Greg Mason, eds., *Women and Work*. Winnipeg: Institute for Social and Economic Research and the Social Sciences and Humanities Research Council.

1983a "Beyond Sexless Class and Classless Sex: Towards Feminist Marxism." *Studies in Political Economy*. 10(Winter):7-43.

1983b *A Working Majority: What Women Must Do for Pay*. Ottawa: Supply and Services Canada for the Canadian Advisory Council on the Status of Women.

Backhouse, Constance and Leah Cohen.
1978 *The Secret Oppression: Sexual Harassment of Working Women*. Toronto: Macmillan.

Barrett, Michèle.
1980 *Women's Oppression Today*. Verso: London.

B.C. Federation of Labour.
n.d. [1983] A Survival Handbook for the Unemployed. Vancouver: pamphlet.

Beechey, Veronica.
1982 "The Sexual Division of Labour and the Labour Process: A Critical Assessment of Braverman." Pp. 54-73 in Stephen Wood, ed., *The Degradation of Work? Skill, Deskilling and the Labour Process*. London: Hutchinson.

Benston, Margaret.
1969 "The Political Economy of Women's Liberation." *Monthly Review* XXI (4, September):13-27.
1982 "Feminism and the Critique of Scientific Method." Pp. 47-66 in Angela Miles and Geraldine Finn, eds., *Feminism in Canada: From Pressure to Politics*. Montreal: Black Rose.
1983 "For Women, the Chips are Down." Pp.44-54 in Jan Zimmerman, ed., *The Technological Woman: Interfacing With Tomorrow*. New York: Praeger.

Bernard, Elaine.
1982 *The Long Distance Feeling. A History of the Telecommunications Workers' Union*. Vancouver: New Star Books.

Bernard, Jessie.
1972 *The Future of Marriage*. New York: Bantam.

Blaikie, Bill.
1982 "Health, Education to Feel Budget Squeeze." *Perception* 5(3, February):40-41.

Blauner, Robert.
1964 *Alienation and Freedom*. Chicago: University of Chicago Press.

BIBLIOGRAPHY

Blishen, Bernard R.
 1969 *Doctors and Doctrines.* Toronto: University of Toronto Press.

Bowles, Samuel and Herbert Gintis.
 1976 *Schooling in Capitalist America.* New York: Basic Books.

Boyd, Monica, Margrit Eichler and John Hofley.
 1976 "Family: Functions, Formation and Fertility." Pp. 13-52 in Gail Cook, ed., *Opportunity for Choice: A Goal For Women in Canada.* Ottawa: Statistics Canada and the C.D. Howe Research Institute.

Braverman, Harry.
 1974 *Labor and Monopoly Capital: The Degradation of Work in the Twentieth Century.* New York: Monthly Review Press.

Brennet, Johanna and Maria Ramas.
 1984 "Rethinking Women's Oppression." *New Left Review.* 144 (March-April): 33-71.

Briskin, Linda and Lynda Yanz.
 1983 *Union Sisters. Women in the Labour Movement.* Toronto: The Women's Press.

Brown, Richard.
 1976 "Women as Employees: Some Comments on Research in Industrial Sociology." Pp. 26-46 in Diana Leonard Barker and Sheila Allen, eds., *Dependence and Exploitation in Work and Marriage.* New York: Longman.

Canada, Advisory Committee on Reconstruction.
 1944 *Post-War Problems of Women: Final Report of the Subcommittee.* Ottawa: King's Printer.

Canada, Consumer and Corporate Affairs.
 1983 *Insolvency Bulletin.* Vol. 3, No. 1. Ottawa: Consumer and Corporate Affairs.

Canada, Department of Finance.
 1981 *Economic Review* April 1981. Ottawa: Supply and Services Canada.

Canada, Department of Labour.
 1960 *Occupational Histories of Married Women Working for Pay.* Ottawa: Queen's Printer.

Canada, House of Commons Task Force on Employment.
 n.d. [1981] *Work for Tomorrow: Opportunities for the '80s.* Ottawa: House of Commons.

Canada, House of Commons, Standing Committee on Health, Welfare and Social Affairs.
 1982 *Report on Violence in the Family. Wife Battering.* Ottawa: Supply and Services Canada.

Canada, Minister of Finance.
 1983 Budget Speech. April 19, 1983. Ottawa: Department of Finance.
Canada, Minister of Reconstruction.
 1945 White Paper on Employment and Income. Ottawa: King's Printer.
Canadian Council on Social Development.
 1983 *Social Development Overview.* (1)2.
Canadian Union of Public Employees.
 1982 Submission to the Labour Canada Task Force on Microelectronics and Employment. Ottawa: Mimeo.
Cavan, Ruth S. and Katherine Ranck.
 1938 *The Family and the Depression: A Study of One Hundred Chicago Families.* Chicago: University of Chicago Press.
Chester, Bronwyn.
 1983 "Job Creation Programs: From Public Works to NEED." *Perception* 6(5):35-36.
Chiplin, Brian and Peter J. Sloane.
 1980 "Sexual Discrimination in the Labour Market." Pp. 283-321 in Alice Amsden, ed., *The Economics of Women and Work.* Markham, Ontario: Penguin.
Clark, Lorenne and Debra Lewis.
 1977 *Rape: The Price of Coercive Sexuality.* Toronto: The Women's Press.
Clark, Susan and Andrew S. Harvey.
 1976 "The Sexual Division of Labour: The Use of Time." *Atlantis* 2(1, Fall):46-65.
Clement, Wallace.
 1983 *Class, Power and Property: Essays on Canadian Society.* Toronto: Methuen.
Coburn, Judi.
 1974 ""I See and am Silent": A Short History of Nursing in Ontario." Pp. 127-163 in Janice Acton, Penny Goldsmith and Bonnie Shepard, eds., *Women at Work: Ontario 1850-1930.* Toronto: The Women's Press.
Cohen, G.
 1977 "Absentee Husbands in Spiralist Families." *Journal of Marriage and the Family* 39:595-604.
Collins, Kevin.
 1978 *Women and Pensions.* Ottawa: The Canadian Council on Social Development.
Commission des Communautés Européenes.
 1982 *Le Programme* FAST. Volume 1. Bruxelles: Commission des Communautés Européenes.

BIBLIOGRAPHY

Connelly, M. Patricia.
1978 *Last Hired, First Fired: Women and the Canadian Work Force.* Toronto: The Women's Press.

Connelly, M. Patricia and Martha MacDonald.
1983 "Women's Work: Domestic and Wage Labour in a Nova Scotia Community." *Studies in Political Economy* 10(Winter):45-72.

Cooley, Mike.
1980 *Architect or Bee? The Human/Technology Relationship.* Sydney: TransNational Co-operative Limited.
1981 "The Taylorization of Intellectual Work." Pp. 46-65 in Les Levidow and Bob Young, eds., *Science, Technology and the Labour Process: Marxist Studies* Volume 1. London: Blackrose.

CSE Microelectronics Group.
1980 *Microelectronics: Capitalist Technology and the Working Class.* London: Blackrose.

Cuneo, Carl.
1979 "State, Class and Reserve Labour: The Case of the 1941 Canadian Unemployment Insurance Act." *The Canadian Review of Sociology and Anthropology* 16(2):147-170.

Dalla Costa, Mariarosa and Selma James.
1972 *The Power of Women and the Subversion of the Community.* Bristol: Falling Wall Press.

Danziger, Kurt.
1971 *Socialization.* Markham, Ontario: Penguin.

Defend Education Service Coalition.
n.d. [1983] *A Time To Speak Out.* Vancouver: Solidarity Coalition pamphlet.

de Kadt, Maarten.
1979 "Insurance: A Clerical Work Factory." Pp. 243-256 in Andrew Zimbalist, ed., *Case Studies in the Labor Process.* New York: Monthly Review Press.

Delphy, Christine.
1981 "Women in Stratification Studies." Pp. 114-128 in Helen Roberts, ed., *Doing Feminist Research.* London: Routledge and Kegan Paul.

Diebel, Linda.
1983 "The Inequities of Restraint." Pp. 42-43. *Maclean's* November 21.

di Manno, Rosie.
1983 "The State of Unions." *Homemakers* (July/August):42-54.

Doeringer, Peter.
1980 "Determinants of the Structure of Industrial Type Labour Markets." Pp.

211-231 in Alice H. Amsden, ed., *The Economics of Women and Work*. Markham, Ontario: Penguin.

Doeringer, Peter B. and Michael J. Piore.
1971 *Internal Labour Markets and Manpower Analysis*. Lexington, Mass.: Lexington Books.

Doern, Bruce G.
1981 "Cutbacks." *Perception* 5(1, October):11-13, 26.

Doern, Bruce G., ed.
1982 *How Ottawa Spends Your Tax Dollars*. Toronto: James Lorimer.

Dominion Bureau of Statistics.
1966 *Labour Force Industry and Occupation Trends 1961 Census of Canada*. (Cat. no. 94-551). Ottawa: Minister of Trade and Commerce.

Dulude, Louise.
1978 *Women and Aging: A Report on the Rest of Our Lives*. Ottawa: Advisory Council on the Status of Women.

Duncan, Mike.
1981 "Microelectronics: Five Areas of Subordination." Pp. 172-207 in Les Levidow and Bob Young, eds., *Science, Technology and the Labour Process*. London: Blackrose.

Economic Council of Canada.
1978 *A Time For Reason*. Fifteenth Annual Review. Ottawa: Supply and Services Canada.
1982a *In Short Supply: Jobs and Skills in the 1980s*. Ottawa: Supply and Services Canada.
1982b *Lean Times: Policies and Constraints*. Ottawa: Supply and Services Canada.
1983 *The Bottom Line: Technology, Trade and Income Growth*. Ottawa: Supply and Services Canada.

Edgell, Stephen.
1980 *Middle Class Couples: A Study of Segregation, Domination and Inequality in Marriage*. London: George Allen and Unwin Ltd.

Edwards, Meredith.
1981 *Financial Arrangements Within Families*. Report Prepared for the National Women's Advisory Council. Australia: Mimeo.

Edwards, Richard.
1979 *Contested Terrain*. New York: Basic Books.

Ehrenreich, Barbara and John Ehrenreich.
1978 "The Professional-Managerial Class." Pp. 5-45 in Pat Walker, ed., *Between Labor and Capital*. Montreal: Black Rose.

BIBLIOGRAPHY

Ehrensaft, Diane.
 1980 "When Women and Men Mother." *Socialist Review* 49 (Vol. 10, No. 1): 37-73.

Eichler, Margrit.
 1978 "Social Policy Concerning Women." Pp. 133-146 in Shankar A. Yelaja, ed., *Canadian Social Policy*. Waterloo: Wilfrid Laurier University Press.
 1980 *The Double Standard: A Feminist Critique of Feminist Social Science*. London: Croom Helm.

Eisenstein, Zillah.
 1979 "Developing a Theory of Capitalist Patriarchy and Socialist Feminism." Pp. 5-40 in Zillah Eisenstein, ed., *Capitalist Patriarchy and the Case for Socialist Feminism*. New York: Monthly Review Press.

Employment and Immigration Canada.
 1981 Labour Market Development in the 1980s. Ottawa: Employment and Immigration Canada.
 1983a Government of Canada Job Creation Programs: An Overview. Ottawa: Employment and Immigration Canada. Booklet.
 1983b Job Creation Policy and Programs. Ottawa: pamphlet.
 1983c Work Sharing: A Perspective. Ottawa: pamphlet.
 n.d. [1983a] Notes prepared in response to a newsletter from the National Action Committee.

Feldberg, Roslyn L. and Evelyn Nakano Glenn.
 1982 "Male and Female: Job Versus Gender Models in the Sociology of Work." Pp. 65-80 in Rachel Kahn-Hut, Arlene Kaplan Daniels and Richard Colvard, eds., *Women and Work: Problems and Perspectives*. New York: Oxford University Press.

Ferguson, Ann.
 1978 "Women as a Revolutionary Class." Pp. 279-312 in Pat Walker, ed., *Between Labor and Capital*. Montreal: Black Rose.

Finkel, Alvin.
 1977 "Origins of the Welfare State in Canada." Pp. 344-370 in Leo Panitch, ed., *The Canadian State: Political Economy and Political Power*. Toronto, University of Toronto Press.

Fitt, Yann, Alexandre Faire and Jean-Pierre Vigier.
 1980 *The World Economic Crisis*. London: Zed Press.

Fox, Bonnie.
 1980 "Women's Double Work Day: Twentieth-Century Changes in the Reproduction of Daily Life." Pp. 173-216 in Bonnie Fox, ed., *Hidden in the Household: Women's Domestic Labour Under Capitalism*. Toronto: The Women's Press.

Fox-Genovese, Elizabeth.
 1982 "Placing Women in History." *New Left Review* 133(May-June):5-29.

Frank, Andre Gunder.
 1981 *Reflections on the World Economic Crisis*. New York: Monthly Review Press.

Friedan, Betty.
 1963 *The Feminine Mystique*. London: Penguin.

Gamble, Andrew and Paul Walton.
 1976 *Capitalism in Crisis: Inflation and the State*. London: Macmillan.

Gardiner, Jean.
 1975 "Women's Domestic Labour." *New Left Review* 89(January-February):47-58.

Garson, Barbara.
 1975 *All the Livelong Day*. Markham: Penguin.

Gaskell, Jane.
 1982 "Educational and Job Opportunities for Women: Patterns of Enrolment and Economic Returns." Pp. 257-306 in Naomi Hersom and Dorothy E. Smith, *Women and the Canadian Labour Force*. Ottawa: Supply and Services Canada.

Glenn, Evelyn Nakano and Roslyn L. Feldberg.
 1979 "Proletarianizing Clerical Work: Technology and Organizational Control in the Office." Pp. 51-72 in Andrew Zimbalist, ed., *Case Studies in the Labor Process*. New York: Monthly Review Press.

Globerman, Steve.
 1981 *The Adaptation of Computer Technology in Selected Canadian Service Industries*. A study prepared for the Economic Council of Canada. Ottawa: Supply and Services Canada.

Gonick, Cy.
 1983 "Boom and Bust: State Policy and the Economics of Restructuring." *Studies in Political Economy* 11(Summer):27-47.

Gordon, David M.
 1972 *Theories of Poverty and Underemployment*. Lexington, Mass: Lexington Books.

Gordon, David M., Richard Edwards and Michael Reich.
 1982 *Segmented Work, Divided Workers: The Historical Transformation of Labour in the United States*. New York: Cambridge University Press.

Gordon, Linda.
 1979 "The Struggle for Reproductive Freedom: Three Stages of Feminism." Pp. 107-135 in Zillah Eisenstein, ed., *Capitalist Patriarchy and the Case For Socialist Feminism*. New York: Monthly Review Press.

Gotlieb, C.C.
 1978 *Computers in the Home: What They Can Do for Us – And to Us*. Montreal: Institute for Research on Public Policy.

BIBLIOGRAPHY

Gouldner, Alvin H.
 1954 *Patterns of Industrial Bureaucracy.* Toronto: Collier-Macmillan.

Grayson, Paul.
 1983 "The Closure of SKF Canada, Ltd." Downsview: Mimeo.

Greenglass, Esther R.
 1982 *A World of Difference: Gender Roles in Perspective.* Toronto: John Wiley and Sons.

Gunderson, Morley.
 1975 "Work Patterns." Pp. 93-142 in Gail Cook, ed., *Opportunity for Choice: A Goal for Women in Canada.* Ottawa: Information Canada.

Hacker, Sally L.
 1982 "Sex Stratification, Technology and Organizational Change: A Longitudinal Case Study of AT&T." Pp. 248-271 in Rachel Kahn-Hut, Arlene Kaplan Daniels and Richard Colvard, eds., *Women and Work: Problems and Perspectives.* New York: Oxford University Press.

Hainsworth, Ray.
 1982 "Microelectronics and Canadian Labour." *The Canadian Forum* Vol. LXI (7, March):8-9, 38.

Hamilton, Roberta.
 1978 *The Liberation of Women.* London: George, Allen and Unwin.

Hartmann, Heidi.
 1976 "Capitalism, Patriarchy and Job Segregation by Sex," Pp. 137-169 in Martha Blaxall and Barbara Reagan, eds., *Woman and the Workplace: The Implications of Occupational Segregation.* Chicago: University of Chicago Press.
 1981 "The Unhappy Marriage of Marxism and Feminism: Towards a More Progressive Union." Pp. 1-41 in Lydia Sargent, ed., *Women and Revolution.* Boston: South End Press.

Hasan, Abrar and Surendra Gera.
 1982 *Job Search Behaviour, Unemployment, and Wage Gain in Canadian Labour Markets.* A Study Prepared for the Economic Council of Canada. Ottawa: Supply and Services Canada.

Hawrylyshyn, Oli.
 1978 *The Economic Nature and Value of Volunteer Activity.* Ottawa: Secretary of State. Mimeo.

Health and Welfare.
 1980 *The Status of Day Care in Canada.* Ottawa: Health and Welfare Canada.

Hepworth, Philip.
 1982 "Social Policy in Times of Fiscal Restraint: A Canadian Perspective." Paper

presented to the 1982 Institute and Annual Meeting of the Saskatchewan Association of Social Workers. Saskatoon, Saskatchewan.

Herman, Harry Vjekoslav.
 1978 *Men in White Aprons*. Toronto: Peter Martin Associates.

Hitchman, Gladys Symons.
 1976 "The Effect of Graduate Education on the Sexual Division of Labour in the Canadian Family." Paper presented at the Western Association of Sociology and Anthropology Annual Meeting. Mimeo.

Humphries, Jane.
 1976 "Women: Scapegoats and Safety Valves in the Great Depression." *The Review of Radical Political Economics* 8(1, Spring): 98-121.
 1977 "The Working Class Family, Women's Liberation and Class Struggle: The Case of Nineteenth Century British History." *Review of Radical Political Economics* 9(3):25-41.
 1980 "Class Struggle and the Persistence of the Working Class Family," Pp. 140-165 in Alice H. Amsden, ed., *The Economics of Women and Work*. Markham, Ontario: Penguin.

Huws, Ursula.
 1982 *Your Job in the Eighties. A Woman's Guide to the New Technology*. Bristol: Pluto Press.

Irvine, John, Ian Miles and Jeff Evans, eds.
 1979 *Demystifying Social Statistics*. London: Pluto Press.

Jenkins, Clive and Barrie Sherman.
 1979 *The Collapse of Work*. Fakenham, Norfolk: Fakenham.

Johnson, Laura C. and Robert Johnson.
 1982 *The Seam Allowance: Industrial Home Sewing in Canada*. Toronto: The Women's Press.

Jordonova, L.J.
 1981 "The History of the Family." Pp. 41-53 in Cambridge Women's Studies Group, *Women in Society*. London: Virago.

Kalbach, Warren and Wayne McVey.
 1971 *The Demographic Base of Canadian Society*. Second Edition. Toronto: McGraw-Hill Ryerson.

Kalbach, Daniel and David Thornton.
 1974 *The Demographic Base of Canadian Society*. Toronto: McGraw-Hill Ryerson.

Kelly, Maria Patricia Fernandez.
 1983 "Gender and Industry in Mexico's New Frontier." Pp. 18-29 in Jan Zimmerman, ed., *The Technological Woman: Interfacing with Tomorrow*. New York: Praeger.

BIBLIOGRAPHY

Kirsh, Sharon.
 1983 *Unemployment: Its Impact on Body and Soul*. Toronto: Canadian Mental Health Association.

Klein, Alice and Wayne Roberts.
 1974 "Besieged Innocence: The Problem and Problems of Working Women – Toronto 1896-1914." Pp. 211-259 in Janice Acton, Penny Goldsmith and Bonnie Shepard, eds., *Women at Work: Ontario 1850-1930*. Toronto: The Women's Press.

Komarovsky, Mirra.
 1940 *The Unemployed Man and His Family: The Effect of Unemployment on the Status of Men in Fifty-nine Families*. New York: Dryden Press.
 1962 *Blue Collar Marriage*. New York: Vintage.

Kome, Penney.
 1982 *Somebody Has To Do It: Whose Work is Housework*. Toronto: McClelland and Stewart.

Kostash, Myrna.
 1982 "Whose Body? Whose Self? Beyond Pornography." Pp. 43-53 in Maureen FitzGerald, Connie Guberman and Margie Wolfe, eds., *Still Ain't Satisfied: Canadian Feminism Today*. Toronto: The Women's Press.

Kronby, Malcolm.
 1979 *Canadian Family Law*. Don Mills: General Publishing.

Kuch, Peter and Walter Haessel.
 1979 *An Analysis of Earnings in Canada*. Ottawa: Supply and Services Canada.

Labour Canada.
 1982 *In the Chips: Opportunities, People, Partnerships*. Report of the Labour Canada Task Force on Micro-Electronics and Employment. Ottawa: Supply and Services Canada.
 1983 *Women in the Work Force*. Part III A Variety of Facts and Figures. Ottawa: Supply and Services Canada.
 1983a *Maternity and Child Care Leave in Canada*. Ottawa: Supply and Services Canada.
 1983b *Commission of Inquiry into Part-Time Work*. Ottawa: Supply and Services Canada. [Wallace Commission].

La Follette, Cicil Tipton.
 1934 *A Study of the Problems of 652 Gainfully Employed Married Women Homemakers*. New York: Columbia University.

Lalonde, The Honourable Marc.
 1983 *Research and Development Tax Policies*. Ottawa: Department of Finance Canada, April.

Land, Hilary.
 1976 "Women: Supporters or Supported." Pp. 108-132 in D.L. Barker and S. Allen, eds., *Sexual Divisions in Society: Process and Change*. London: Tavistock.
 1978 "Sex-Role Stereotyping in the Social Security and Income Tax Systems," Pp. 127-142 in Jane Chetwynd and Oonagh Harnett, eds., *The Sex Role System*. London: Routledge and Kegan Paul.

Lautard, Hugh.
 1976 "The Segregated Labour Force Participation Of Men and Women in Canada: Long Run Trends in Occupational Segregation by Sex, 1891-1961." Paper presented at the Western Association of Sociology and Anthropology Annual Meetings. Mimeo.

Lebowitz, Michael.
 1982 "The General and Specific in Marx's Theory of Crisis." *Studies in Political Economy* 7(Winter):5-25.

Lewis, Ian.
 1964 "In the Courts of Power – The Advertising Man." Pp. 181-210 in Peter L. Berger, ed., *The Human Shape of Work*. Chicago: McMillan.

Lichtman, Richard.
 1975 "Marx's Theory of Ideology." *Socialist Revolution* 23(1, January-March):45-76.

Lipton, Charles.
 1967 *The Trade Union Movement in Canada 1827-1959*. Toronto: Canadian Social Publications.

Lipsig-Mummé, Carla.
 1983 "La Renaissance du Travail à Domicile dans les Économies Développées." *Sociologie du Travail* (juillet-août-septembre):313-335.

Lockhart, Alexander.
 1979 "Educational Opportunities and Economic Opportunities – The 'New' Liberal Equality Syndrome." Pp. 224-237 in John Allan Fry, ed., *Economy, Class and Social Reality*. Toronto: Butterworth.

Lopata, Helena.
 1971 *Occupation: Housewife*. New York: Oxford University Press.

Lowe, Graham and H. Northcott.
 1984 "Working Conditions and Job Stress Among Postal Workers." Paper presented at the Fifth Conference on Workers and Their Communities. Ontario Institute for Studies in Education, Toronto, May.

Lowe, Marian.
 1983 "Sex Differences, Science and Society." Pp. 7-17 in Jan Zimmerman, ed., *The Technological Woman: Interfacing With Tomorrow*. New York: Praeger.

BIBLIOGRAPHY

Luxton, Meg.
1980 *More than a Labour of Love: Three Generations of Women's Work in the Home.* Toronto: The Women's Press.
1981 "Taking on the Double Day." *Atlantis* 7(1, Fall): 12-22.
1983 "Two Hands for the Clock: Changing Patterns in the Gendered Division of Labour in the Home." *Studies in Political Economy* 12(Fall):27-44.

MacDonald, Maureen.
1983 "Trouble for Teen Mothers in Nova Scotia." *Perception* 7(1, Sept./Oct.): 16-17.

Mackasey, The Honourable Bryce.
1970 *Unemployment Insurance in the 70s.* Ottawa: Queen's Printer.

MacKay, H.
1983 "Social Impact of Unemployment." *Perception* 6(5): 32-34.

Mackintosh, Maureen M.
1979 "Domestic Labour and the Household." Pp. 173-191 in Sandra Burman, ed., *Fit Work for Women.* Canberra: Australian National University Press.

MacLeod, Linda.
1980 *Wife Battering in Canada: The Vicious Circle.* Ottawa: Supply and Services Canada.

Mahon, Rianne.
1977 "Canadian Public Policy: The Unequal Structure of Representation." Pp. 165-198 in Leo Panitch, ed., *The Canadian State: Political Economy and Political Power.* Toronto: University of Toronto Press.
1983 "Canadian Labour in the Battle for the Eighties." *Studies in Political Economy* 11(Summer):149-175.

Mandel, Ernest.
1964 An Introduction to Marxist Economic Theory. New York: Merit Publishers. Pamphlet.
1968 *Marxist Economic Theory* Vol. 1. New York: Monthly Review Press. Translated by Brian Pearce.

Marchak, Patricia.
1979 "Labour in a Staples Economy." *Studies in Political Economy* 2(September):7-35.

Marglin, Stephen.
1976 "What Do Bosses Do?" Pp. 13-54 in André Gorz, ed., *The Division of Labour.* Sussex: Harvester.

Marsh, Leonard.
1935 *Employment Research.* Toronto: Oxford University Press.
1939 The Mobility of Labour in Relation to Unemployment. Offprint of Papers

and Proceedings of the Canadian Political Science Association.
1940 *Canadians In and Out of Work.* A Survey of Economic Classes and their Relation to the Labour Market. Toronto: Oxford University Press.

Marsh, Peter.
1981 *The Silicon Chip Book.* Glasgow: Sphere Books.

Marx, Karl.
1977 *Capital.* Volume 1. Toronto: Random House.

Maslove, Allan and Gene Swimmer.
1980 *Wage Controls in Canada 1975-78.* A Study of Public Decision Making. Montreal: The Institute for Research on Public Policy.

Massey, Doreen and Richard Meegan.
1982 *The Anatomy of Job Loss.* London: Methuen.

Mathews, Roy.
1983 *Canada and the Little Dragons.* Montreal: The Institute for Research on Public Policy.

McClain, Janet with Cassie Doyle.
1983 Women as Housing Consumers. Ottawa: Mimeo.

McClendon, McKee.
1976 "The Occupational Status Attainment Process of Males and Females." *American Sociological Review* 41(February):52-64.

McDonald, Lynn.
1977 "Wages of Work: A Widening Gap Between Women and Men." Pp. 181-191 in Marylee Stephenson, ed., *Women in Canada.* Don Mills: General Publishing.

McFarlane, Bruce A.
1975 "Married Life and Adaptations to a Professional Role: Married Women Dentists in Canada." Pp. 359-366 in Parvez S. Wakil, ed., *Marriage, Family and Society.* Toronto: Butterworth.

McGrath, Colleen.
1979 "The Crisis of Domestic Order." *Socialist Review* 43(Vol. 9, No. 1 January-February):11-30.

McIntosh, Mary.
1978 "The State and the Oppression of Women." Pp. 254-289 in Annette Kuhn and Ann Marie Wolpe, eds., *Feminism and Materialism.* London: Routledge and Kegan Paul.
1979 "The Welfare State and the Needs of the Dependent Family." Pp. 153-172 in Sandra Burman, ed., *Fit Work For Women.* Canberra: Australian National University Press.

BIBLIOGRAPHY

McKie, D.C., B. Prentice and Paul Reed.
 1983 *Divorce: Law and the Family in Canada.* Ottawa: Supply and Services Canada.

McLaren, Angus.
 1977 "Women's Work and the Regulation of Family Size: The Question of Abortion in the Nineteenth Century." *History Workshop* 4:70-81.
 1978"Birth Control and Abortion in Canada, 1870-1920." *Canadian Historical Review* LIX(3):319-340.

McQuaig, Linda.
 1983 "The High-Tech Job Threat." *Maclean's* May 16:32-33.

Meissner, Martin.
 1971 "The Long Arm of the Job: A Study of Work and Leisure." *Industrial Relations* 10:239-260.

Meissner, Martin, Elizabeth Humphreys, Scott Meiss and William Sheu.
 1975 "No Exit for Wives: Sexual Division of Labour." *The Canadian Review of Sociology and Anthropology* 12 (4, Part 1, November):424-439.

Meltz, Noah and David Stager.
 1979 *The Occupational Structure of Earnings in Canada, 1931-1975.* Ottawa: Supply and Services Canada.

Menzies, Heather.
 1981 *Women and the Chip: Case Studies of the Effects of Informatics on Employment in Canada.* Montreal: The Institute for Research on Public Policy.
 1982 *Computers on the Job.* Toronto: James Lorimer.
 1983 "The Future is Now." Pp. 13-22 in Jacqueline Pelletier, ed., *The Future is Now: Women and the Impact of Technology.* Ottawa: Women and Technology Committee.

Milkman, Ruth.
 1976 'Women's Work and the Economic Crisis." *The Review of Radical Political Economics* Vol. 8(1, Spring):73-97.
 1980 "Organizing the Sexual Division of Labor: Historical Perspectives in 'Women's Work' and the American Labor Movement." *Socialist Review* 49(Vol. 10, No. 1):95-150.

Mills, C. Wright.
 1959 *The Sociological Imagination.* New York: Grove.

Mincer, Jacob and Solomon Polochek.
 1980 "Family Investments in Human Capital: Earnings of Women." Pp. 169-205 in Alice Amsden, ed., *The Economics of Women and Work.* Markham, Ontario: Penguin.

Mitchell, Juliet.
 1974 *Psychoanalysis and Feminism.* New York: Vintage.

Molyneux, Maxine.
 1979 "Beyond the Domestic Labour Debate." *New Left Review* 116 (July-August):3-27.

Morgan, D.H.S.
 1975 *Social Theory and the Family*. London: Routledge and Kegan Paul.

Morgan, Winona.
 1939 *The Family Meets the Depression: A Study of a Group of Highly Selected Families*. Minneapolis: The University of Minnesota Press.

Morton, Peggy.
 1972 "Women's Work is Never Done." Pp. 46-68 in *Women Unite*. Toronto: The Women's Press.

Moscovitch, Allan.
 1982 "The Rise and Decline of the Canadian Welfare State." *Perception* 6(2, November/December):26-28.

Myrdal, Alva and Viola Klein.
 1956 *Women's Two Roles*. London: Routledge and Kegan Paul.

Nakamura, Alice, Masao Nakamura and Dallas Cullen in collaboration with Dwight Grant and Harriet Orcutt.
 1979 *Employment and Earnings of Married Females*. Ottawa: Statistics Canada.

National Council of Welfare.
 1976 *One in a World of Two's*. Ottawa: National Council of Welfare.
 1979 *Women and Poverty*. Ottawa: National Council of Welfare.

Oakley, Ann.
 1974 *The Sociology of Housework*. New York: Pantheon.
 1981a *Subject: Women*. Toronto: Random House.
 1981b "Interviewing Women: A Contradiction in Terms." Pp. 30-61 in Helen Roberts, ed., *Doing Feminist Research*. London: Routledge and Kegan Paul.

O'Brien, Mary.
 1979 "Reproducing Marxist Man." Pp. 99-116 in Lorenne Clark and Lynda Lange, eds., *The Sexism of Social and Political Theory*. Toronto: University of Toronto Press.
 1981 *The Politics of Reproduction*. Boston: Routledge and Kegan Paul.

O'Connor, James.
 1973 *The Fiscal Crisis of the State*. New York: St. Martin's Press.

Oliver, Carole.
 1983 "Abortion Under Attack." *Canadian Forum* LXII(726, March):37, 42.

Ontario, Legislature.
 1982 Bill 179. An Act Respecting the Restraint of Compensation in the Public

BIBLIOGRAPHY

Sector of Ontario and the Monitoring of Inflationary Conditions in the Economy of the Province. 2nd Session, 32nd Legislature, Ontario: Toronto: Queen's Printer.

Ontario, Legislature Assembly, Standing Committee on Social Development.
1982 *First Report on Family Violence: Wife Battering*. Toronto: Legislative Assembly.

Organization for Economic Co-operation and Development.
1980 "The 1974-75 Recession and the Employment of Women." Pp. 359-385 in Alice H. Amsden, ed., *The Economics of Women and Work*. Markham, Ontario: Penguin.
1983 OECD *Economic Outlook*. Paris: OECD.

Ostry, Sylvia.
1968 *The Female Worker in Canada*. (Cat. no. 99-553). Ottawa: Queen's Printer.

Ostry, Sylvia and Mahmood Zaidi.
1979 *Labour Economics in Canada*. Third Edition. Toronto: Macmillan.

Palteil, Freda.
1982 "Battered Women: Concepts, Prospects and Practices." *Intervention* 63:15-24.

Panitch, Melanie.
1982 "Winds of Change." *Perception* 6(2, November/December):10-12.

Parkin, Frank.
1972 *Class Inequality and Political Order*. London: Paladin.

Parsons, Talcott.
1952 *The Social System*. New York: Routledge and Kegan Paul.
1956 *Family, Socialization and Interaction Process*. New York: Routledge and Kegan Paul.
1964 *Essays in Sociological Theory*. New York: Free Press.

Pease, John, William H. Form and Joan Huber Rytina.
1970 "Ideological Currents in American Stratification Literature." *American Sociologist* 5(2, May):127-137.

Pelletier, Jacqueline.
1983 *The Future is Now: Women and the Impact of Microtechnology*. Ottawa: Women and Technology Conference.

Peitchinis, Stephen.
1978 *The Effects of Technological Changes on Educational and Skill Requirements of Industry*. Research Report, Department of Industry, Trade and Commerce, Technological Innovations Studies Programmes, Ottawa.
1979 "Technological Changes and the Demand for Skilled Manpower in Canada." Paper prepared for the Nature of Technological Changes and the Effects on

Employment, Education and Skills, funded by the Technology Branch of Department of Industry, Trade and Commerce.
1980 "Technological Changes and the Sectoral Distribution of Employment." Revised version of a paper presented to 1979 annual meeting of the Western Economic Association, Las Vegas.
1982 "Microelectronic Technology and Employment: Reality and Fiction." Paper presented at the Workshop on Microelectronics Information Technology and Canadian Society Conference, Queen's University, May.

Petchesky, Rosalind.
1978 "Dissolving the Hyphen: A Report on Marxist-Feminist Groups 1-5." Pp. 373-390 in Z. Eisenstein, ed., *Capitalist Patriarchy and the Case for Socialist Feminism*. New York: Monthly Review.

Phidd, Richard and Bruce Doern.
1978 *The Politics and Management of Canadian Economic Policy*. Toronto: Macmillan.

Piotrkowski, Chaya S.
1978 *Work and the Family System*. New York: The Free Press.

Pollert, Anna.
1981 *Girls, Wives, Factory Lives*. London: Macmillan.

Porter, John.
1965 *The Vertical Mosaic*. Toronto: University of Toronto Press.
1967 *Canadian Social Structure. A Statistical Profile*. Toronto: McClelland and Stewart.
1979 "The Future of Upward Mobility." Pp. 65-87 in John Porter, *The Measure of Canadian Society: Education, Equality and Opportunity*. Agincourt, Ontario: Gage.

Porter, Marion, John Porter and Bernard Blishen.
1973 *Does Money Matter? Prospects of Higher Education*. Toronto: Institute for Behavioural Research, York University.

Power, Margaret.
1976 "Women and Economic Crises: The 1930s Depression and the Present Crisis." *The Journal of Australian Political Economy* 4(March):3-12.

Public Service Commission of Canada.
1984 *Annual Report*. Ottawa: Supply and Services Canada.

Ramkhalawansingh, Ceta.
1974 "Women During the Great War." Pp. 261-307 in Janice Acton, Penny Goldsmith and Bonnie Shepard, eds., *Women at Work: Ontario 1850-1930*. Toronto: The Women's Press.

Rasmussen, Linda, Lorna Rasmussen, Candace Savage and Anne Wheeler.
1976 *A Harvest Yet to Reap: A History of Prairie Women*. Toronto: The Women's Press.

BIBLIOGRAPHY

Reich, Michael, David M. Gordon and Richard C. Edwards.
 1980 "A Theory of Labour Market Segmentation." Pp. 232-241 in Alice H. Amsden, ed., *The Economics of Women and Work*. Markham, Ontario: Penguin.

Reno, Bill.
 1982 "Supermarket Technology." *The Canadan Forum* LXI (7, March):10-11, 13.

Roberts, Barbara.
 1983 "No Safe Place: The War Against Women." *Our Generation* 15(4, Spring):7-26.

Roberts, Helen, ed.
 1981 *Doing Feminist Research*. London: Routledge and Kegan Paul.

Ross, David.
 1983 Some Financial and Economic Dimensions of Registered Charities and Volunteer Activity in Canada. Ottawa: Secretary of State. Mimeo.

Rubery, Jill.
 1980 "Structured Labour Markets, Worker Organization and Low Pay." Pp. 242-270 in Alice Amsden, ed., *The Economics of Women and Work*. Markham, Ontario: Penguin.

Ruben, Gayle.
 1976 "The Traffic in Women: Notes on the Political Economy of Sex." Pp. 157-210 in Mayna Reiter, ed., *Toward an Anthropology of Women*. New York: Monthly Review Press.

Rubin, Lillian Breslow.
 1976 *Worlds of Pain: Life in the Working Class Family*. New York: Basic.

Sargent, Lydia.
 1981 "New Left Women and Men: The Honeymoon is Over." Pp. xi-xxxii in Lydia Sargent, ed., *Women and Revolution*. Boston: South End Press.

Sawhill, Isabel V.
 1980 "Economic Perspectives on the Family." Pp. 125-139 in Alice H. Amsden, ed., *The Economics of Women and Work*. Markham, Ontario: Penguin.

Science Council of Canada.
 1982 *Planning Now For an Information Society. Tomorrow is Too Late*. Hull: Supply and Services Canada.

Seccombe, Wally.
 1974 "The Housewife and Her Labour Under Capitalism." *New Left Review* 83 (January-February):3-24.
 1975 "Domestic Labour – A Reply to Critics." *New Left Review* 94 (November-December):85-96.
 1980 "The Expanded Reproduction Cycle of Labour Power in Twentieth Century Capitalism." Pp. 217-266 in Bonnie Fox, ed., *Hidden in the Household. Women's*

Domestic Labour Under Capitalism. Toronto: The Women's Press.
1983 "Marxism and Demography." *New Left Review* 137(January-February):22-47.

Seidman, Ann, ed.
1978 *Working Women: A Study of Women in Paid Jobs.* Boulder, Colorado: Westview Press.

Serafini, Shirley and Michel Andrieu.
1981 *The Information Revolution and its Implications for Canada.* Ottawa: Supply and Services Canada.

Shragge, Eric.
1983 "A Libertarian Response to the Welfare State." *Our Generation* 15(4, Spring):36-47.

Siltanen, Janet.
1981 "A Commentary on Theories of Female Wage Labour." Pp. 25-40 in Cambridge Women's Studies Group, ed., *Women in Society.* London: Virago.

Skoulas, Nicholas.
1974 *Determinants of the Participation Rate of Married Women in the Canadian Labour Force: An Econometric Analysis.* Ottawa: Information Canada.

Slotnick, Lorne.
1983 "Abortion Politics Shift Dramatically." *Goodwin's* 1(2, Fall):7.

Smith, Dorothy E.
1973 "Women, The Family and Corporate Capitalism." Pp. 2-35 in Marylee Stephenson, ed., *Women in Canada.* Toronto: New Press.
1974 "Women's Perspective as a Radical Critique of Sociology." *Sociological Enquiry* 44(1):7-13.
1979 "A Sociology for Women." Pp. 135-187 in J.A. Sherman and E.T. Beck, eds., *The Prism of Sex: Essays in the Sociology of Knowledge.* Madison: University of Wisconsin Press.

Social Planning Council of Metropolitan Toronto.
1980 *Working Papers for Full Employment.* Toronto: Social Planning Council of Metropolitan Toronto.
1982 *A Job for Everyone: A Response to "Un" Employment Policies in Canada.* Toronto: Social Planning Council of Metropolitan Toronto.
1983 *...And the Poor Get Poorer. A Study of Social Welfare Programs in Ontario.* Toronto: The Social Planning Council of Metropolitan Toronto and the Ontario Social Development Council.

Sokoloff, Natalie.
1980 *Between Money and Love: The Dialectics of Home and Market Work.* New York: Praeger.

BIBLIOGRAPHY

Spencer, Byron G., Dennis C. Featherstone.
1970 *Married Female Labour Force Participation: A Micro Study*. (Cat. no. 71-516). Ottawa: Queen's Printer.

Statistics Canada.*
1976 Economic Characteristics – Occupation by Industry. 1971 Census of Canada (Cat. no. 94-792 (SE-1)). Ottawa: Minister of Industry, Trade and Commerce.
1978 Economic Characteristics – Industry Trends, 1951-1971. Special Bulletin 1971 Census of Canada (Cat. no. 94-793 (SE-2)). Ottawa: Industry, Trade and Commerce.
1979 Historical Labour Force Statistics: Actual Data, Seasonal Factors, Seasonally Adjusted Data (Cat. no. 71-201). Ottawa: Supply and Services Canada.
1979 Labour Force Annual Averages, 1975-1978 (Cat. no. 71-529). Ottawa: Supply and Services Canada.
1979 Guide to Labour Force Survey Data (Cat. no. 71-528). Ottawa: Supply and Services Canada.
1980 Perspectives Canada III (Cat. no. 11-507). Ottawa: Supply and Services Canada.
1981 An Overview of Volunteer Workers in Canada. February 1980. Ottawa: Supply and Services Canada.
1981 Hospital Annual Statistics (Cat. no. 82-232). Ottawa: Supply and Services Canada.
1982 1981 Census Dictionary (Cat. no. 99-901). Ottawa: Supply and Services Canada.
1982 Consumer Prices and Price Index. April-June 1982 (Cat. no. 62-010). Ottawa: Supply and Services Canada.
1983 Corporations and Labour Unions Returns Act Part II (CALURA) (Cat. no. 71-202). Ottawa: Supply and Services Canada.
1983 Canadian Statistical Review October 1983 (Cat. no. 11-003E). Ottawa: Supply and Services Canada.
1983 Social Security National Programs. Other Programs 1982 (Cat. no. 86-511). Ottawa: Supply and Services Canada.
1983 Vital Statistics. Volume II. Marriages and Divorces (Cat. no. 84-205). Ottawa: Supply and Services Canada.
1983 Vital Statistics. Volume III. Mortality (Cat. no. 84-206). Ottawa: Supply and Services Canada.
The Labour Force (Cat. no. 71-001). Ottawa: Supply and Services Canada. Various issues.

* Since there are a large number of references to recent Statistics Canada publications, detailed references are provided within the text.

Stilwell, Frank.
1981 "Unemployment and Socio-Economic Structure," in Bettina Cass, ed., *Unemployment. Causes, Consequences, and Policy Implications*. Kensington, Australia: Social Welfare Research Centre. The University of New South Wales.

Stinson, Jane.
1980 Technological Change and Working Women. Report prepared for The Organized Working Women Conference on Women and Employment. February. Toronto: Mimeo.

Stirling, Robert and Denise Kouri.
1979 "Unemployment Indexes – The Canadian Context." Pp. 169-205 in J.A. Fry, ed., *Economy, Class and Social Reality*. Toronto: Butterworths.

The Bank Book Collective.
1979 *An Account to Settle. The Story of the United Bank Workers*. (SORWUC). Vancouver: Press Gang.

Tumin, Melvin.
1970 "Some Principles of Stratification: A Critical Analysis." Pp. 378-386 in Melvin M. Tumin, ed., *Readings on Social Stratification*. Englewood Cliffs: Prentice-Hall.

Vanier Institute of The Family.
1982 A Familial Perspective on Micro-Computer Communication. Ottawa: Mimeo.

Vickary, Claire.
1979 "Women's Economic Contribution to the Family." Pp. 159-220 in Ralph E. Smith, ed., *The Subtle Revolution*. Washington: The Urban Institute.

Wajcman, Judy.
1981 "Work and the Family: Who Gets 'The Best of Both Worlds'?" Pp. 9-24 in Cambridge Women's Studies Group, ed., *Women in Society*. London: Virago.

Walker, Kathryn E. and Margaret E. Woods.
1976 *Time Use: A Measure of Household Production of Family Goods and Services*. Washington: The American Home Economics Association.

Warskett, George.
1982 "The Choice of Technology and Women in the Paid Work Force." Pp. 133-164 in Naomi Hersom and Dorothy E. Smith, eds., *Women and the Canadian Labour Force*. Ottawa: Social Science and Humanities Research Council of Canada.

Webber, Maryanne.
1983 Supplementary Measures of Unemployment. Ottawa: Statistics Canada. Mimeo.

Weiner, Andrew.
1983 "Knowing Left from Right. A Capitalist's Guide to Marxism, in this the

BIBLIOGRAPHY

Centennial of the Philosopher's Death." *The Financial Post Magazine* (March 1):14-22.

Weitzman, Lenore.
 1979 *Sex Role Socialization*. Palo Alto, California: Mayfield.

White, Julie.
 1980 *Women and Unions*. Ottawa: Supply and Services Canada.
 1983 *Women and Part-Time Work*. Ottawa: Supply and Services Canada.

Wilkins, Russell.
 1982 Health and Safety Aspects Associated With the Use of Microelectronics Technology in the Workplace: An Overview of the Current Debate Concerning Visual Display Terminals. Report Prepared for the Labour Canada Task Force on Micro-Electronics and Employment. Montreal: Mimeo.

Williams, Richard M.
 1983 "Thinking About Technological Change." *Perception* 6(4, March/April):12-14.

Wolfe, David.
 1977 "The State and Economic Policy in Canada, 1968-75." Pp. 251-288 in Leo Panitch, ed., *The Canadian State: Political Economy and Political Power*. Toronto: University of Toronto Press.
 1983 "The Crisis in Advanced Capitalism: An Introduction." Studies in Political Economy" (Summer):7-26.

Wood, Stephen, ed.
 1982 *The Degradation of Work? Skill, Deskilling and the Labour Process*. London: Hutchinson.

Young, Iris.
 1980a "Socialist Feminist Theory and the Limits of Dual Systems Theory." *Socialist Review* 50/51 (Vol. 10, No.2/3):169-188.
 1980b "Beyond the Unhappy Marriage: A Critique of the Dual Systems Theory." Pp. 43-69 in Lydia Sargent, ed., *Women and Revolution*. Boston: South End Press.

Zaretsky, Eli.
 1976 *Capitalism, the Family and Personal Life*. London: Pluto Press.
 1982 "The Place of the Family in the Origins of the Welfare State." Pp. 188-224 in Barrie Thorne, ed., *Rethinking the Family*. New York: Longman.

Zeman, Z.P.
 1979 The Impacts of Computer/Communications on Employment in Canada: An Overview of Current OECD Debates. Report prepared for the Department of Communications, Telecommunications Economics Branch, Montreal: The Institute for Research on Public Policy.